BEAUFORT

BEAUFORT
A HISTORY

ALEXIA JONES HELSLEY

Foreword by Lawrence S. Rowland

THE
History
PRESS

Published by The History Press
Charleston, SC 29403
www.historypress.net

Front Cover Image:
Shrimp boats on the Beaufort River. The seafood industry epitomizes Beaufort's historic
dependence upon her waterways. By the late 1920s, Beaufort County led the state in number
of licensed shrimp boats. *Ned Brown, photographer. Courtesy of the author.*

Back Cover Image:
Issuing rations at the John Joyner Smith plantation near Beaufort, c. 1866. Black soldiers
camped on the Smith plantation—Old Fort, now the naval hospital grounds. Thomas
Wentworth Higginson, on his first glimpse of Camp Saxton, noted "the decaying house and
tiny church amid the woods." Elizabeth Hyde Botume ran a school for the contrabands
there. Upon her arrival, she wrote that "[a] large number of...refugees had been brought
there."
No. 10076.7. Courtesy of the South Caroliniana Library, University of South Carolina.

First published 2005
Second printing 2006
Third printing 2014

Manufactured in the United States

978-1-59629-027-3

Library of Congress Cataloging-in-Publication Data

Helsley, Alexia Jones.
Beaufort : a history / Alexia Jones Helsley.
p. cm.
Includes bibliographical references and index.
ISBN 1-59629-027-7 (alk. paper)
1. Beaufort (S.C.)—History. I. Title.
F279.B3H45 2005
975.7'99--dc22
2005007033

CONTENTS

Foreword

Beaufort has one of the oldest recorded histories in North America. From the first landing of Spanish sailors from Santo Domingo in 1514 through the first Protestant colony in the new world commanded by French Huguenot Captain Jean Ribault (1562) to the first official capital of Spanish Florida at Santa Elena (1566–1587), the history of Beaufort County pre-dates Jamestown, Virginia, and Plymouth Rock, Massachusetts, by nearly a century.

As the Spanish empire in the American Southeast diminished, English adventurers filled the void. Captain William Hilton (1663) and Colonel Robert Sandford (1666) explored the Sea Islands, and the first English settlers of South Carolina from Barbados held the colony's first election on Lady's Island opposite Beaufort in 1670. Scottish Indian traders were the first permanent settlers, establishing "Stuart Town" in 1685 and instigating a Spanish invasion in 1686. Colonial wars with Spain prompted a lookout (1703) and frontier fort (1706) with a garrison of British Redcoats to guard the inland passage. Around this frontier fort, the town of Beaufort grew. In 1709, the traders petitioned the Lords Proprietors of Carolina in London for the charter for a new town. The charter for the town of Beaufort was granted January 17, 1711, as the second oldest English town in South Carolina. It was named for Henry Somerset, 2nd Duke of Beaufort, one of the eight Lords Proprietors.

Beaufort was burned during the Yemassee War (1715–1728) and rebuilt around St. Helena's Anglican Parish (1712) and church (1724). Rice, indigo and cattle formed the basis of the colonial economy, prompting the importation of African slaves who soon formed the majority of the sea island population. The settlement of Savannah, Georgia, (1733) and the removal of the Spanish menace at St. Augustine (1763) led to great prosperity. Beaufort was the colonial capital of South Carolina for four days in October 1772, a specific grievance against King George III that is listed in the Declaration of Independence.

Long staple cotton, introduced to the Sea Islands by William Elliott II in 1790, was a gift from Loyalist refugees who had become rich on the Bahamian Islands. The sea-island cotton era (1790–1861) was the most prosperous era in Beaufort's five-hundred-year history. Great mansions, a literary flowering and the Beaufort College (1795) all characterized the Periclean

Age of old Beaufort. But Beaufort's great wealth was based on slavery and the Civil War ended Beaufort's antebellum prosperity and the institution of slavery.

The U.S. Navy occupied Port Royal Sound in November 1861, inaugurating the Port Royal Experiment to assist the newly freed African-Americans. Penn School on St. Helena Island was the first (1862) freedman's school in the occupied South.

Reconstruction brought twenty years of black Republican rule and the rise of ex-slave Congressman Robert Smalls (1839–1915) to the highest levels of local, state and national political power. The rise and fall of the phosphate industry (1870–1907) and the U.S. naval station at Port Royal (1877–1901) led to a boom and bust economy in the late nineteenth century. Beaufort went from abject poverty and a 40 percent decline in population in the early twentieth century to the wealthiest and fastest growing county in South Carolina in the late twentieth century.

Old Beaufort has one of the longest, most varied and most instructive stories in all of American history. This story—told by one of South Carolina's premier archivists and historians, and a dedicated native of old Beaufort—will surely entrance residents, visitors and tourists alike.

Lawrence S. Rowland
Professor Emeritus
University of South Carolina at Beaufort

Acknowledgements

M ANY HANDS ARE NEEDED FOR any task of importance. The author gratefully acknowledges the assistance of Beth Bilderbeck, photographic archivist, and Herb Hartsook, director of the South Caroliniana Library; Grace Morris Cordial, South Carolina resources coordinator of the Beaufort County Library; Marion "Mr. Archives" Chandler, Steve Tuttle and Brian Collars of the South Carolina Department of Archives and History; and the helpful staff of the South Carolina State Library. South Carolina is blessed with great historical resources and dedicated individuals who care for them and make them available for research.

Special thanks to Ned Brown, Beaufort photographer extraordinaire.

For sharing their personal recollections of Beaufort, I am grateful to Julie Zachowski, Lynda Kirkland, my siblings, Martha Denka, Uel Jones, Georgeanne Hammond and to my parents, George and Evelyn Jones. On a personal level, I would not have finished this project without the aid and encouragement of my husband, Terry; our children, Cassandra and Jacob; and our son-in-law, John Paschal.

Anyone studying Beaufort's history owes a great debt to Dr. Lawrence Rowland for his groundbreaking research and to the Beaufort County Historical Society, past and present.

This book has been a labor of love. Moving to Beaufort in 1955, I encountered a strange and enchanting world. As historian Carl L. Becker suggested in his 1931 address to the American Historical Association, "Every Man His Own Historian," total objectivity is illusory. We are not only a part of all we have met, but we also bring our own world views to the study of history and the historical record. Consequently, this book represents my view of Beaufort's history and my evaluation of the sources for that history. As always, my views of the 1950s and 1960s in Beaufort are seen through the prism of being the daughter of Dr. George A. Jones, pastor of the Baptist Church of Beaufort.

Prologue

FALLING IN LOVE WITH BEAUFORT is easy. Infatuation asks no questions. Loving Beaufort is different. Love requires appreciation for the unique chiaroscuro that is Beaufort—for the patterns of light and shadow in her history. The shade of the live oak, the gray of the moss, the filtered sunlight or the blinding burst from the water are the natural sources of light and shadow. But Beaufort's history also has light and shadow—the seen and the unseen—of the majestic homes and the hidden slave quarters.

Under those oak trees stride the shades of the cacique (chief) of Parris Island, Henry Woodward, LaChere, Seymour Burroughs, the Tory Andrew Deveaux, "Tuscarora Jack" Barnwell, the Reverend Lewis Jones, the Reverend Richard Fuller, Robert Smalls, Elizabeth Hyde Botume, Abbie Holmes Christensen, W. Brantley Harvey Jr., Henry Chambers and Harriet Keyserling. These are names that conjure images of Beaufort's past; names that point toward Beaufort's present; names that capture the paradoxical nature of Beaufort.

The physical landscape is the visitor's first clue that he has entered a different land. Beaufort the city nestles on a curve of the Beaufort (Port Royal) River on Port Royal Island, the largest of the sixty-plus islands that constitute modern Beaufort County. The town owed its healthy climate to its location between the river and Pigeon Point Creek. The inland passage, now the Intracoastal Waterway, linked early Beaufort with the ports of Savannah, Georgia, and Charleston. Waterways were the primary transportation routes of proprietary and colonial South Carolina. The rivers and creeks of the area as well as the deepest natural harbor on the East Coast (Port Royal Harbor) invited settlement but posed security risks. The duality of Beaufort is of ancient lineage.

Chapter 1
A Fair and Fit Place, until 1587

The story of Beaufort the city is intertwined with that of Beaufort the district, the county and the area that since 1562 has been known as Port Royal. Englishmen and Scots pushed into the frontier south of Charles Town seeking new homes and opportunities. The Indian trade called many, and some found the business profitable. To others, opportunity lay in raising cattle on the broad savannas. Still others looked up and saw a future in naval stores. These early adventurers penetrated the marsh, crossed the waterways and made homes on the islands of Beaufort County, then designated as Port Royal County. Ambitious men, they asked for a port, and the town painstakingly rose from the lush semitropical landscape. Before the Europeans, there were the Native Americans. Before the English ever settled there, the French and Spanish had left their mark.

Melting ice caps created the intriguing landscape of the Port Royal area. There are more than sixty islands in Beaufort County. Generally, geographers classify sea islands into two categories—barrier islands, such as Hunting Island and Fripp Island, and remnant islands, such as Lady's Island and Port Royal Island. Barrier islands are constantly shifting and changing as wind and surf move sand from the northern end of the island to the southern. Remnant islands are more stable. They were once part of the mainland. The Sea Islands lie in South Carolina's coastal zone. Several rivers—the Combahee, the Pocotaligo and the Edisto—arise in the coastal zone and flow into Port Royal Harbor and St. Helena Sound. These are called black rivers because of the tannic acid released by decaying leaves. Between the islands flow a number of creeks and rivers—Coosaw or Whale Branch; Broad or Beaufort; Tullifinny; and Combahee.

EARLY INHABITANTS

The original denizens of the Carolina Lowcountry are shadowy figures. Archaeologists probe shell middens (deposits of domestic debris that accumulated over many years) to scrutinize stone artifacts and pottery shards, seeking clues to their lives, social structures and family organization. The first Englishmen met wily caciques (chiefs) with island chiefdoms who knew the Spaniard and his friar. The English encountered Native Americans in the late seventeenth

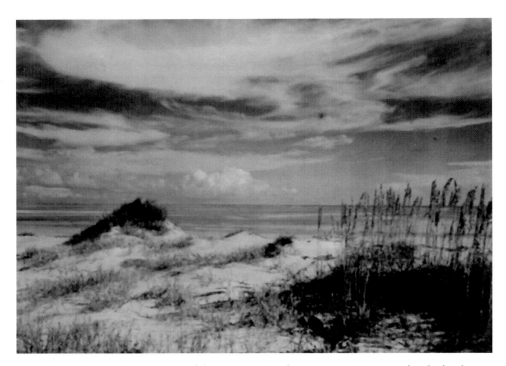

Fripp Island dunes, 1972. As poet Edith Bannister Dowling wrote in 1959: "High tide, by the sea oats, on this quiet shore." Fripp Island, one of Beaufort County's barrier islands, is the site of a residential community. *Courtesy of Ned Brown, photographer.*

century in South Carolina who were very different from those explorers Lucas Vasquez de Ayllon or Hernan de Soto had met earlier. Naming the Native Americans of old Beaufort District is a challenge. Historian Dr. Lawrence Rowland called them Escamacu/Guale; Dr. Walter Edgar, in his monumental study *South Carolina: A History*, the Edisto; and archaeologist Dr. Chester DePratter, the St. Helena Indians. By the seventeenth century, the Native Americans of Port Royal were usually called St. Helena. Gene Waddell, in his book *Indians of the South Carolina Lowcountry, 1562–1751*, suggested that the inhabitants may have adopted the Spanish place name as their own. William Hilton and Robert Sandford do not mention tribal names, but refer to the chiefs by their location—e.g., cacique of Kiawah and the cacique of the Edisto.

EXPLORATION

John Cabot's voyage in 1497 gave England a claim to North America. Sailing for France, Giovannio de Verrazano explored the North American coast as far south as South Carolina

in 1524. Yet, in 1514, Lucas Vasquez de Ayllon, a Spaniard who lived on Espanola (Hispaniola), sent agents northward in search of a new labor supply. The first fleet probably made landfall somewhere along the coast of North or South Carolina. On a subsequent expedition, Ayllon's Spaniards captured some of the indigenous people and sailed for Ayllon on Espanola. One of the few who survived the kidnapping was Francisco Chicora. Chicora charmed the Spaniards and later Spanish King Charles V with wonderful stories, real and embroidered, of the people who inhabited the coastal plain.

As a result, Charles V gave Ayllon a commission to explore and settle the area. Ayllon returned to the West Indies and in 1525 dispatched a vessel to scout the coastal region north of Florida. On 18 August 1525, the feast day of St. Helena (Santa Elena was noted for her discovery of the Holy Cross and for being the mother of the Emperor Constantine), Ayllon's scouts spotted a point of land and named it Punta de Santa Elena in honor of the saint. Thus, they bestowed upon the eastern coast of North America its longest-lived place name.

The scouting mission completed, Ayllon recruited six hundred volunteers for his planned settlement. He outfitted them with livestock and African slaves, and even sent friars to minister to their spiritual needs and to evangelize the American Indians. During the summer of 1526, the expedition made landfall somewhere on the coast of South Carolina or Georgia. The exact location is unknown. Archaeologists and historians who have studied the subject extensively are unsure.

The Ayllon settlement, San Miguel de Gualdape, had a short but significant life. From the outset, the settlement faced a series of debilitating challenges. First, a supply ship disappeared at sea. Second, the erstwhile faithful Chicora, their interpreter, defected. Then, the guiding light for the expedition, Ayllon, along with many others, contracted fever and died. The Spaniards had built the town in a low-lying area; so, the illness could have been mosquito-born. One faction of the settlers mutinied, removed Ayllon's successor, and then abused the natives and the black slaves. The Indians resisted, and the slaves launched the first known slave uprising in North America. The colonists quelled the rebellion and executed the mutineers. Unfortunately, winter was coming and the colonists lacked sufficient supplies to survive until the spring. The mutiny had alienated the natives, who were the only possible source of assistance. As a result, the remnant of Ayllon's expedition abandoned San Miguel de Gualdape, the first attempted European settlement in North America, and returned to Espanola (Hispaniola) in 1527. Ayllon's bright dream died from disease, dissension, and despair.

In 1540, Hernan de Soto led a party of Spaniards on an extensive trek through the Southeastern United States. De Soto launched his expedition in the Florida panhandle and then proceeded overland through Georgia, South Carolina, North Carolina, into Tennessee and on the Mississippi River area where he died. En route he encountered Cofitachequi, the center of a Mississippian chiefdom on the Wateree. By 1540, the Native Americans whom de Soto and his party met had

already been altered by earlier exposures to Europeans, either at San Miguel de Gualdape or by shipwrecked sailors. Diseases for which the native population had no immunity had already ravaged tribes and left desolate villages in their wake. European goods had joined the stream of products traded from the coastal region deep into the interior. The Columbian Exchange—as Alfred W. Crosby Jr., professor emeritus of American studies, history and geography at the University of Texas, Austin, named this collision between cultures and microbes, flora and fauna—was underway in South Carolina.

Spain was still interested in the Port Royal area. The deep harbor was an attractive haven for corsairs to guard Spain's treasure fleets as they slowly and cumbersomely followed the Gulf Stream current and crossed the Atlantic to Spain. So, in 1557 King Phillip II commissioned another expedition to settle at Santa Elena. Historian Paul E. Hoffman argued that the Spanish king also had other perhaps more compelling reasons to focus on the Port Royal area. According to Hoffman, the wonderful tales of the Land of Chicora and its identification with Santa Elena spurred Phillip II to add the site to Spain's list of proposed settlements. While Hoffman contended that Chicora lay on the Santee River, other researchers have located Ayllon's settlement elsewhere. Peter Martyr d'Anghiera, Spanish historian, had written glowing accounts of the fertility of Chicora and of the people that lived there. He also spoke of pearls and silver—two items of particular interest to the Spaniards. In 1551, Francisco Lopez de Gomara published *General History of the Indies*, a history that retold the Chicora story. The Gomara publication influenced Phillip II and his court. While the king's original cedulas, orders, are only known from a letter to Tristan de Luna in 1559, as cited there, the king's first concern was to Christianize the Indians. His second interest was to develop a safe haven for shipwrecked Spanish seamen, and third, he wanted to ensure that neither the French nor any other country settled on land claimed by Spain. The Dominicans, modeling the Franciscans, were interested in sending missionaries to the area. The Franciscans wanted to expand their influence and spread missions from Mexico into the Gulf Coast.

Tristan de Luna sent an expedition in 1560. Encountering bad weather, the ships sailed no closer to the mainland than Havana, Cuba. On 16 May 1561, Angel de Villefane, with four ships carrying between seventy and one hundred men, left Havana sailing toward their destination of Port Royal. While scouting the area, a hurricane sank three of the expedition's four ships and killed a fourth of the crew. Another Spanish effort came to naught. When queried, Villefane's crew emphatically stated that no one could settle in such an inhospitable place as Santa Elena.

JEAN RIBAUT

Now, it was France's turn. In 1562, Admiral Gaspar Coligny of the French navy, a French Huguenot, dispatched Jean Ribaut, also influenced by tales of the place called Chicora, with

a corps of Frenchmen to found a settlement site in La Florida. Seeking to establish a haven for the much persecuted French Protestants and secure glory for France, Ribaut and his 150-man crew sailed from France in two ships. En route to La Florida, on 17 May 1562, Ribaut discovered a broad deep harbor and named it Port Royal. He called it "one of the...fayrest havens of the world."

Ribaut and his men landed on Parris Island and built Charlesfort. Nearby, the French erected a column bearing the French coat of arms. Desperate for supplies, Ribaut left his fledgling settlement of thirty men and returned to France. Unfortunately, he landed in the middle of a bloody religious civil war and was briefly imprisoned in England. His return stretched from a few to many months.

The French settlement failed when Ribaut's return with the much-needed supplies was delayed. The French had built Charlesfort on swampy terrain, and food shortages plagued the twenty-eight settlers who remained. In addition, mutiny and ill will tormented the Frenchmen as they squabbled with each other and antagonized the neighboring Escamacu and Orista. The beleaguered Frenchmen traveled to meet the Guale, an Indian group that lived on the Georgia Sea Islands, and successfully acquired much needed supplies. Then, disaster struck, and they lost everything when fire destroyed their storehouse. Lacking food, beset by natural threats and despotic management, the men's morale suffered. Two of them drowned, and Captain Albert de la Pierria hanged one and banished another named LaChere, without food or water, to Lemon Island. Outraged and despondent, the remaining men mutinied and killed the captain.

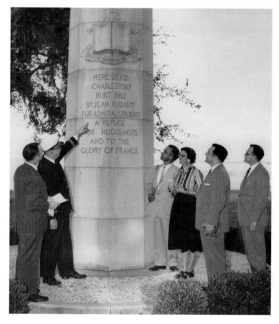

The Ribaut column, Parris Island, 4 March 1958. Members of the South Carolina Baptist Historical Society held their annual meeting in Beaufort and toured the area's historic attractions. Pictured from left to right are Dr. George A. Jones, unknown, Robert Major, Loulie Latimer Owens, L. E. McCormick and Dr. Joe King. In 1962, Beaufort County launched a major commemoration of Jean Ribaut's settlement on Parris Island. *Official Marine Corps Photograph. Courtesy of George A. and Evelyn Jones.*

19

Under their new leader Nicolas Barre, the survivors decided to abandon Charlesfort and return to France. With the help of the neighboring Native Americans, the men built a ship from locally available materials. Having secured what water and supplies they could, approximately twenty-one men set sail for France.

Amid tales of cannibalism, an English ship finally rescued the survivors. One story involved LaChere. During their voyage, the ship entered a windless pocket, and the men soon exhausted their supplies of food and water. They ate leather and slowly began to die. Facing starvation, the men turned to cannibalism. LaChere sacrificed himself to feed his countrymen who along with Barre were rescued. The survivors reached France before the Rene de Laudonniere expedition sailed for the southeastern coast of North America.

La Florida

Spain was not amused by French incursions on her territory. In 1564, a raiding party from Cuba captured Ribaut's column with the seal of France. The Spaniards also seized Guillermo Rouffi, one of Ribaut's men who had remained with the Indians rather than risk his life at sea on a leaky, poorly constructed ship. Meanwhile, Admiral Coligny had launched another French effort to colonize Florida—Fort Caroline. Hearing rumors of this new French colony in Florida, the king of Spain sent Pedro Menendez de Aviles to eliminate the French problem and create a permanent Spanish settlement in Florida. In 1565, Menendez sailed to La Florida and established St. Augustine. Menendez captured and destroyed Fort Caroline and repulsed an attack on St. Augustine. French hopes for a toehold in the Southeastern United States died when Ribaut and de Laudonniere met their bloody deaths on the beaches of Florida.

In the spring of 1566, Menendez sailed for Port Royal. The Spaniards built Fort San Felipe in order to secure the settlement of Santa Elena. In April of that year, Menendez made Santa Elena on Parris Island the capital of the Spanish province of La Florida and named Esteban de las Alas to serve as provincial governor. Santa Elena became a launching pad for new expeditions into the interior of North America. Juan Pardo led two such explorations. The first built a small fort possibly in North Carolina. On his second trip, he built four small forts.

Santa Elena grew from a military post to a settlement. Families came, and the town grew. Immigrants were given land and other incentives to settle. By 1568, the diverse population of Santa Elena included farmers, artisans such as a tailor and blacksmith, soldiers, missionaries, and a doctor. Santa Elena had a town government, a church and a tavern. Despite a thriving trade, raising enough food for the colony was a constant challenge. The search for food led the Spaniards to raid the neighboring Indian settlements. Life was precarious in Santa Elena. The colony fended off an Indian attack in 1570, but then faced a typhus outbreak in 1571. Governor las Alas returned to Spain in 1573. His departure initiated a series of foolish and

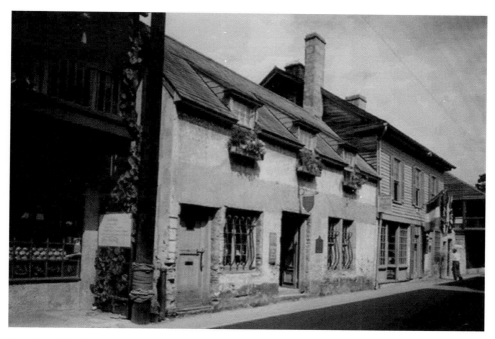

Don Juan Paredes House, 54 Saint George Street, St. Augustine, Florida. In 1565, Don Pedro Menendez de Aviles landed eight hundred colonists (including twenty-six women and an unknown number of slaves) and founded St. Augustine, the oldest permanent European settlement in North America. *A. Beaudoin. HABS, FLA,55-SAUG.34-1. Courtesy of the Library of Congress.*

corrupt leaders, whose poor leadership triggered the Escamacu War that lasted from 1576 through 1579.

In 1576, Spanish settlers raided several villages and killed three Indian leaders. Provoked, the Guale, Edisto, St. Helena (Santa Elena) and other Native American groups banded together and attacked the settlement. The garrison of fifty suffered thirty casualties, and on 22 June, an onslaught of five hundred natives drove the settlers to flee the town for the fort. The attackers surrounded the beleaguered fort and waited. Finally in July, the women inside the fort forced Hernando de Miranda to abandon the site. With the Spaniards gone, the Indians burned the town and the fort. Native Americans not only attacked San Felipe and Santa Elena, but also other Spanish settlements. The survivors fled to Cuba or St. Augustine.

The ill-fated French attempted to plant another outpost in the area in 1576. That colony soon failed amid conflict with their Native American neighbors. Later, Spanish raids killed any survivors held by the neighboring Native Americans.

In 1577, Pedro Menendez-Marques, the new governor of La Florida, returned and refortified the area with a prefabricated fort, Fort San Marcos. The Spaniards built a second,

larger and better-equipped fort in 1584. Settlers returned and rebuilt Santa Elena. The new town, although no longer a provincial capital, prospered. By 1580, archaeologists estimate, four hundred people lived in thirty buildings on a fifteen-acre tract. The settlers had a church, a tavern and a potter.

Despite the apparent success of Santa Elena, other forces conspired toward its dissolution. The English attempted an unsuccessful settlement on Roanoke Island in 1585. In 1586, Sir Francis Drake harried the Spanish settlements in the Caribbean and even burned St. Augustine. Consequently, in 1587, the Spaniards decided to concentrate their resources at St. Augustine. They ordered the fort and town abandoned, and relocated the settlers to St. Augustine.

Archaeologists have been excavating the Santa Elena area for more than thirty years. These excavations on Parris Island are uncovering the lost stories of Santa Elena, San Felipe and Charlesfort. On 21 September 2004, the Charlesfort-Santa Elena National Historic Landmark was dedicated.

Chapter 2

Englishmen, Scots and Yemassee, 1587–1703

Hotly contested by the French and Spanish forces for more than a hundred years, the Port Royal area finally attracted the attention of the English. Exploratory missions by Captain William Hilton in 1663 and Robert Sandford in 1666 described a veritable paradise with fertile soil, plentiful waterways and amenable native inhabitants. As Sir John Yeamans wrote in 1670, "the scituation [sic] is pleasant beyond expression."

After Oliver Cromwell died and England's experiment with Puritan rule ended, overtures were made to Charles, the son of the beheaded Charles I, to leave the security of France and take the throne of England. Charles agreed and was crowned King Charles II. As king, one of Charles II's primary goals was securing the prosperity of his kingdom. Toward that end, he made several grants of large tracts of land in North America in order to promote settlement there and, at times, to recompense political supporters. In 1663, he rewarded eight loyal supporters with a grant to the territory known as Carolana. Charles I had originally granted the territory to Sir Robert Heath, who had named it Carolana in the king's honor. Carolus is the Latin form of Charles. The grant included all the land that lay between 31° and 36° north latitude. The eight Lords Proprietors of the new province of Carolina included nobles and knights. They were the Earl of Clarendon (Edward Hyde), the Duke of Albemarle (George Monck), the Earl of Craven (William Craven), Baron Berkeley of Stratton (John Berkeley), Baron Ashley of Wimborne St. Giles (Anthony Ashley Cooper), Sir George Carteret, Sir William Berkeley and Sir John Colleton.

Captain William Hilton

On 10 August 1663, William Hilton embarked from Barbados to explore this new area for the Lords Proprietors. By 26 August, Hilton had reached the coast of South Carolina. He explored the waterways, especially in the vicinity of Hilton Head Island. He also visited and traded with the Escamacu Indians at Santa Elena (Parris Island). Hilton's writings offered a contemporary account of Native Americans living in the Carolina Lowcountry. He described a

village with a large, central, round, dove-house-shaped building covered with Palmetto fronds. This structure had a number of rooms and a high seat where the cacique sat. There was also a structure similar to a guardhouse on twelve-foot-high stilts and a number of smaller houses.

The ruins of Charlesfort and the presence of the Spanish were much in evidence. A cross stood in front of the roundhouse; the natives reported visits from a friar, and the Spaniards in the area corresponded with Hilton during his visit. Hilton described oak, bay, walnut and pine trees. The native inhabitants planted corn, watermelons, muskmelon and pumpkin. Grapes grew wild, the woods teemed with deer and turkeys, and the marshes with waterfowl. The glowing description could be a model for a chamber of commerce promotional brochure. When he left the area, Hilton took Wommony, the son of the cacique of Santa Elena, Shadoo and Alush to Barbados. The men later returned to Carolina, as they were on hand to greet Robert Sandford, the next Englishman to visit the area.

CAPTAIN ROBERT SANDFORD

Similarly, in 1666 Captain Robert Sandford, a Cape Fear settler sent by Sir John Yeamans, investigated the region. He also visited Nisquesalla, the Escamacu cacique of Parris Island, and described identical settlement features. He noted that the Indian town was on an island, and that the "whole Country is nothing else but severall Islands made by the various intervenings of Rivers and Creekes." The cacique sent his nephew with Sandford to be educated in the English language and customs. In his place, Sandford left an adventurous young English surgeon, Henry Woodward, to learn the language and culture of the Native Americans and develop trading opportunities. Woodward had many adventures and was even captured by the Spaniards. He returned to the province on the first boat to become an influential force in the founding of the new colony and the development of Beaufort. The proprietors rewarded Woodward with a grant of 150 acres of bounty land for "arriveing [sic] in the first ffleet." The proprietors and later the king used bounty land—that is free land for certain classes of immigrants—particularly to encourage foreign Protestants to settle in the new colony. In a literal sense, Woodward was the first English settler in South Carolina. The Barnwells are one of several prominent Port Royal families that trace their lineage from Woodward. His connections with the Native Americans formed the basis for South Carolina's lucrative Indian trade.

Sandford also carefully observed the unique terrain of the Carolina Lowcountry. He carefully noted the "drowned Marshes...Crowned here and there with small ground of wood, consisting of dry plantable Land, surrounded by a good space with...pasture Land." His favorable account attested to by his fellow travelers—Henry Brayne, Richard Abrahall, Thomas Giles, George Cary, Samuel Harvey and Joseph Woory—and other descriptions induced the proprietors to attempt a settlement in Carolina.

The view of the Beaufort River from Bay Street, 1960. The town was laid out along the curve of the river. *Courtesy of George A. and Evelyn Jones.*

In 1670, the eight Lords Proprietors of Carolina initially sent three ships, the *Carolina*, the *Port Royal* and the *Albemarle*, with a hundred English colonists to their province with instructions to settle at Port Royal. Of the three, only the *Carolina* successfully made the voyage. Anchoring in Port Royal Harbor, local Native Americans advised the prospective settlers to seek a less exposed location. With input from the cacique of Kiawah, the settlers landed on Old Town Creek and eventually moved their settlement of Charles Town to the peninsula formed by the Ashley and Cooper Rivers, the present location of Charleston.

THE PORT ROYAL AREA

The Queen and the cacique of Edisto ceded all land between the Stono and Savannah Rivers to the Lords Proprietors of Carolina in 1684. By that time, Englishmen, such as Caleb Westbrooke, had settled in the Port Royal area to pursue the Indian trade. By 1700, the Carolina trade extended from Charles Town to the Mississippi and Tennessee Rivers. There were two trade routes out of Charles Town. One ran overland to Savannah Town (across from Augusta, Georgia) on the Savannah River. The other ran from the Port Royal area down the Savannah River.

On 2 October 1684, Henry Erskine (Lord Cardross) brought a group of Scottish covenanting Presbyterians to South Carolina. The emigrants included thirty-five Scottish prisoners sentenced to banishment for their participation in abortive uprisings or Presbyterians who had run afoul of Anglican rules. At least one involuntary immigrant was aboard; Elizabeth Lining was kidnapped by the ship's captain! All of the 149 souls, who originally embarked on the *Carolina Merchant* captained by James Gibson, survived the 10-week sea voyage. One died shortly after landing, but many rapidly succumbed due to the unwholesome atmosphere of Charles Town. The Scots had landed during a deadly outbreak of malaria in Charles Town. Large numbers died, and others abandoned the project. The Scots suffered dreadfully from the climate, insect-born disease, and misfortune. A companion ship bearing additional settlers and supplies was lost at sea. Undeterred, in November, Cardross and a small party of fifty-one proceeded to settle Stuart Town near present-day Beaufort. By March 1685, the new residents had already built several houses in the new town. Cardross and the Reverend William Dunlop reported to Sir Peter Colleton, one of the Lords Proprietors of Carolina, on the Scots' efforts to trade with the Cusso and other Indian groups, and on their impressions of the newly arrived Yemassee, a tribe of Native Americans fleeing Spanish rule in Florida. The arrival of the Scots coincided with the Lowcountry occupation of the Yemassee . According to Cardross, the Scots had "consented" to the Yemassee settlements because the Indians were "so considerable and warlike" that there was no other option. The later history of Yemassee-settler relations in the Lowcountry justified Cardross's misgivings. Despite their perseverance and early progress, the Scottish settlement at Stuart Town was short-lived.

The Scots alienated the Charles Town merchants by their attempts to monopolize the trade with the Yemassee and other Indian groups through the lower Savannah River trading route. The residents of Stuart Town also offended the governmental establishment with their refusal to submit to Charles Town suzerainty. They preferred to deal directly with the Lords Proprietors. The proprietors had promised Stuart Town residents a separate colony, but the Scots also wanted their own proprietor's deputy and an independent government. Perhaps more importantly, they antagonized the Spaniards in St. Augustine by inciting the Yemassee to raid the Spanish Indian missions in North Florida. For example, in March 1685, the Yemassee burned several Indian towns in Florida, killed fifty Indians and brought twenty-two back to Carolina as slaves.

In revenge for these attacks, on 17 August 1686, Spanish forces raided and drove the Scottish settlers from the town and into hiding in the woods. General Thomas de Leon led a hundred Spanish and Indian attackers in three ships to Stuart Town. The outnumbered and underarmed Scots fled the town. The Spaniards pillaged the town and its vicinity for three days, killed the livestock, destroyed crops, captured two men and a boy, and then burned Stuart Town.

De Leon and his forces raided inland as far as Edisto Island and Willtown, ravaging property and seizing white and black residents. Attempts to rout de Leon were hampered by a hurricane that struck 26 August and doused the area with rain and wind. Roads were impassable, fences flattened and any crops or belongings not taken by the Spaniards were destroyed by the storm and its aftermath. En route to Charles Town, the hurricane scattered the Spanish fleet, sank de Leon's vessel and saved the capital from attack.

Among the known survivors of Stuart Town were Lord Cardross, William Dunlop, John Stewart and perhaps Thomas Nairne. Cardross returned to Europe. Dunlop remained in Carolina until 1690 and then returned to Scotland. Stewart, an Indian trader, was also an agricultural innovator and attempted to grow cotton a hundred years before its widespread cultivation in the Sea Islands. On 21 April 1698, Stewart had one thousand acres surveyed on St. Helena Island, "being a Neck of Land formerly Inhabited by the Pocatalagoes, Lying North West of ye Lands Setled [sic] by Mr. Thomas Niern [Nairne]." Stewart acquired an additional 500 acres in 1702 and had two warrants for 640 acres and 400 acres respectively in Granville County in 1710.

Thomas Nairne, with John "Tuscarora Jack" Barnwell (acquired land in 1703), was one of the first settlers of the Port Royal area. As early as 1698, the proprietors granted Nairne land on St. Helena Island. A Renaissance man, he explored the Lowcountry area and was actively involved in the Indian trade and in colonial politics. Appalled by the poor treatment endured by the Native Americans in South Carolina, Nairne lobbied for fair treatment by the traders and legal redress for abuses. Also concerned for the spiritual good health of the Yemassee, in 1705 he criticized the Reverend Samuel Thomas for ministering only to the slaves of Goose Creek and ignoring the Yemassee in Beaufort District. In 1707 colonial leaders, recognizing Nairne's strengths in the area of Indian relations and his commitment to remedying injustices, named him Indian agent.

Other early settlers in the Beaufort area included William Bray and John Palmer. Lady's Island is named for Elizabeth Axtell Blake, widow of Governor Joseph Blake who had a warrant for the island.

THE YEMASSEE

Originally, the Yemassee were probably Tama Indians who had abandoned their central Georgia homeland and relocated near St. Augustine to escape the Westo, a fierce warlike people who crossed the Savannah River and settled in the western reaches of South Carolina. In 1674 the redoubtable Henry Woodward visited the Westo near Silver Bluff in modern Aiken County. According to Woodward, the central town of the Westo was laid out in a haphazard fashion with a number of long bark-covered houses that were also roofed with bark. From

the tops of these houses hung scalps of slain enemies. The Westo were cautious and had secured their town with a single palisade on the Savannah riverside and a double-palisade on the landward side. Wise precautions as word arrived during Woodward's visit of impending attacks by the Chickasaws and related groups. Woodward's visit launched trade between Charles Town and the Westo. Initially, the colonial government welcomed these fierce warriors as a buffer on the colony's exposed western frontier.

In 1684, Altamaha, a Tama chief, left St. Augustine and relocated to South Carolina. His action may have triggered the general exodus of Indian peoples from Florida that followed. The Yemassee who settled in South Carolina, according to archaeologist Dr. Chester DePratter, were predominantly Guale and Tama. The Tama had lived north of St. Augustine on Amelia and Cumberland islands, and across Appalachicola Bay on St. George Island. The Guale were a coastal people who inhabited the Georgia Sea Islands. They resisted Spanish control until the Spaniards burned their towns and maize fields. By the 1680s, the Guale had dispersed and joined other Native American groups in the interior. Despite their different origins, the South Carolina records refer to both the Guale and Tama as Yemassee.

Dissatisfied with their treatment by the Spaniards, approximately two thousand fled to South Carolina, perhaps following the lead of Altamaha. At first, the Yemassee settled on St. Helena and Hilton Head islands. But after the Spaniards destroyed Stuart Town and raided the area in 1686, the Yemassee fled inland to the Ashepoo and Combahee Rivers. The length of their exile there is debated, but at least by 1707, they had returned to the Port Royal area.

The reserved Yemassee lands, the "Indian Land," lay between the Combahee and Savannah Rivers. There, the Yemassee settled in ten towns known as the Upper Towns and the Lower Towns. Altamaha, an early immigrant, led the Yemassee (Tama) of the Lower Towns of Altamaha, Ocute and Chechesee. The Lower Towns were located on the mainland of the area then known as Port Royal County. North of these towns were three settlements of Euhaw who had entered South Carolina in 1703. The Yemassee Upper Towns were Pocotaligo, Pocosabo, Huspah, Tulafina, Sadketche, Tomatley and Sapella. Pocosabo was located on the mainland across Whale Branch from Port Royal Island. The names of Tulafina and Sadketche live on as the Tullifinny and Salkehatchie Rivers. Many of the Indians who settled in these lower towns were originally Guale.

Chapter 3

A New Town—Threats and Promises, 1704–1754

I N 1711, THE IDEA OF A southern buffer to protect Charles Town from Native American and Spanish threats surfaced. Planters in the Port Royal area, now called Granville County, petitioned the Board of Trade, which governed the North American colonies, to establish a port on the Port Royal River. As early as April 1706, the Board of Trade had investigated the cost of fortifying the Port Royal area. Estimates included the cost of building a fort and barracks, acquiring ordnance and provisions, and establishing a garrison.

By 1710, many had claimed grants in the Port Royal area. Among many others, former Stuart Town settlers John Stewart and Thomas Nairne had early grants on St. Helena Island. On 12 January 1698 or 1699, [John] Pinny received a warrant that included "that point of land, lying on Port-Royall river below the Bluff, on which the Scott's [sic] Town formerly was commonly known by ye Name of ye Spanish Point." On 22 February 1704, John Barnwell had a grant for land on Scott's Island in Port Royal County. On 25 October 1707, John Conniers received a grant in Granville County. Between those dates, the name of the region changed from Port Royal County to Granville County. The area continued to be designated Granville County until after the American Revolution.

These early settlers raised cattle and corn, traded with the Indians, and saw the potential profit in naval stores. The pioneers in the area doubtless wanted not only a port, but also a town, a fort and other semblances of eighteenth-century frontier civilization. At the same time, British merchants were pushing for another seaport in South Carolina. The potential for profit was a powerful incentive for the proprietors who continually sought ways to enhance the returns from their Carolina investment.

On 19 July 1707, the South Carolina Commons House of Assembly commissioned Captain Thomas Nairne, John Cochran, Alexander Mackey, Thomas Palmenter and Richard Reynolds to maintain and develop roads, bridges and creek cuts south of St. Helena Sound. These commissioners, all area landholders, had an obvious economic stake in the territory and were probably some of the individuals who lobbied the proprietors for a port in the Port Royal area.

In April 1709, the proprietors met with several London, England, merchants and inhabitants of the Carolina Lowcountry and approved a plan to lay out a port in the Port Royal area. Nairne, who had a special interest in the port project, was probably one of the lobbyists. On 17 January 1711, the proprietors responded favorably to the request and signed a charter creating "upon the River called Port Royal in Granvil [sic] County...a Town call'd Beaufort Town...to be a Sea Port." Beaufort, whose name honored the Duke of Beaufort, was designed as an outlet for naval stores, cattle and crops (such as corn and wheat) grown in the interior, as well as a base for scout boats that patrolled the inland passage that would one day (1733) link Savannah and Charles Town. In 1707, Henry Somerset, the Duke of Beaufort, had acquired from Lord Granville the proprietary share that had originally belonged to George Monck, the Duke of Albemarle. Consequently, the town of Beaufort was born—a town that, according to historian Yates Snowden, would be "the intellectual and aristocratic rival" of Charles Town.

Specific directives in Charles Craven's commission as governor of South Carolina, dated 15 March 1711, instructed him to appoint four men each from Colleton and Granville counties to study the Port Royal River shore and determine the best location for a town. Their report and the first plan for Beaufort were returned to England but are not known to have survived. A later plan located a fort between Scott and West Streets, and showed the lot numbers that corresponded to the first surveys and grants in 1717. Consequently, while the date the town was surveyed is not known, it is likely that the survey was completed before the first lots were granted. The site chosen for the new town was idyllic—twenty-five feet above sea level on a peninsula. The town sits on Beaufort River that flows into Port Royal Harbor the finest natural harbor on the Southeastern coast of the United States. The area enjoys a temperate, humid, semitropical climate. For many decades, if not centuries, visitors to Beaufort would comment on the oranges as citrus trees of several varieties flourished. At least into the 1960s, orange, lemon and grapefruit trees occasionally grew under Beaufort's sheltered riverside bluffs until attacked by unseasonal frosts.

The original town boundaries were Hamar Street on the west, Duke Street on the north, East Street on the east and the Beaufort River to the south. Black's Point lay east of East Street, and the parish glebe land north of Duke Street. The early street names of Carteret, Craven, King, Prince and Duke seem to have direct connections to the town's origins. Carteret was named for Sir George Carteret, one of the original eight Lords Proprietors; Craven, for William Craven, the Earl of Craven, another proprietor, or for Governor Charles Craven who was responsible for selecting the town site. King probably was named for King George I; Prince, for Prince George; and Duke, for the Duke of Beaufort. Port Royal Street would appear to reflect the royal origins of the new town. The fact that the street's name was changed to Port Republic after independence supports this view. Church Street is apparently an early attempt at town planning. It is interesting to note that the Episcopal Baptist and

Presbyterian churches are clustered in the vicinity of the aptly named Church Street. Scott and Hamar Streets may have been named for two early Beaufort lot holders, Captain William Scott and Captain Joseph Hamar. Early settlement developed along Bay Street, and the town plan reserved the square where Carteret and Craven Streets intersected for public purposes.

The Beaufort plan with its regular grid resembles that of Charles Town. Charles Town, in turn, was likely modeled on English settlements, such as Londonderry, of seventeenth-century Northern Ireland.

Recognizing the strategic importance of the area, and fearing Spanish and Indian incursions, the South Carolina had appointed Nairne to develop border watches on his and other plantations in the Port Royal area as early as 1707. In 1713, the colony stationed two scout boats on Port Royal Island. The scouts monitored the waterways for hostile intruders. One scout boat patrolled the passages between Port Royal and St. Augustine. The other scout boat was responsible for the area between Port Royal and Stono, about twenty miles southwest of Charles Town.

On 10 November 1711, the South Carolina General Assembly appointed Nairne, John Barnwell, Henry Quintyne, Edmund Bellinger and Thomas Townsend to lay out a sixteen-foot-wide roadway from the islands of St. Helena and Port Royal to the Ashepoo River. Between 1711 and 1714, a road was cut across Port Royal Island from the Whale Branch (Coosaw River), crossing on the north to the new town of Beaufort to the south. Across Whale Branch a road stretched to the Combahee River crossing. Beaufort was no longer as dependent on water transportation. Routes existed to connect her with the settlements and settlers of the interior. As a result, for over two centuries, the Whale Branch Ferry was to be Beaufort's primary connection with the mainland.

In 1711, Beaufort area resident Captain John Barnwell accepted a special commission to assist the beleaguered colony of North Carolina. The fierce Tuscarora had risen in rebellion and threatened the survival of that colony. Among their early victims was John Lawson, one of the commissioners to survey the line between North and South Carolina, and a co-founder of Bath and New Bern, North Carolina. Barnwell led a troop of blacks, Yemassee and a few whites to quash the uprising. His success earned him the sobriquet "Tuscarora Jack." Barnwell was instrumental in the settlement of Beaufort and prominent in the affairs of the area. A trader and explorer, he first proposed the idea of the townships that were later implemented by Governor Robert Johnson. The township plan was one of several factors that prompted the Board of Trade to settle the colony of Georgia in 1733. In 1704, Barnwell, a communicant of the Church of England, so vigorously championed the rights of dissenters in the province that he was expelled from the vestry. Barnwell, the progenitor of one of Beaufort's most prominent families, died in 1724 and is buried in the churchyard of St. Helena Parish Church.

On 7 June 1712, the South Carolina Commons House of Assembly created a new parish—St. Helena—for the new town. Rector William Guy, who was assigned to the parish, originally

conducted services in the homes of the residents. Time and several acts were necessary before the church could be built. In 1716, the legislature provided that fines for unimproved lots could be used to build the church and manse. An area not to exceed fifty acres was set aside in 1717 as glebe land to support the planned church. In 1724, parishioners constructed St. Helena Parish Church in three months' time.

The following year, the Society for the Propagation of the Gospel in Foreign Parts dispatched the Reverend Lewis Jones to minister to the parish. Arriving in Beaufort in 1725, Jones served there until his death in 1746. The society at one point attempted to transfer Jones to St. James, Goose Creek, a larger and wealthier parish. The vestry of St. Helena demurred. If Jones left, they contended, St. Helena was so remote that if a new minister were not found, "anyone who died, even if a Christian, must be buried like dogs." In light of this sentiment, the society relented, and Jones continued his dedicated service to Beaufort and St. Helena Parish. In his will, Jones left funds to support a school at Beaufort for poor students. For twenty-five years, following his vision, the vestry of St. Helena made annual appropriations to educate Beaufort's poor.

Following Jones's death, when the vestry and wardens wrote requesting a minister, they cited the wonderful harbor at Port Royal and Beaufort's fine placement for trade. They also

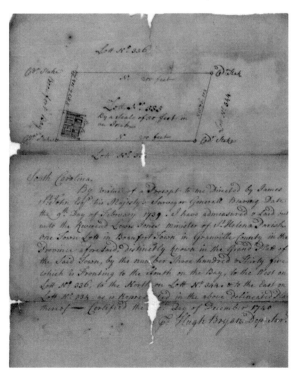

Plat for the Reverend Lewis Jones. Jones served as minister for St. Helena Parish Church from 1725 to 1745. The style of the house drawn on the plat may represent pre-Revolutionary architecture in Beaufort. Hugh Bryan, the surveyor, was one of Whitefield's converts and a founder of Stoney Creek Presbyterian Church. *Records of the Secretary of the Province, Surveyor General, Colonial Plats, Folder 987, Plat 987-5. Courtesy of the South Carolina Department of Archives and History.*

echoed the hopes of many in the area that Beaufort would be designated a port of entry. The parish's fortunes appeared to be improving in 1734 when Captain John Bull presented the church with a silver communion service honoring his deceased wife. Yemassee had carried off Bull's wife in 1715 and, according to one story, only her shoes were ever seen again.

Regrettably, the bishop of London and the Society for the Propagation of the Gospel in Foreign Parts did not always send the best and most upright of men to fill colonial pulpits. The parish of St. Helena had its share of questionable and undesirable rectors. In 1756, justifiably disgusted, the vestry of St. Helena ousted the Reverend William Peasley. Peasley, it seemed, had a penchant for fornication with a number of women and also seriously neglected his duties to his parishioners. He attacked one man and refused to visit the bedside of the dying. The latter was, perhaps, the more heinous crime. Members of the vestry were outraged that on at least two occasions, Peasley ignored the summons of the dying and allowed "them to leave the World without the benefit of that spiritual Comfort they so earnestly desired." In 1772, St. Helena Parish again received a rotten apple. This time they refused to admit the Reverend Edward Ellington because his behavior, which may have involved fishing on Sunday, affronted the town's residents.

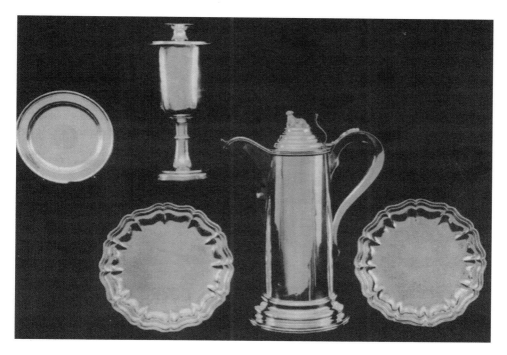

St. Helena's Episcopal Church communion plate, 1972. In 1734, John Bull donated a silver communion service to St. Helena's in memory of his wife. *Courtesy of Ned Brown, photographer.*

33

THE YEMASSEE WAR

The Yemassee uprising of 1715 threatened the plans for the new town and delayed her development. Initially, the Yemassee had provided a welcome buffer between the English settlements and the Spanish in Florida. But tensions grew between the settlers and the Yemassee. Settlers encroached on Yemassee lands, their livestock destroyed the tribe's crops and trade abuses fostered overwhelming debts that the Indians could not pay. Some traders even enslaved debtors' family members to "encourage" repayment. Traders beat Yemassee men and women, burned their homes and stole from them. Some even raped Yemassee women. Meanwhile, the Spaniards worked hard to develop a rapprochement with the Yemassee and to drive a wedge between them and the English settlers. In time, mistreated by the English, courted by the Spanish and with their natural resources dwindling, the Yemassee joined with the Creeks in Georgia and Alabama under the noted Creek leader Emperor Brims, the Ashepoo, the Catawba and other Indian groups in staging a major uprising against the English that was well-organized and unexpected. The wily Brims was known for making alliances of convenience with Europeans and American Indians alike. Some scholars credit the Creeks with masterminding the uprising.

On 15 April 1715, Good Friday, in a coordinated effort, the Yemassee in South Carolina, with the Creeks in Georgia and Alabama, attacked and killed the traders and their families who lived in their towns. The Yemassee at Pocotaligo attacked not only the traders in their midst but also an experienced negotiating party, sent by Governor Charles Craven, which included Indian Agent Thomas Nairne.

At the 12 April 1715 meeting of the Commissioners of the Indian Trade, William Bray of Bray's Island reported that an Indian named Cuffy, because he had "a great Love for her and her two Sisters," had warned his wife of impending trouble with the Creek. Samuel Warner had also heard rumors about Creek dissatisfaction from the Palachacola. The governor and commissioners sent Samuel Warner to arrange a meeting, and sent Bray, Nairne and John Cochran to negotiate with the Yemassee at Pocotaligo. The negotiators talked peacefully with the Yemassee and retired amicably after dinner with no hint of their impending doom.

In the morning, the Yemassee, painted red and black, surprised the unsuspecting Carolinians. Some of the Carolinians in the camp, such as the veteran traders John Wright and John Ruffley, were killed immediately; others, such as Cochran, his wife and possibly their four children, were held captive and later killed. Nairne, who had espoused a code of fair treatment for the Indians, endured four days of excruciating torture before dying. The Yemassee inserted slivers of lighter pine through his skin and then lit them. It was a slow and painful way to die.

Two men are known to have escaped the carnage. One hid in the marsh and finally made his way to safety in the settlements on the Ashepoo River. Captain Seymour Burroughs, the other, bravely fought his way through the Indians. Seriously wounded by shots to his back and through his mouth, he forged ahead, swam a river and brought the ghastly news to John Barnwell's plantation near Seabrook. Yemassee raiders later killed one of the Burroughs children and carried his wife as a captive to St. Augustine, but with the intercession of the Huspah King, whose earlier intervention had saved the life of Charles Bryan, she and her husband were eventually reunited.

Only the extraordinarily courageous effort of Seymour Burroughs prevented the deaths of hundreds on Port Royal Island and any who lived in the vicinity of the new town. Heeding Burroughs's warning, Barnwell alerted the neighboring settlements and the inhabitants of the town of Beaufort. Under the leadership of the Reverend William Guy, rector of St. Helena Parish Church, three hundred settlers and a few slaves sought refugee aboard a merchant ship providentially docked in Beaufort Bay. The Yemassee fired on the ship, and the settlers responded with cannon fire from the ship. After several hours, the Yemassee burned the town, as they had the majority of the plantations on Port Royal Island, and left. Little is known of this lost Beaufort. The ship with its frightened cargo sailed for Charles Town.

The mainland settlements had no early warning, with disastrous consequences. Estimates suggest that between eighty and ninety died in Granville County, and more than a hundred died in Colleton County. Eventually, two battles secured the southern frontier—Governor Craven with a force of two hundred men defeated the Yemassee near Salkehatchie Swamp, and Colonel John Barnwell and Captain Alexander MacKay captured Pocotaligo and killed, captured or dispersed its defenders. These actions drove the Yemassee from the Port Royal area, but Indian attacks persisted in other parts of the province. North Carolina, remembering the Tuscarora War, sent reinforcements, as, somewhat begrudgingly, did the colony of Virginia. Even with the assistance of the North Carolinians and Virginians, the situation in South Carolina remained desperate until South Carolinians negotiated a treaty of support with the Cherokee. If the Cherokee had backed the insurgents, the outcome could have been very different for the South Carolinians.

In 1715, the scout boats were relocated from Port Royal Island to Willtown, but the militia built a small fort for defense on Port Royal Island. This Port Royal fort probably stood south of the town either on Spanish Point or at the site of the United States Naval Hospital. In 1716, two scout boats were reassigned to the Port Royal area and based at the fort. The scouts reconnoitered the waterways for war canoes and other invaders.

The Lowcountry situation remained uncertain. Apalachees raided the Port Royal settlements in July 1715, and in August 1715, Carolinians scored a stunning ambush of ten Yemassee war canoes at Daufuskie. In August 1716, in a major challenge to the peace of the

area, Yemassee raiders ambushed and killed Major Henry Quintyne, the commander of the Port Royal Scouts, Thomas Simons, Thomas Parmenter, one of the first settlers on Port Royal Island, and others near Port Royal. The attackers scalped Dr. Rose and left him for dead, but he surprisingly recovered.

In 1716, the assembly established a company of rangers to patrol the coasts, and an act in 1717 set the ranges for the scouts. One company was responsible for the area between the Indian lands and the Savannah River, another had its headquarters on Edisto Bluff, and the third held watch above Charles Town. Although a final treaty was signed with the Creeks in 1718, the Sea Islands remained a dangerous place.

Even when the war ended and the Yemassee withdrew to Florida, the borderlands were not pacified. Circa 1717, a fort was built at Beaufort to protect the fledgling town. In 1722, the fort had fallen into great disrepair, and the government authorized John Barnwell to make new gun carriages and restore the fort as a defensible position. Also, in 1722 an Independent Company of Foot, regular British army troops, was stationed at the Beaufort, or Port Royal Fort. Although the fort was rebuilt in 1724, the independent company was transferred to Georgia in 1727. One scout boat was ordered to guard the fort. Despite the fort, the scout boats, the troops, the victories and the treaties, Spanish-encouraged Indian raids on the southern frontier continued for decades, and life at Port Royal remained perilous and uncertain.

A NEW START

With the Yemassee War behind them, efforts resumed to settle the new port of Beaufort. The Commons House of Assembly enacted legislation that specified the size of lots in Beaufort (not more than half an acre) and the requirement that anyone taking up one of the front lots had to build on the property within two years. Owners of other lots had three years in which to build. The earliest grant in the town of Beaufort for Lot No. 1 is dated 25 July 1717, and it was issued to Captain John Beamore. By August more than seventy grants generally for lots east of Charles Street had been issued. Beaufort's entrepreneurs obtained the lots on the north side of Bay Street that overlooked the river. In 1722, the Commons House of Assembly authorized a free school for Beaufort. Such schools were not operated free of tuition but rather were required to educate ten poor students annually, if the court had properly referred the students.

The year 1724 was significant: St. Helena Church was built, and John "Tuscarora Jack" Barnwell died. With Barnwell's death, the old guard was gone. Barnwell, Nairne, Lord Cardross and Henry Woodward had shared a dream of Beaufort as a center of the Indian trade. That dream died with the Yemassee War. Woodward's son John assumed many of Barnwell's military responsibilities. John Woodward became commander of the scouts and was charged

with completing Fort King George. On a personal level, the Commons House of Assembly also awarded John Woodward the contract to furnish the fort and scouts with supplies from his store in Beaufort. The Yemassee War cost Beaufort Nairne's leadership and dimmed her commercial aspirations. The Beaufort area never regained its Indian trade routes. Traders from Charles Town using the inland trading path siphoned off the former Beaufort trade. The war also destroyed the area's cattle herds and lessened, if not eliminated, her trade in livestock. Given her location and three-pronged economy—Indian trade, cattle raising and naval stores—historians ponder how powerful a commercial center Beaufort might have become without the devastation wrought by the Yemassee War.

In September 1726, another terrifying series of raids swept the area. The citizens of Port Royal petitioned the governor for assistance in repulsing the "Spanish Indians." Acting Governor Arthur Middleton used contingency funds to outfit an expedition and initiated plans to construct a new fort, Fort Prince Frederick, at Beaufort. While plans were underway, the situation at Beaufort worsened as Indian raiders killed the scout boat crew on Daufuskie in January 1728. Later that year John Palmer led an expedition that successfully routed the Yemassee as they were camped under the walls of Castillo de San Marcos, St. Augustine's fort.

A side view of St. Helena Parish Church. Construction on the parish church began in 1724. The South Carolina Commons House of Assembly laid out the parish in 1712. *Copy photograph, Ned Brown, Charles G. Luther. Local History Collection, No. 2186464. Courtesy of the Beaufort County Library, Beaufort.*

With Palmer's raid, the Spanish lost influence among the Native Americans, and the Port Royal area enjoyed a rare respite from violence. South Carolina's transition from a proprietary to a royal colony in 1729 brought even greater security to the area because with her new status came a new governor, Robert Johnson, with new ideas. One of his proposals concerned a series of townships to secure South Carolina's borders. The British government endorsed the township plan but diverted two of South Carolina's proposed townships to found the new colony of Georgia. In addition to creating a buffer between South Carolina and the Spaniards in Florida, the new colony of Georgia was created to be a haven for persecuted Protestants and a "second chance" for Britain's incarcerated poor.

The town of Beaufort needed peace and stability. By 1731, when Captain James Sutherland visited, the town had not grown. Sutherland described a poorly populated site with a "few straggling houses."

In 1733, General James Oglethorpe and the first group of Georgia settlers landed near Yamacraw and founded the town of Savannah. With the new colony underway on her southern frontier, Robert Johnson, the first royal governor of South Carolina, in 1734 initiated his township scheme in Carolina by settling Purrysburg on the Savannah River. The founding of Georgia and the settlement of the Swiss at Purrysburg brought to Beaufort and the Port Royal region the greatest security the area had ever experienced. Yet, the memory of the years of war and raiding parties, death and destruction continued to color the Port Royal residents' outlook with fear and apprehension.

With Georgia securing South Carolina's southern frontier, the 1730s brought heightened economic development. Rice cultivation of the inland swamps between the Combahee and Coosawhatchie Rivers blossomed and brought the planters new wealth. As early as 1706, a memorandum, received by the Board of Trade on 22 April, extolled the desirability of Carolina rice, calling it "the best yett known in the world." Although rice was grown early in South Carolina's history, the exact origin of rice cultivation in the province remains in doubt. One tradition has Henry Woodward ordering rice from Madagascar prior to 1685, while another credits the East India Company with sending a bag of rice in 1696. There were at least two strains of rice cultivated in South Carolina. The more famous is known as Carolina Gold. From their early efforts at planting upland rice, Port Royal planters began to grow rice along South Carolina's swampy waterways.

Rice production required a large labor force to clear the swamps, build the necessary dykes and retaining pools, and cultivate and process a labor-intensive crop. Growing rice brought the first major influx of African slaves to the Port Royal region and led in time to the development of large plantations. With its limited cultivation area, the Carolina Gold variety of rice made a few South Carolina planters extraordinarily wealthy. South Carolina's coast resembled the West Indies more than it did the Chesapeake (the site of North America's first plantation

economies), and the gap widened between rich and middling, and between middling and poor settlers. The large slave force, often from the rice-growing regions of Africa, contributed to the development of the unique Gullah culture on the Sea Islands. British support made rice a more desirable crop. Just as it had done with indigo, the British government encouraged the production of rice. The Heywards were one of the Granville County families that found fame and fortune in rice.

Exploiting the proximity of St. Augustine, fugitive slaves fled there as early as 1687. On 7 November 1693, the Spanish King Charles II promulgated a royal policy (cedula) guaranteeing the escaping slaves (male and female) freedom in Spanish territory. In 1715, ninety-eight slaves from St. Helena Parish escaped to St. Augustine. In 1725, converted Yemassee led a group of slave refugees to St. Augustine. The Spanish governor appointed one of these refugees, Francisco Menendez, to lead the slave militia. As some of the Spanish governors did not uniformly enforce the cedula of 1693, the Spanish king reaffirmed the policy of granting freedom to slaves who fled to Spanish Florida. Hundreds, perhaps thousands, of slaves fled South Carolina and especially the Carolina Lowcountry for new lives in Florida. Many achieved their freedom by adopting Catholicism, working for Spanish authorities and serving in the militia.

So many fled to Florida that in 1738 the Spanish government created a special settlement for these refugees—Garcia Real de Santa Teresa de San Mose, known as Moosa or Fort Mose to the Carolinians. The former slaves negotiated for self-government, independent of St. Augustine, and their town served as an early warning system for the Spaniards in St. Augustine. The former slaves also joined the Yemassee in raiding the Port Royal area. Some historians credit a mission in 1739 by Captain Piedro with inciting the Stono Slave Rebellion, the first large-scale slave uprising in South Carolina. In 1740, General James Oglethorpe of Georgia led an expedition against St. Augustine. The raid destroyed the town of Mose but failed to subdue St. Augustine. Survivors of the Mose settlement moved to St. Augustine and lived there for thirteen years before rebuilding their town. In 1763, Spain surrendered Florida to the British as a condition of the Treaty of Paris that ended the French and Indian War. At that time, the Spaniards evacuated the inhabitants of St. Augustine and Garcia Real de Santa Teresa de San Mose to Cuba.

With Spanish incursions, Yemassee and slave raids, and even French pirates plying their waterways, the Port Royal area suffered major loss of crops and its work force. For example, St. Helena Parish had 224 slaves in 1725 and only 170 in 1726. As a result, the town of Beaufort grew slowly and many of the early lot grantees never occupied nor developed their property.

ANOTHER START

In 1724, an effort to revitalize the town faired slightly better. Lot holders were required to build homes within a set period of time or forfeit the property. On 23 February 1738,

Lieutenant Governor William Bull wrote the South Carolina Commons House of Assembly that he had ordered "an exact Survey and Plat" to be made in order "to promote the better settling of Beaufort Town." Bull recommended that the Commons House enact legislation requiring lot holders to build within a certain time frame or pay a fine. The money collected could be used for "the Benefit of the Town or Harbour."

With another act in May 1740, the Commons House of Assembly enacted very similar legislation that fined the owners of unimproved lots rather than requiring the forfeiture of such lots. As a condition of receiving the grant, lot holders had to agree to build a "tenantable House" thirty feet long and fifteen feet wide with at least one brick chimney within three years of the date of the grant. Failure to build the required building within the three years made the lot holder liable for an annual fine of two pounds of proclamation money. The fines collected under the act of 1740 funded the education of the parish's poor children. After twelve years, the ownership of the lots not properly improved would revert to the crown. Between 1743 and 1774, certificates of survey for town lots in Beaufort were registered in the auditor general's office. This registration allowed the fines to be assessed and collected.

Between 4 April 1743 and 30 April 1744, fifteen individuals received grants for one or more Beaufort town lots. The grant recipients were Stephen Bull, Wiliam Bull Junior, Thomas Burton, Robert Williams, Colonel William Hazard, Eliza Wigg, Nicholas Haynes, Richard Woodward, Paul Grimbal, Thomas Grimbal, Sarah Woodward, Mary Hudson, William Lyford, George Livingstone and Frederick French. Most grantees only acquired one lot, but Richard Woodward was the major investor with six.

As part of the revitalization effort, a new fort—Fort Prince Frederick—was built in 1734. In 1733, Governor Robert Johnson had purchased one hundred acres on Scott's or Smith's Point east of the Beaufort River. Even with the prosperity and relative security of the 1730s, defense

The Hepworth Pringle House, 214 New Street, 1968. This house may be the oldest in Beaufort. Usually dated between 1717 and 1720, the house represents the style of the first houses probably built in Beaufort. *South Carolina National Register of Historic Sites, Beaufort County. Courtesy of the South Carolina State Historic Preservation Office, South Carolina Department of Archives and History.*

remained a major focus. Beaufort merchant and planter John Delabere had the contract to complete the construction of Fort Prince Frederick. Although the fort had tabby walls five feet high and five feet thick at the top—Tabby is a construction material made of native shellfish shells (usually oysters), lime and sand—Fort Prince Frederick never offered much security. By 1740, the fort was in serious disrepair. British troops and scout boats were stationed there intermittently until construction began on a new fort—Fort Lyttelton—in 1758.

Fort Prince Frederick was poorly situated militarily, and morale, despite rations of rum, was a constant problem. There was little in the way of entertainment for soldiers stationed there, and the fort was a long way from Charles Town. Enlisted men and officers clashed. Responses to these disagreements differed. In March 1734, Peter Howard deserted his company, and in 1735, an argument over a debt erupted between Rowland Sarjean and Lieutenant Donegal of the fort. Donegal sent Sarjean to Charles Town in irons. In Charles Town, after reviewing the facts of the matter, the governor released Sarjean and filed charges for false imprisonment against the fort commander. The fort was poorly provisioned and even lacked a proper flag. The situation was so dire that in 1739 General James Oglethorpe, who had founded Savannah, was emboldened to request powder and other resources on the garrison's behalf. Oglethorpe was concerned because the defense of Beaufort and of the Port Royal area was critically important to the new colony of Georgia.

At this time, the remnants of Fort Prince Frederick's tabby walls stand on the grounds of the United States Naval Hospital. Despite encroachment of the river, the tabby walls have drawn visitors in every century. Art classes and picnickers have been intrigued by this picturesque ruin.

While the fort may have been poorly maintained, there was sufficiently threatening activity in the Port Royal region to justify the residents' concern and strengthened lobbying efforts to enhance area security. On 13 June 1751, Thomas Wigg wrote Governor James Glen complaining of Indian unrest. According to Wigg on 11 June 1751, sixteen Indians, who claimed to be Cherokee, disembarked on Lady's Island within four or five miles of the town of Beaufort, killed two "friendly" Indians, and kidnapped three women and children. The settlers had last glimpsed the invaders "in a Creek near Beaufort." Wigg's letter illustrated that while frontier life was safer after the founding of Georgia, occasional Indian raids continued until the Revolutionary War. Security was a relative term. The letter also provided a picture of the diversity of life in the vicinity of Beaufort. As late as 1751, Indians still inhabited parts of Lady's Island, living in apparent harmony with the white residents. The "friendly" Indians may have been settlement Indians who lived in or near the white settlements.

By 1735, the "new" ports of Beaufort and Georgetown were active enough to rival Charles Town for the lucrative Carolina trade. By the following year, Beaufort had the requisite customs officials and a collector of the port. The collector of the port was concerned with collecting

duties on imports. Although Beaufort grew to be a thriving port during the colonial years, she never outpaced Charles Town. For example, in the calendar year from March 1764 through March 1765, 40 ships cleared the port of Beaufort as compared with 360 that cleared the port of Charles Town. Yet, in the years leading up to Revolution, the Beaufort area outpaced the growth of the rest of South Carolina. This period of rapid growth would be mirrored by the decades preceding the Civil War and the late twentieth century.

With the founding of Savannah and the new colony of Georgia, merchants and mariners traveled frequently between Beaufort and Savannah. The Beaufort-Savannah trade was a natural exchange given the tides and currents of the Intracoastal Waterway. Mercantile firms had branches in both towns. Mariners and sea captains invested in both areas, and there was considerable social interaction. Traffic with Savannah grew after the American Revolution and continued through the steamboat era and the construction of the Talmadge Bridge across the Savannah River in 1954. For example, in 1776, Samuel Grove, a mariner who had become a merchant and married the widow of Beaufort resident James Kean, bought three lots in Beaufort and relocated there. Grove's new purchases had belonged to Francis Stuart and included Lot 10 with a tabby house, Lot 34 and a low-water lot with an unfinished tabby store. Many of the wharves and stores in Beaufort were built on these low-water lots—that is, lots that extended to the low-water mark of the tide.

A "Young Gentleman," traveling in South Carolina between 1733 and 1734, visited the town of Beaufort. While noting how "pleasantly situated" the town was, he bemoaned its lack of growth. The "indifferent" state of Beaufort, from his perspective, was the result of absentee landholders who so tightly controlled the surrounding land that others who might want to settle in the area could not obtain land.

According to Lawrence Rowland, in 1736, a group of Angolans imported into Savannah were the first slaves offered for sale in Beaufort. The *South Carolina Gazette* listed Jean Pierre Purry and David Montagut as the owners. Yet, according to Daniel C. Littlefield's research in the Naval Office Records, the largest cargo of slaves directly imported into Beaufort also arrived in 1736. Captain David Mallorie sailed the *Sussah* into Beaufort with 198 slaves on board. Samuel Montagut paid the duties on 1,557 of the slaves and James Delos on the other 40. These two accounts appear to concern the same cargo of slaves but differ as to the details.

Despite occasional activity, Beaufort remained a secondary port for the slave trade. Charles Town was the primary entrepôt for the frequently lucrative South Carolina slave trade. Prior to the Revolution, for only three years between 1736 and 1757 did the port of Beaufort collect duties for the direct importation of slaves from Africa and then only on about two hundred slaves. According to the records, no slaves were imported into Beaufort after 1757. Yet, demand grew as rice and indigo planting spread. Historian Daniel C. Littlefield contends from the ads in the *South Carolina Gazette* that Beaufort, far from not importing any slaves after 1757,

actually imported approximately one thousand slaves between 1760 and 1765. Therefore, direct slave imports into Beaufort may have exceeded those into the port of Georgetown, making Beaufort second, a distant second to be sure, to the port of Charles Town. If Littlefield's conjectures are correct, the Beaufort importers were either evading the duties due or bribing port officials. Such evasions and venial officials contributed to British frustration with colonial revenues. British frustration—and the desire to make the colonies profitable and to pay off debts from the French and Indian War—led British officials to enact the Grenville and Townshend Acts, the Stamp Act, as well as other wildly unpopular tax acts that led eventually to the American Revolution. What transpired in Beaufort was repeated in every port of the thirteen British colonies.

The Port Royal rice planters preferred slaves from certain African localities. This ethnic hierarchy is seen in slave advertisements and planter correspondence. The Port Royal planters considered slaves from Senegambia, the Gold Coast (Ghana) and the Windward Coast (Guinea, Sierra Leone and Liberia) highly desirable. Slaves from the Gold Coast (Ghana) were sometimes equated with those from Senegambia, and slaves from Angola were also acceptable. Advertisements in the *South Carolina Gazette* in the 1760s play to these preferences by announcing 170 Gold Coast slaves, 200 Guinean slaves from the Windward Coast and 200 from Gambia.

Regardless of the source, as more slaves entered the Port Royal area, more fled southward. More than sixty slaves fled Port Royal Island in 1738. In October 1749, twenty-one slaves at Beaufort stole a boat from Captain James MacKay and sailed to St. Augustine. In addition to normal runaways, Spain frequently sent agents into South Carolina to agitate the work force and entice slaves to run away to Florida. When direct action failed, Spain turned to indirect activities to hamper growth in South Carolina. Two such slave recruitment missions in 1736 and 1739 may have influenced the perpetrators of the Stono Rebellion. The slaves captured after the rebellion stated their intention to flee to St. Augustine.

THE GREAT AWAKENING

In 1737 John Wesley as a harbinger of the Great Awakening came to Beaufort as the guest of the Reverend Lewis Jones. Wesley and his brother Charles had previously visited the Port Royal area in 1736 before Charles returned to England. The more persuasive George Whitefield arrived in Georgia in 1738. The coming of the Great Awakening brought religious turmoil to the black and white residents of the Port Royal area. Converts revived old churches and established new churches, and missions to the slaves multiplied.

The charismatic Whitefield, however, was not universally lauded in South Carolina. Accepted in Beaufort, Whitefield had serious problems in Charles Town. During his second

preaching mission there in January 1740, Alexander Garden, the commissary of the Bishop of London, refused to permit Whitefield to preach from the pulpit at St. Philip's Church in Charles Town. According to Garden, Whitefield had violated the order of service as prescribed by the Book of Common Prayer. Preaching in Beaufort, Whitefield had also attacked the faith of Archbishop John Tillotson. Garden and Whitefield had a long, acrimonious and public dispute, one that affected and polarized their followers.

Whitefield, despite his difficulties in Charles Town, became the guiding light for the Euhaw Baptist Church at Coosawhatchie and for the Stoney Creek Independent Presbyterian Church at Pocotaligo. The latter grew out of his preaching, which had transformed the former congregation. With heightened zeal, Euhaw established missions on Port Royal, St. Helena and Hilton Head islands. The Port Royal Mission became the Baptist Church of Beaufort. The mission on St. Helena Island is the Brick Church at Penn Center. Thus, while the effect of the Great Awakening on the colony of South Carolina as a whole was negligible, the evangelical movement it spawned flourished in and profoundly affected Beaufort District.

In 1740, Colonel Nathaniel Barnwell, Hugh Bryan, Jonathan Bryan, the Reverend Lewis Jones and the Reverend William Tilly visited Whitefield in Savannah. During the visit, Barnwell was converted. Jones was the Anglican rector of St. Helena Church; Tilly was the minister for the Baptist church at the Euhaws. Tilly died in 1745, and Francis Pelot, a Swiss from Purrysburg, served as pastor of the Euhaw Church from 1746 to 1774. Whitefield enjoyed a long relationship with the Euhaw Church and considered Tilly a "lively Baptist minister."

The Euhaw Church claimed descent from the preaching of the Reverend William Screven of Charles Town on Edisto Island c. 1700. Baptist work came to the Lowcountry early. At some point prior to the Reverend Tilly's death in 1744, the Euhaw Church had members meeting at Port Royal and Hilton Head islands. The Euhaw Church continued to consider itself a part of the Charles Town church until 5 May 1746. The work of the Euhaw Church spread to St. Helena Island as well as to Port Royal and Hilton Head islands where the congregation erected a meetinghouse.

The Euhaw Church called Joseph Cook as pastor in 1776, but when marauding British plundered the area, Cook fled inland. Nothing is known of the congregation during the British occupation of Beaufort. As British troops patrolled the area, it is likely that some of the congregation dispersed and the remnant met infrequently at less public sites.

At Whitefield's urging, Hugh Bryan—a vestry man at St. Helena's who had married Katherine, the daughter of "Tuscarora Jack" Barnwell—preached the "new birth" to the slaves of Beaufort District. The slaves' enthusiastic response brought fear to the hearts of religious and governmental authorities. To compound his offence, in 1740, Bryan published a letter in the *South Carolina Gazette* blaming the Stono Rebellion of 1739, the Charles Town fire of 1740 and the English defeat outside the walls of St. Augustine that same year on the sins of the South Carolina

Saltus-Habersham House (Belk-Simpson Building), 802–806 Bay Street. The Stuart family once owned this property. Reportedly, Charles Wesley, the hymn-writing brother of the Reverend John Wesley, found refuge there when the boat that was carrying him sank. At one time, the Whitman and Bristol Jewelry Store occupied the building, and steamships from Charleston and Savannah docked behind the building. *South Carolina National Register of Historic Sites, Beaufort County. Courtesy of the South Carolina State Historic Preservation Office, South Carolina Department of Archives and History.*

colony. A resident of Prince Williams Parish, at the request of the Commons House of Assembly, Bryan was arrested and asked to explain his unusual behavior. Although Bryan apologized, he and his brother Jonathan continued to preach to the slaves on their plantations.

The two brothers, Hugh and Jonathan Bryan, were among the small cadre of Whitefield supporters who organized the Stoney Creek Church in Prince William's Parish on 20 May 1743. The Reverend William Hutson was the first minister for the congregation and continued in that capacity until 1756. The congregation built its first meetinghouse in 1744.

These evangelical preachers also demonstrably touched the slaves of Beaufort, much to the chagrin of Anglican missionaries and the Reverend Lewis Jones, the rector of St. Helena Church in Beaufort. To Jones, the evangelicals taught enthusiasm not religion. Yet, according to historian Lawrence Rowland, "[t]he conversion of the slaves to Christianity was one of the most important events in South Carolina history." For Rowland, "the particular form of evangelical Christianity practiced by many black Americans to this day may have begun with George Whitefield, the Great Awakening and the Bryan brothers of the Beaufort District."

The Bryans; Colonel Nathaniel Barnwell, the son of Tuscarora Jack Barnwell; and Captain James McPherson were all also involved in the settlement of Savannah. Hugh Bryan was a land

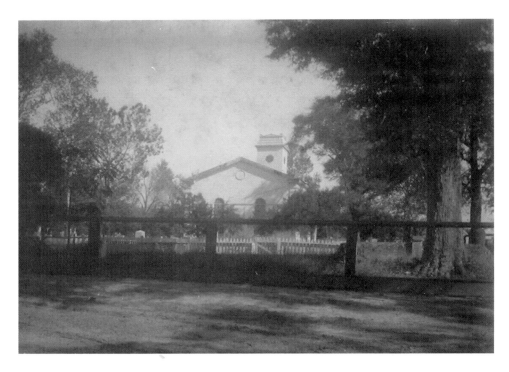

The rear view of the Baptist Church of Beaufort, c. 1910, taken from the New Cemetery of St. Helena Parish Church. *Christensen Family Papers, Folder 47. Courtesy of the South Caroliniana Library, University of South Carolina.*

surveyor in Georgia. Jonathan Bryan (1708–1788) served on the Governor's Council in Georgia, championed the rights of Georgia's settlers and was a Revolutionary War patriot imprisoned by the British. In 1793, the State of Georgia created Bryan County named in his honor.

In October 1742, John Martin Boltzius, a Lutheran minister, traveled by ship from Savannah to Charles Town. En route, on 18 October, he visited Beaufort. He found the town "well situated, but still badly built even if better than Savannah." Though damning with faint praise, the remark illustrates a truth of Beaufort's development. The town was always being compared either to Charles Town or Savannah. The town of Beaufort, with her chequered past of interrupted development, grew slowly.

On 21 May 1744, the Reverend Robert Orr claimed three town lots—Nos. 322, 323 and 324—and the square bounded by King, Charles, North and Newcastle Streets in trust for the Presbyterian (Dissenter) congregation in Beaufort. The Presbyterians maintained Lot 323 as a cemetery from 1739 to 1856. The grave of Dissenter John Beamer, who died in 1739, may be found there. Today, St. Helena Parish Church owns this property. Between 1757 and

1772, the Reverend Archibald Simpson, pastor at Stony Creek, also preached for the Beaufort congregation. By 1756, the Beaufort meetinghouse was in disrepair, and efforts were made in 1770 to build a new one. The founding and growth of Stony Creek seemed to detract from the Presbyterian work in Beaufort. By 1768 Beaufort, although the older congregation, was essentially a mission work. Simpson's departure for Scotland in 1772 and the coming of the Revolution ended this early chapter in the history of Presbyterianism in Beaufort.

By the 1740s, the Port Royal area had grown sufficiently for the Commons House to divide St. Helena Parish and create two new parishes—Prince William's Parish, bounded by the Combahee, in 1745, and St. Peter's Parish, bounded by the Savannah River, in 1747. St. Luke's Parish along the Coosawhatchie River was added in 1767. By the Revolution, there were four Anglican parishes in Beaufort District.

Charles Purry, son of Jean Pierre Purry, the founder of Purrysburg, abandoned that township and opened stores at Okatee and in Beaufort. Relocating to Beaufort, Purry flourished as a storekeeper until his murder in 1754. Purry's body was found in the river with bags of shot weighing down his arms and legs. An investigation revealed that three of Purry's slaves—a woman and her two brothers—had conspired in his death. One of the men was gibbeted (that is, hung and left suspended for public view) in Beaufort and before his execution confessed to a large conspiracy involving eight other slaves and the intended death of two additional Beaufort residents. The coup de grâce was the slaves' assertion that if successful, the conspirators would have "taken a schooner in the harbour" and made "their way to St. Augustine."

Although the slaves were quickly apprehended and punished, the Purry murder and alleged slave conspiracy that fell in such close proximity to the Stono Rebellion of 1739 heightened the anxiety level in Beaufort and the Port Royal area. Security fears and many complaints about the condition of Fort Prince Frederick finally pushed the South Carolina General Assembly to begin construction of a new fort in 1758. Named for Governor William Henry Lyttelton, Fort Lyttelton lay a mile and a half south of the town on Spanish Point, once the site of the ill-fated Stuart Town. A garrison remained at the fort until 1766.

Indian raids may have decreased, but the growth of the slave population and the presence of the Spanish in St. Augustine continued to cast a pall over the area's economic development.

Chapter 4
Toward Independence, 1755–1783

I N THE FIRST DECADES OF settlement, Indian trade, naval stores and cattle were Beaufort's trade engines. The Yemassee War of 1715-1718 had destroyed the cattle-raising industry as an export industry and eliminated the Port Royal area as a major player in the Indian trade. First, the Yemassee, the great trade brokers, were gone, and second, the great loss of life left large areas untenanted. Given the danger of Indian and Spanish raiders on Port Royal waterways, traders focused on the overland routes, and Charles Town merchants usurped much of the Port Royal trade. The Port Royal economy began to recover as settlers found new sources of revenue.

By the 1730s, planters had discovered that the tidal creeks of the Port Royal area were ideal for rice production. For planters of Port Royal, Carolina Gold and indigo were the pre-Revolutionary War cash crops. Although much of the indigo grown in South Carolina was considered inferior to the French product, the British government—with its mercantile philosophy—needed raw materials and offered a substantial bounty or subsidy for indigo. In 1748, the British parliament placed a bounty of sixpence (later fourpence) per pound on indigo produced by the American colonies. At that time, the French West Indies was the major supplier of indigo for European import. Great Britain needed six hundred thousand pounds per year and was frequently locked in power struggles with the French. Being able to acquire a highly desired raw material from her colonies held great advantages for the British.

Experimentation by Eliza Lucas both before and after her marriage to Charles Cotesworth Pinckney proved that quality indigo could be produced in South Carolina and in marketable quantities. While Pinckney was not the only experimenter with indigo, she was a successful one, producing her first marketable crop in 1744. Andrew Deveaux of St. Helena Parish was an early convert to indigo production. By 1746, South Carolina was exporting 5,000 pounds and by 1748, 135,000 pounds. Prior to the American Revolution, South Carolina exported more than 1 million pounds of indigo.

London markets paid well for Beaufort-grown indigo. Even after the Revolution when the bounty was removed, some Port Royal planters still grew indigo locally. Prior to the American Revolution, indigo had been the crop of choice for the planters on Hilton Head Island

and elsewhere in Granville County. Beaufort District's William Elliott lobbied for indigo production into the 1820s.

Therefore, before the Revolution, indigo was the crop with greatest potential for the smaller planters—the erstwhile middle class. The British bounty made Carolina indigo commercially viable. With the bounty, even small holders with only a few workers found the crop lucrative. Although these middling planters such as the Parmenter and Reynolds families never achieved the great wealth of the Bulls, Barnwells and similar families, they managed to thrive and leave a numerous progeny. The true "princes" of the Port Royal area with great wealth and political power were the Barnwells and the Heywards. Their descendants built on these early foundations and continued to direct the growth and prosperity of Beaufort and the Port Royal area through the antebellum years.

The militia muster rolls of 1757 offer a unique overview of the inhabitants of Beaufort. The law required that all white males between the ages of sixteen and sixty enroll for militia service. These rolls, therefore, offer a comprehensive look at who was living on Port Royal and St. Helena islands at that time. The two companies belonged to the Southern Regiment of Granville County under the command of Colonel Thomas Wigg, Lieutenant Colonel Daniel Heyward and Major Andrew Deveaux. Captain John Gordon and Lieutenant Francis Stuart led the Port Royal Company of 105 men. Surnames represented in the company proper include Aggnew, Annonet, Bowman, Bland, Box, Burton, Bennit, Bona, Barton, Bogh, Boyd, Bell, Cox, Cookson, Delagaye, Dawson, Delabare, Davis, DeSaussure, Dalton, Emsdon, Evans, Ferguson, Fairchild, Freeman, Fulse, Few, Wineman, Walker, Godfrey, Green, Guin, Givens, Elliott, Grayson, Hird, Harris, Hext, Houd, Hutchinson, Jones, Iten, Kelsall, Livingston, Moses, Moroney, Mitchell (a black man), McLane, Mareus, Myers, Nash, Orr, O'Bryan, Sterling, Stone, Watson, Wells, Stone, Shedland, Story, Smith, Searson, Sutherland, Streather, Stevens, Parmenter, Page, Peters, Palmer, Powell, Perryclear, Ruff, Richards, Russell, Richardson, Reeves, Russell, Wilkinson, Welch, Waters, Williams, Watson, and Gough. This listing reflects the original order of the names because the different alphabetical groupings may reflect different settlements on the island.

In addition to the militia company, the following were listed as alarm men: Colonel John Mullryne, John Hutchinson, William Harvey, James Thomason, John Chapman, Nathaniel Green, Richard Rickets, John Henny and Thomas Nelson. The alarm men were individuals who—whether from age, physical disability or position—were normally exempt from militia service. Consequently, they were the reserves available in times of extreme emergency.

As John Delagaye was a merchant in the town of Beaufort until he quit the colony in 1769 (he relocated his mercantile business to France), the Aggnew through Walker surnames may indicate the male inhabitants of the town in 1757. If that hypothesis is correct, then the following men were the male residents of Beaufort in 1757: Andrew Aggnew, Robert Annonet,

Thomas Bowman, George Bland, Phillip Box, Benjamin Burton, John Bennit, Jacob Bona, William and Isaac Barton, George Bogh, John Boyd, William Bell, Thomas Cox, John Cookson, John Delagaye, Thomas Dawson, George and John Dendrick Delabare, William Davis, Daniel DeSaussure, Henry Dalton, Ambrose Emsdon, William Evans, John Ferguson, Robert Fairchild, William Freeman, Ernest Fulse, Samuel Few, Lend. Wineman and Thomas Walker.

With economic prosperity in the hinterlands, the town of Beaufort grew as well. Growth brought new businesses, a grammar school taught by a Scotsman named Commings and an enhanced social life. In the 1760s, the *South Carolina Gazette* advertised bonfires and fireworks at Fort Lyttelton and the annual Port Royal sail races. In the 1760s, the colony granted titles to the low-water lots on the south side of Bay Street. Generally, merchants such as Francis Stuart and John Gordon obtained title to these lots. Beaufort's merchants traded in rice and indigo, and operated dry goods stores for the town's inhabitants. Some merchants built their homes on one side of the street and their stores across Bay Street. Others filled in the low-water lots and constructed stores, wharves, homes and outbuildings on the south side of Bay Street. Prosperous establishments in the town of Beaufort would have had a variety of outbuildings, including a washhouse, kitchen, dairy, smokehouse and stable. Few structures from before the Revolutionary War era survive in modern Beaufort.

Between 1766 and the outbreak of the American Revolution, Beaufort was a center for shipbuilding. James Black's shipyard on the Point built at least three ships in this period—the *Ashley Cooper*, the *Atlantic* and the *Georgetown*.

Beaufort's status improved when the circuit courts were approved in 1769 and began to function in 1772. The first Beaufort court convened in November of that year and often concerned itself with issues of slave control. In 1773, the Beaufort grand jury complained that Beaufort slaves played "trap-ball and fives" on the sabbath. Trap-ball was an English folk game, probably from the fourteenth century, and an antecedent of cricket. To play, a ball was placed in a swiveling trap. When the trap was spun, the ball was released. The batsman would then try to hit the ball with a stick and score runs. Fives was another English ball game that required a high stone wall (such as was often found in churches) for play. Puritan ministers in England denounced such play by 1625. That slaves in Beaufort were playing English games in 1773 illustrates one type of cultural transference. Were they playing fives against the wall of St. Helena Parish Church? In 1775, the Beaufort District grand jury complained about the illegal trade in provisions between area slaves and itinerant traders.

An "English traveler" in 1774 reported that Beaufort was a "well peopled good looking town better than half as big as Charles Town" with a "fine river" that was navigable to the Atlantic. Noting that, at low tide, only about twelve feet of water covered the bar in Charles Town harbor, this visitor thought Beaufort would be a better capital for South Carolina than would Charles Town. The timing of these comments is of interest as the governor of South Carolina,

Lord Charles Montagu, had tried in 1772 to convene a legislative assembly in Beaufort, thereby making Beaufort the temporary capital of South Carolina. Montagu hoped to gain the upper hand in his continuing struggle with the patriots of Charles Town. He also wanted a governor's mansion comparable to Tryon's palace (built for Governor William Tryon) in North Carolina. Montagu had rejected the housing offered by the Commons House and was living at Fort Johnson at the time. Housing was only one of several contentious points that separated the governor and the leaders of the Commons House in 1772.

A cannonade greeted Montagu's arrival in Beaufort on 7 October 1772. John Barnwell Jr. offered conciliatory welcoming remarks. Many prominent Beaufort leaders presented their respects to the governor. According to Montagu, the Beaufort members of the Commons House of Assembly had offered to build him a suitable residence there. Beaufort's town fathers dreamed the switch might be permanent.

On 10 October 1772, after the governor kept them waiting for three days, the Commons House of Assembly convened in Beaufort's new courthouse—possibly the first governmental use of the new facility. Despite Montagu's attempts to discourage the opposition members from Charles Town from attending the session, most of them moved very quickly and arrived before the meeting date. Montagu's ploy failed, and after a brief session, he returned the assembly to Charles Town. Montagu had precedents for his action. In 1761, Lieutenant Governor William Bull, fearing an outbreak of yellow fever, had summoned the Commons House of Assembly to Ashley Ferry. In Massachusetts, Governor Thomas Hutchinson, in an effort to avoid the negative atmosphere of Boston, had moved that colony's General Court to Cambridge. Although Montagu's strategy failed, he may have achieved a form of immortality by influencing the writers of the Declaration of Independence. The declaration cited as an abuse of royal authority that the king or his representative convened "colonial legislative bodies at places unusual, uncomfortable, and distant from the depository of their public records, for the sole purpose of fatiguing them into compliance with his measures."

Whether the threat to relocate the capital was real is debatable. Christopher Gadsden, leader of Charles Town's Sons of Liberty and a member of the Commons House of Assembly, feared the possibility. Yet, Charles Town's long history and political clout continued to prevail over the natural advantages of Beaufort and Port Royal Harbor, and Montagu's attempt doomed his leadership in the colony and strengthened the opposition to British rule.

The strategic value of Beaufort's harbor, however, was not lost on the British. The harbor was deep enough for the largest ships and within a few days' sailing from the Bahamas and Jamaica. Several shipbuilders operated in the area, and the live oak was prime shipbuilding material. During the colonial period, several efforts were made to have

naval facilities constructed in the area. William Bull had even offered to donate land for such a facility.

In 1776, Sir Peter Parker, admiral of the fleet, in addition to attacking Charles Town, was supposed to assess the suitability of the Beaufort area as a British naval base. With the British naval blockade of the coast of North America, there was an urgent need for repair facilities along the coast.

Despite, or in spite of, the embargoes on exports and the British naval blockade, Southern shipping continued to prosper in the early years of the Revolution. Ships from Beaufort were among those successfully eluding the British warships. In February 1777, the commissioners of South Carolina's navy ordered Captain John Mercier to have his sloop *Beaufort* outfitted and armed. In July, the commissioners sent Mercier to carry a load of rice from Beaufort to Cape Francois, Haiti, or another port on Hispaniola for sale. On 20 March 1777, the Marquis de Lafayette, Baron DeKalb (John Kalb) and other Europeans embarked for Port Royal but inadvertently landed near Georgetown. Control of Beaufort and Port Royal Harbor had at least two attractions for the British—the harbor itself and the desire to prevent the American forces from utilizing it. Beaufort found herself in a similar predicament in 1862.

At the time of the American Revolution, the town of Beaufort had grown beyond its early east-west bounds of East and Charles Streets. By the 1740s, the town had added Harrington, Monson, Bladen, Newcastle and Adventure Streets. As the names correlate with individuals crucial to Beaufort's development, certain assumptions can be made regarding the naming of Beaufort's early streets. East is a direction, but Charles II was the English king who had given the province to the eight Lords Proprietors in 1663. Sir John Harrington was a Knight of the Bath. Sir William Monson was a naval hero of Cadiz. Bladen Street may honor Lieutenant Colonel Martin Bladen. In 1717, Bladen was named one of the commissioners of the Board of Trade. The Duke of Newcastle, William Cavendish, was an English general. The name "Adventure" may, per Mabel Runnette, longtime Beaufort librarian, recall the name of Captain William Hilton's ship. By 1778, there were seventy houses in Beaufort.

While the Revolution brought little military disruption to the area, the conflict seriously affected Beaufort's merchants and divided the population. The Beaufort area produced on one hand, prominent Loyalists, who supported the king, such as Lieutenant Governor William Bull and Andrew Deveaux. On the other hand, Beaufort District was home to leading patriots such as Thomas Heyward Jr., signer of the Declaration of Independence, and Daniel DeSaussure, whose son was imprisoned by the British in St. Augustine. The Deveaux and Heyward families were old ones in the area, and both Deveaux and Heyward had been militia officers in Beaufort District. Colonel Andrew Deveaux is perhaps best

remembered for his daring recapture of the Bahamas from the Spanish in April 1783 after the treaty of peace had been signed. In 1782, Spain had seized the islands with South Carolina assistance. His Carolina lands confiscated, Deveaux was refugeeing in St. Augustine when he conceived his audacious plan. Deveaux also fought for the British at the Battle of Beaufort, raided extensively in Beaufort District, and was involved with the sieges of Savannah and Charles Town. Traditionally, Deveaux commanded the detachment of Prevost's troops that burned Sheldon Church in 1779. Both Andrew Deveaux and his son Andrew Deveaux Jr. had their lands confiscated.

The Revolution came to South Carolina with a vengeance when the British leadership, despairing of their efforts to induce surrender by capturing the Middle Atlantic states, turned to their southern strategy. The American victory at Saratoga, New York, produced an open declaration of support from France and indirect assistance for the American cause from other European countries. Consequently, in 1778, the British turned to the South, where they expected to find great Loyalist support and easy victories.

On 29 December 1778, Savannah fell into British hands. In 1779, the British under Major General Augustine Prevost attempted to gain a beachhead in South Carolina by advancing on

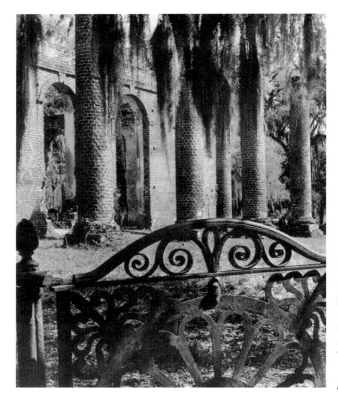

Ruins of Old Sheldon Church, 1972. The Parish Church of Prince William's Parish was burned by Colonel Augustine Prevost's troops during the Revolutionary War, rebuilt and later burned by General William T. Sherman's forces in 1865. *Courtesy of Ned Brown, photographer.*

Beaufort. Prevost sent Major Gardiner with a detachment to occupy Port Royal Island. General William Moultrie with three hundred militiamen, mainly the Beaufort militia commanded by General Stephen Bull, defended the island. On 3 February 1779, the forces met near Grays Hill. Moultrie and his men won a resounding victory. Two of the militiamen with Moultrie were Edward Rutledge and Thomas Heyward Jr., both members of the Charleston battalion of artillery and both of whom had signed the Declaration of Independence. Unfortunately, Moultrie's men lacked the ammunition to pursue the enemy and the commander of Fort

Fort Pulaski, Savannah, Georgia, c. 1958. Built between 1833 and 1847, Fort Pulaski honored Count Casimir Pulaski, a native of Poland, who died at the Battle of Savannah during the Revolutionary War. The fort was surrendered to Union forces in 1862 and the port of Savannah closed to shipping. From left to right are Martha Jones, Uel Jones, Nancy Jane Geoghagan, Alexia Jones, Georgeanne Jones, Dr. George A. Jones and Irene Page. *Courtesy of George A. and Evelyn Jones.*

Lyttelton, fearing a British victory, had spiked the fort's guns before the engagement. Prevost's forces raiding in the area burned the Sheldon Church in May 1779.

In the summer and fall of 1779, the British occupied the Sea Islands and Beaufort. Following their defeat at Stono on 19 June 1779, Prevost and his troops left that area and retired to Port Royal Island. General Augustine Prevost liked Beaufort both for its climate and location. Using Beaufort's extensive waterways, he had access to all parts of Beaufort District and the surrounding mainland.

During his residency, Prevost had his headquarters at the corner of Port Republic and Bay. Prevost detailed Lieutenant Colonel John Maitland with a force of nine hundred men—Hessian mercenaries and regular British troops to occupy Beaufort. Impressed with the salubrious nature of Beaufort, Maitland established his headquarters on the corner of Carteret and Port Royal and used the courthouse and jail as hospitals. The British warship HMS *Vigilant*, although in poor repair, stood guard in Beaufort harbor for three months in 1779, ready to repel invaders or to blow up the town. The British fortified the Shell Road on the outskirts of the town. According to tradition, the British even stabled their horses in St. Helena Parish Church. The church did sustain damage during the occupation. Maitland precipitously evacuated Beaufort in November 1781 to assist with the defense of Savannah, leaving his artillery and supplies behind, but the British did not leave Beaufort District until 1782.

Following the surrender of General Benjamin Lincoln on 12 May 1780, not only Charles Town but also the entire South Carolina Lowcountry was under British control. Except for Maitland's temporary absence in 1779 to assist with the defense of Savannah, Maitland and the British secured Beaufort and the Port Royal area for two years. Ironically, the British hospital and naval facilities there were economic boons for the area and for Beaufort's Loyalist merchants. In a similar fashion, Beaufort would also sit out the Civil War occupied by "enemy" forces.

After the fall of Charles Town in 1780, Lord Cornwallis appointed a Beaufort resident, James Fraser, an English surgeon, to serve as acting barracks master in occupied Charles Town. Fraser held that position for nine months and had his property confiscated by the South Carolina legislature. He left South Carolina in 1783. John Edwards, another former Beaufort merchant, who had relocated to Charles Town in the 1770s, also left for England in 1783.

British raids in the Port Royal area ironically burned the home of ardent Loyalist and former lieutenant governor of South Carolina, William Bull. Lieutenant Colonel Banastre Tarleton also used requisitioned horses from the area to mount his troops. Other raids and even death visited the Port Royal area. British depredations eroded support for the crown in the countryside.

Many slaves in the Beaufort area—such as Primus who spoke well—joined the British army after the fall of Charles Town. John Murray, the Earl of Dunmore and the last royal governor of Virginia, had issued a proclamation in 1774 promising freedom for slaves who

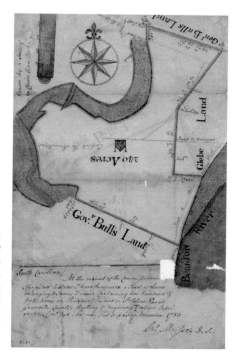

Plat of the property of James Fraser. Fraser was an English physician who lived in Beaufort before the Revolutionary War. After the surrender of Charles Town to the British, Lord Cornwallis asked Fraser to serve as barracks master in Charles Town. The State of South Carolina confiscated Fraser's property, and in 1782, he returned to England. *Commissioners of Forfeited Estates, Plats. Courtesy of the South Carolina Department of Archives and History.*

fled to the British lines. Many slaves fled when British troops were in their vicinity. The flight of the work force, skirmishes between patriot and Tory troops, and raids to garner supplies for the combatants brought great disorder to the plantations of Port Royal Island and the Beaufort area. In the fall of 1782, the British finally evacuated Charles Town and thereby not only ended the Carolina Lowcountry's role in the American Revolution, but also its part in the British Empire.

Chapter 5

Post-war Recovery, 1784–1829

MUCH OF BEAUFORT'S SLAVE WEALTH fled the area during the Revolution. Some took advantage of British inducements to cross British lines, while others continued the long tradition of seeking refuge in Florida. Hundreds of the slaves who had fled to the British lines were abandoned on Otter Island by the retreating British and died of camp fever. For many, that dream of freedom was a costly delusion.

ECONOMIC RECOVERY

The loss of slave laborers and the destruction of homes, crops and livestock left the Port Royal area's economy in ruins. As a result of troop requisitions, few in the district had horses, and many had had their homes pillaged and destroyed. Thieves frequented the public roads, and travel was not safe. The loss of the bounty on indigo forced planters in the area to seek another cash crop. Cattle-raising in some areas of Beaufort District never recovered from the ravages of the Revolutionary War. Yet, the end of the Revolution also opened new markets for Port Royal produce. No longer was American trade constrained by the British Navigation Acts. Americans could trade with any nation. Rice was still profitable, especially with the increased use of tidal cultivation and improved rice mills. However, cotton, especially after Eli Whitney invented the cotton gin and applied for a patent in 1793, was the crop of Beaufort's future. Economically, as trade resumed, the town of Beaufort fared better than the countryside. Her Loyalist merchants had fled the town, but patriots such as Daniel DeSaussure returned. DeSaussure and John Mark Verdier were part of Beaufort's rejuvenated mercantile class after the Revolution. Shipbuilding, mercantile establishments and a nascent service industry brought a fragile economic stability to the town.

As a result of this post-Revolutionary growth, in 1785 Beaufort expanded into the adjoining common lands and her northern boundary line became Boundary Street. The intervening street names—Washington, Greene and Congress—reflected her attachment to the patriot cause. The name of Washington Street could honor George Washington, the commander-in-

chief of the Continental Army during the Revolution and first president of the United States, or his cousin Colonel William Washington, another Revolutionary hero. General Nathanael Greene led continental troops into South Carolina in 1780 and harried Lord Cornwallis to Yorktown. The name Congress also has several possibilities depending upon the date the name was assigned. First, the street could be named for the Continental Congress that successfully prosecuted the war with Great Britain; the Congress of the United States established by the Articles of Confederation; or if named after 1788, the United States Constitution.

Beaufort in 1785 was a rough place. In that year, the South Carolina General Assembly enacted legislation that prohibited town residents from raising hogs. Apparently, some residents not only kept hogs but allowed them to roam freely through the town. Any fines assessed were given to the wardens of St. Helena to support the poor. Act No. 1271 (1785) also prescribed the election by taxpayers of Commissioners of the Streets for Beaufort on "Easter Monday in every year." The Commissioners of the Streets were in charge of maintaining the town's streets, removing "nuisances" and keeping roadways clean. Removing the hogs from the town limits was a step toward cleaner streets.

Post-war Beaufort society was also rough. Many planters were "hospitable" men who drank hard, enjoyed practical jokes and lewd stories. They swore frequently, and enjoyed hunting, fishing, racing and cockfighting. According to William Grayson, these men considered "Sunday...a day of boat-racing, foot-racing, drinking and fighting." Dueling was common after the Revolution. This situation changed as a revived interest in religion flourished as the new century unfolded.

In 1788, South Carolina—including St. Helena's seven delegates: John Barnwell, Robert Barnwell, William Elliott, John Joyner, John Kean, James Stuart and William Hazzard Wigg—ratified the United States Constitution. That year, the court for Beaufort District met at Coosawhatchie, not Beaufort. The mainland planters preferred a more central location for the courthouse and jail. Coosawhatchie lay in a profitable agricultural area, but its location near the Tullifinny and Coosawhatchie Rivers made the town an unhealthy place to live and work during the summer months. A summer jail term in Coosawhatchie could be fatal. Some of the town's residents spent the summer months in Gillisonville or in another nearby town whose location was perceived to be healthier. Consequently, the South Carolina General Assembly moved the Beaufort District Courthouse from Coosawhatchie to Gillisonville in 1836.

Between September 1784 and December 1786, fourteen ships, brigs, schooners and sloops cleared Beaufort harbor. The ships were bound for London; Cowes ("the Home of World Yachting") on the Isle of Wight; New Providence in the West Indies; St. Augustine; Charleston; and Georgia. Six, almost half of the ships, carried only ballast, having deposited their cargoes at the pier. The others hauled a variety of livestock (including sheep, hogs, and poultry),

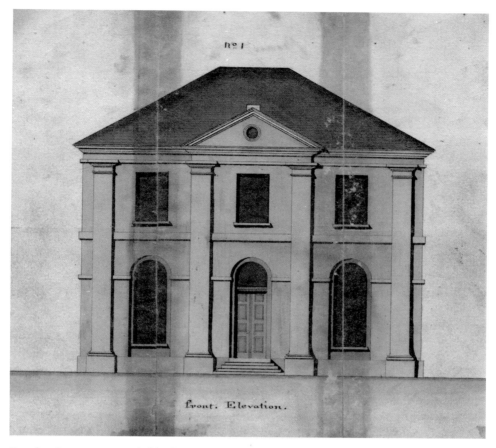

nº 1

Front. Elevation.

Beaufort Court House, probably designed by William Jay c. 1819. Jay, an English-trained architect, maintained offices in Savannah and Charleston before he returned to England in 1823. The South Carolina Board of Public Works employed Jay to design courthouses and other public buildings. *Plans of Buildings, MB 17-7. Courtesy of the South Carolina Department of Archives and History.*

turpentine, cotton, indigo, food crops (corn, potatoes, peas), rice, deerskins and furs. One was bound for Georgia with a cargo of fifty-nine slaves. These port clearances demonstrate that in the years immediately following the Revolution, many of the residents of Beaufort District still clung to such pre-Revolutionary wealth builders as naval stores, indigo, cattle and the animal pelts once derived from the area's thriving Indian trade.

In 1790, the population of Beaufort District was 19,137. Reflecting the region's heavy dependence upon slave labor, the district had 4,343 white and 14,794 black inhabitants. Of the latter number, 153 were free blacks. In 1796, the town of Beaufort had about 200 residents.

After the Revolution, Joseph Cook returned and reestablished the Euhaw Baptist Church. Following Cook's death in 1790, the church called the Reverend Henry Holcombe of Pipe Creek in St. Luke's Parish. Holcombe assumed the ministerial duties for the Euhaw Church and her far-flung missions (arms) at Beaufort, on Hilton Head Island and on St. Helena Island. On 21 November 1795, Holcombe moved to Beaufort and built a small meetinghouse for the congregation there. He enjoyed great success in Beaufort but had difficulties traveling to Euhaw to conduct services. While in Beaufort, Holcombe was president of the Beaufort Society, organized to encourage the study of literature and law. He was also instrumental in the establishment of Beaufort College and served as a trustee.

In 1799, Holcombe moved to a church in Savannah, and the Reverend Joseph B. Cook, son of the earlier minister, became Euhaw's pastor. Cook also chose to live in Beaufort. A revival, which had begun under Holcombe's pastorate in Beaufort, continued under Cook's ministry. Consequently, with the increase in membership, Cook decided to establish a new independent church in Beaufort. Among Cook's converts was Thomas Fuller, whose son Richard would join the Baptist Church during a later revival. According to Fuller, he was baptized on 6 November 1803 in the river with a number of black converts. In his diary, Fuller noted, "This act has caused some estrangement between my friends and myself."

On 8 January 1804, John Rose and Jonathan Witter, on behalf of the Euhaw congregation, gave letters to 154 members including 18 white members and 136 slave members, and also

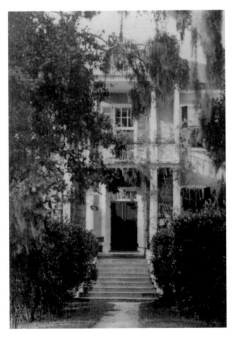

Tabby Manse, 1942. Tabby Manse was the home of Thomas Fuller, who was converted by George Whitefield, and father of Richard Fuller, pastor of the Baptist Church of Beaufort. *Copy photograph, Ned Brown. Local History Collection, No. 2165021. Courtesy of the Beaufort County Library, Beaufort.*

transferred to the new congregation all of Euhaw's property on Port Royal and St. Helena islands. Cook became pastor of the new church that was constituted as The Baptist Church of Beaufort on 27 January 1804. Until after the Civil War, the membership of most, if not all, Beaufort churches was predominantly black.

Between 1790 and 1800, the Presbyterian Church in Beaufort reappeared as an Independent or Congregational Church. On 28 April 1804, Dr. Benjamin M. Palmer was ordained at Beaufort. On 21 December 1804, the South Carolina General Assembly incorporated the Independent Church of Beaufort. At the time of its incorporation, the church had a membership of eighteen white and two black members. By 1806, the church's membership had grown to twenty-four white and six black members.

In 1807, the General Assembly authorized the church to employ a lottery to raise up to $3,800 to be used at the discretion of the congregation. Deacons for the Independent Congregation were Dr. James E. B. Finley and Stephen Lawrence. The wardens were John Benton and Samuel Lawrence. Dr. Finley came to Beaufort in 1803 and opened a school for boys on Bay Street. He also published a mathematical treatise and wrote a poem commemorating the destruction of the barbeque shed during the storm of 1804. Finley gave the keynote address for the dedication of Beaufort College.

Presbyterian Church warden Major Samuel Lawrence was also intendant (or mayor) of Beaufort and an officer with the 1st Battalion, 2nd Regiment of Artillery, South Carolina Militia. In 1813, the church asked to be incorporated as the Presbyterian Church of Beaufort. The General Assembly granted the request. However, with the death of Lawrence in 1815, the Independent Church declined and by 1830 had disappeared from the religious life of Beaufort. The ruins of the Presbyterian Church building, built in 1804, were evident as late as 1879. The Presbyterians also built a chapel where the St. Helena Parish House now stands. The Presbyterian burial ground was there as well.

In April 1796, the Frenchman Duc de La Rochefoucauld-Liancourt visited Beaufort in company with Charleston merchant Robert Pringle. La Rochefoucauld-Liancourt complained about the difficulties in reaching Beaufort by land. According to his account, he found crossing the Broad River to be time consuming, and when once across, more aggravation awaited. As the ferry from the mainland could not carry two carriages and horses at the same time, traversing the river necessitated two trips across a two-mile wide body of water. After the carriages and horses were safely across, the town lay an additional ten miles from the landing. When he finally reached Beaufort, La Rochefoucauld-Liancourt found a town of sixty houses, many of the "handsomest" being built on the waterfront. He marveled at tabby as a building material and lauded the port of Beaufort for having "the most beautiful harbour in all the southern states." He also noted the difficulties in defending such a port and found the existing floating batteries inadequate for the challenge.

The visiting Frenchman also marveled at the area's almost worshipful attachment for the Marquis de Lafayette. Several Beaufort residents advocated extreme measures to free Lafayette from his imprisonment. Lafayette, following the rise of the Jacobin faction during the French Revolution, had fled to Belgium.

There he was captured by Austrians (with whom France was at war) and imprisoned by the Prussians until 1797. La Rochefoucauld-Liancourt found Beaufort a patriotic place with great respect for the Constitution and the president.

La Rochefoucauld-Liancourt's visit provided a Janus-like look at Beaufort before and after the Revolutionary War. The French visitor noted that while between forty and fifty ships visited the harbor annually before the war, only a few did so in 1796. The challenges of overland travel led many to send their products by sea directly to Charles Town. The war and the occupying British had also inhibited Beaufort's shipbuilding industry. For example, James Black, a successful shipbuilder before the Revolution, died during the war. In 1796, one ship was constructed in two or three years—a decrease from four or five ships per year before the war. La Rochefoucauld-Liancourt also noted the shift from indigo production to the planting of sea-island cotton. Four years earlier, the sixty or seventy planters on Port Royal Island had grown indifferent or mediocre indigo. In 1796, all grew cotton. The amount of cotton exported from Beaufort increased exponentially between 1790 and 1820.

With the coming of cotton, Beaufort became, according to historian Edward McCrady, "the wealthiest, most aristocratic and cultivated town of its size in America." To another, the coming of cotton launched the "Periclean Age"—the material, artistic, and intellectual zenith—of Beaufort.

For Beaufort District planters, cotton became king. With cotton came large plantations, an increase in the slave labor force and money. As a result, the planters built the imposing, columned mansions that lined Beaufort's streets. While few indigo growers had town homes, town houses for the cotton planters were de rigeur.

Architecturally, sea-island cotton made Beaufort the town it is today. While a few colonial planters had town houses in Beaufort, the Greek Revival architecture found along the Bay and on the Point reflect the wealth of Beaufort District cotton planters. Barnwell, Fripp and others built brick, frame and occasionally tabby monuments to their achievements. Cotton also was the economic engine that drove a certain way of life, a certain world view among the wealthiest of Beaufort's citizens. Planters competed with one another in the elegance of their homes, the quality of their libraries, the speed of their horses, their piety and their intellectual attainments. The Beaufort planters were literate, well educated and well informed on the news of the day. The sons of the Beaufort planters, after completing a strong preparatory program at home, attended college. Some chose an Ivy League establishment such as Harvard or Yale. Others matriculated at the South Carolina College. Many of these students were graduated

at the head of their classes. Robert W. Barnwell, for example, led his class at Harvard even though Ralph Waldo Emerson was a classmate. Barnwell went on to serve in the United States House of Representatives, as a United States and a Confederate States senator and as president of the South Carolina College, later the University of South Carolina.

This golden age of Beaufort was shaped not just by wealth and accomplishment, but also by spiritual upheaval and the ever-present reality of slavery. The George Whitefield and Daniel Baker revivals changed lives, added dramatically to the membership of Beaufort's churches and produced an unusually large and talented class of ministers. Among them were Stephen Elliott (1806–1888), professor at South Carolina College, Episcopal bishop of Georgia and the preeminent prelate of the Southern Episcopal Church during the Civil War.

In 1786, Beaufort reached another milestone. The South Carolina General Assembly had chartered the Beaufort Society as well as the St. Helena Society for educational and religious purposes. Another, the Beaufort District Society, joined their ranks in 1791. In 1795, the General Assembly chartered these groups as trustees of the Beaufort College. Among the first trustees, in addition to the aforementioned Henry Holcombe, were Stephen Elliott and Henry William DeSaussure. At their inaugural meeting in March 1796, the trustees selected General John Barnwell to be the first president of the college. Given the uncertainties on the national level between the United States and Revolutionary France, the trustees decided to delay construction of a college building. Fearing war and the exposed position of Beaufort, they did not want to risk their resources in an area with so little protection. However, President Barnwell did petition the South Carolina General Assembly in 1797 to clarify the wording of the 1795 act of incorporation. While the original act had given the trustees of the college the right to possess "all the vacant Lots in the Town of Beaufort" for the "benefit of the said College," the act had not established a mechanism whereby the trustees could ascertain which lots in the town were vacant.

Not all residents of Beaufort supported the General Assembly's decision to fund the college through the sale of vacant lots in the town. In 1796, five residents of Beaufort protested the idea alleging that the idea "excited great concern and alarm" and threatened to "involve them in many grievous Lawsuits and perhaps deprive them of property honestly obtained." The petitioners—George Hipp, Henry White, Richard Proctor, John B. Jones and Joachim Hartkins—asked the legislature to delay implementation of the plan. From the petitions and the legislative action, it would appear that the issue of the ownership of unimproved lots continued to plague Beaufort even after the Revolutionary War.

In addition to educational concerns, the citizens of Beaufort continued their efforts to improve transportation and communication—particularly with the mainland. Consequently, in 1796, the South Carolina General Assembly incorporated the Port Republic Bridge Company to establish better access between Port Royal Island and the mainland. The process

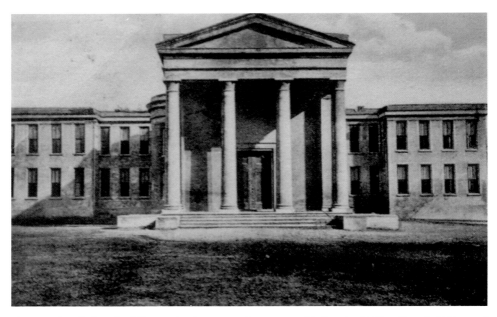

The Beaufort College building, 1911. In 1909, wings were added to the 1852 college building and the facility was used as an elementary school for many years. *Copy photograph, Ned Brown, W. R. Bristol, Beaufort. Local History Collection, No. 2186746, Beaufort County Library, Beaufort.*

was difficult, and not until William Elliott assumed control of the company in 1806 was the project completed. Under Elliott's leadership, the company built two causeways joined by a rope-pulled ferry.

In 1796, the South Carolina General Assembly passed a resolution that required the committee concerned with the streets in the town of Beaufort to "have the said town resurveyed as near the original Plan as possible." The completed survey was to be filed with the secretary of state, and the citizens holding lots in the town were to "be taxed in proportion to the value thereof" in order to pay for the survey.

On 4 November 1802, with great ceremony, the cornerstone for the college building was laid. A procession of interested parties congregated at John Cross's tavern near Bay and West, and marched to the building site. The assemblage included the Masonic lodges of Beaufort and St. Helena, more than a hundred schoolboys, teachers, the Beaufort Library Society, the St. Helena Society, the Beaufort Society, trustees of the college and interested citizens. Dr. [James] E. B. Finley, president of the Library Society, spoke commemorating the event. Two hundred joined the celebration, ate dinner under specially erected tents and, per the minutes of the trustees, "passed the remainder of the day in cheerful festivity."

One component of that festivity might have been the "old barbeque shed" that stood near the college property. The barbeque shed was an eating and drinking establishment enjoyed by Beaufort residents for many years until it was destroyed by a great storm in 1804. The storm featured high winds and high waves that terrorized the Sea Island coastal areas of South Carolina and Georgia. Cherishing the long traditions and convivial memories of the barbeque shed, Dr. James E. B. Finley published a poem about its destruction by the hurricane of 1804 in the *Charleston Courier*.

As originally envisioned, Beaufort College was to have a primary school, a grammar school with a strong preparatory course, and a college with a curriculum that included science, ancient languages, metaphysics, history, law, moral philosophy and theology. The college trustees had high aspirations for the college. However, despite their aspirations, and the college's generous endowment and fine building, by 1812 the school had sunk to the status of a local academy.

In the fall of 1811, the Reverend Martin Luther Hurlbut, a native of Massachusetts, landed in Beaufort. Upon learning of the previous college president's death, Hurlbut applied to be president of the college. After his departure for New Hampshire, the trustees of Beaufort College offered him the position. Hurlbut arrived in March and promptly became embroiled in controversy with the trustees, the parents of his nine- and twelve-year-old pupils, and his brilliant young assistant James Louis Petigru.

He accused the board of mismanagement and such neglect of the college building that, by 1812, the once stately building was "a heap of ruins." Salaries, curriculum and the library were other points of controversy. His conflict with Petigru grew out of the latter's position with the college. Petigru had joined the college staff as assistant in 1810 and had functioned as the interim acting president. He had even entertained aspirations to the position, which Hurlbut's hiring had squelched. Hurlbut and Petigru clashed over discipline, the latter's insubordination and even Petigru's chair. After a serious confrontation, the two discussed their differences, decided to cooperate and developed a long-term friendship. Hurlbut's relations with the parents of his students were rocky as he failed to understand either the fragile economic position of the parents or the type of education they desired for their sons.

Also, Hurlbut did not like Beaufort. He did not like the weather, slavery or the town's politics. He found the weather humid and feared the hurricanes that had afflicted the area in 1813. From his perspective, slavery was an oppressive labor system. Finally, Hurlbut was not enamored with the Jingoist Republicanism of South Carolina's War Hawks. For example, South Carolina's John C. Calhoun supported the United States' declaration of war in 1812.

Nevertheless, the college's academic position improved under Hurlbut's tutelage. The college numbered among its graduates Robert W. Barnwell, later a United States senator and president of South Carolina College, and John A. Stuart, later an editor of the *Charleston Mercury*. In 1814, Hurlbut resigned and moved to Charleston, but not before he had laid a

strong educational base. Hurlbut's successor was Dr. William Brantley, pastor of the Baptist Church and later president of the College of Charleston. William J. Grayson held the position of assistant. This academic renaissance of the college abruptly ended in the year 1817.

The town grew in the decades following the American Revolution and Beaufort was incorporated on 17 December 1803. By 1805, according to the *Charleston Courier*, there were 1,600 persons (944 of whom were black) and 180 students living in 120 houses in Beaufort. Among other amenities, the town boasted thirteen stores, four schools, three churches (St. Helena, the Baptist Church of Beaufort and a Presbyterian congregation), Beaufort College, a boardinghouse, a jail and an arsenal.

In 1809, the South Carolina General Assembly approved new boundaries for the town of Beaufort, as the Beaufort River became the town's eastern and southern boundary. The new boundaries followed a line that began:

[A]*t the south end and on the west side of Hamar street; thence running north on the same side of the said street, until it intersects Boundary street; thence east, on the north side of Boundary street, until it reaches Port Royal river; thence directly east, across the channel of the said river; thence along the eastern and southern side of the said river, until it reaches a point directly south of Hamar street; and thence, directly north to Hamar street.*

An intendant and wardens governed the town of Beaufort. After 1809, by act, they were elected annually on the first Monday in August and served one-year terms.

With this act, the area known as the Point, or Black's Point, was added to the town of Beaufort. The South Carolina General Assembly in 1811 empowered the intendant and wardens of Beaufort to lay out streets there. The act also prescribed a process for assessing damages and compensating property holders through whose lots the streets would run. These streets were given the names of Revolutionary leaders. Hancock Street honored John, president of the Second Continental Congress that ratified the Declaration of Independence. Pinckney Street could have been named for Charles "Constitution Charlie" Pinckney who helped write the United States Constitution, or his cousin and co-signer of the Constitution, Charles Cotesworth Pinckney. Laurens Street again has two options: Henry Laurens, the American diplomat imprisoned in the Tower of London until exchanged for Lord Cornwallis, or his dashing son John Laurens who was killed at Combahee Bluff in August 1782. Hamilton Street probably recognized the contributions of Alexander Hamilton, aide to George Washington and first secretary of the treasury. Hayne Street was named for Isaac Hayne, an American hero, executed by the British in 1781. Hayne Street was later renamed Federal Street.

These acts may have been the legislative response to a long-running battle (one that resurfaced in late twentieth-century Beaufort) about the ownership of the low-water lots,

The Old Point. This view shows the Green, a park that occupied a city block. In the distance is Paul Hamilton's home, the Oaks. *Copy photograph, Ned Brown. Local History Collection, No. 2186134. Courtesy of the Beaufort County Library, Beaufort.*

especially those that lay at the heads of city streets. Or, phrased differently, could the town extend streets to the river's edge, and, if so, what were the rights of the merchants who had built wharves, warehouses and mercantile establishments over the contested areas? It was a contest between public rights, as represented by the Commissioners of Streets for Beaufort and certain concerned citizens, and the inviolability of private property rights. In the more recent case, the City of Beaufort could not prove title to the low-water lots at the end of streets running east to west.

Economic resurgence brought new development on the south side of Bay Street. This activity by merchants such as John Bold, John Rhodes and Francis Saltus raised concerns about access to the river. As early as 1795, in response to a petition of Edward Barnwell, lawmakers enacted legislation, known as the Act of 1795, making it illegal for anyone to improve the low-water lots in Beaufort—especially improvements that would bar public access to the river on lots at the end of two existing north-south streets. Barnwell had alleged that if the owners of the lots in question build upon them, "there will be no public landing in any part of the said town." As a consequence, anyone traveling to the town by water would have to pay wharfage to the owners of the lots in order to land.

Two petitions in 1796 presented the other side of this conflict between public access and private property rights. In 1796, John Bold and John Rhodes of the firm Bold & Rhodes petitioned the South Carolina legislature concerning a low-water lot that measured 120 feet at the front and 202 feet in depth. The situation was complicated because the colony had granted John Gordon title to this particular lot in 1764. The property had since changed hands several times, with no one questioning the validity of the title. In 1796, Bold & Rhodes asked the legislature to "dismiss the application made for an Investigation into the validity of the Grants." Similarly, Francis Saltus complained to the legislature that the Act of 1795, if implemented, threatened buildings that he had already erected on his lot. Specifically, Saltus had built a house and outbuildings on the lot. His lot had also originally been granted in 1764. Saltus asked the legislature to confirm the validity of his grant and "leave him undisturbed in the Quiet enjoyment of his property."

In reply, in 1798, the South Carolina General Assembly enacted an "Act to prevent certain streets in Beaufort from being stopped." So, John Rhodes again sought amelioration from the legislature. He asked to be allowed to complete a casement to protect his wharf as well as retain ownership of the land if he permitted public access and only built wharves and not buildings thereon. The legislative committee submitted a favorable report. Francis Saltus again sought legislative assistance in 1800. Apparently, the 1798 act had specified that owners of affected properties should be compensated for any buildings that had to be removed. However, a clause in the act specified that such payments would be made only after the Commissioners of the Streets for Beaufort had filed suit against the property owner. Saltus had built his kitchen and other supporting structures on the questionable "improved land." This phrase suggests that Saltus had actually filled in part of his low-water lot in order to have more space to build. Saltus in his petition described his improvements on the lots and his concern for the public. While he had built a wharf, he had left a passage that ran between his store and his house from Bay Street to the wharf. Consequently, public access was not impaired. In addition, Saltus pointed out the unfairness of an act that singled out two streets running from Bay Street to the river but did not address other obstructed streets elsewhere in the town of Beaufort.

Consequently in December 1800, the General Assembly repealed the act of 1798 that prevented "certain streets in Beaufort from being obstructed." According to the act, the 1798 legislation unfairly affected citizens who had purchased certain lots on the Bay, had erected houses and wharves on those lots, and who wanted to retain title to their property and not receive arbitrary compensation. The act provided that property owners who wished "to retain their right to lots opposite the streets in the town of Beaufort, and not to receive compensation" had to register their intention in writing to the Commissioners of the Streets for Beaufort. Such owners were then forever forbidden to construct any buildings on the lots or make any "other improvements thereon than wharves, so as to leave the heads of said streets open and unobstructed."

Robert Means, as intendant, again asked the legislature to intervene in the street/river access controversy. In 1821, Means and the Beaufort town wardens asked to have West Street opened to the river by continuing the street through Lots Nos. 6 and 31, and the low-water lots south of them. According to Means, the town had tried to purchase the offending property. But the current proprietory had only a life's interest and the beneficiary of the reversion refused to sell. Opening the street would enable the town to tear down a derelict house on Lot No. 6 that stood in the way of the proposed street path. The house was a nuisance and a fire hazard as it was "inhabited frequently by low white people and Negroes who by their carelessness disturb the Peace of the Neighborhood."

In response to this plea, legislation approved in 1821 specifically called for West Street to be opened to the river. The act also provided that the owners of Lots 31 and 6 that lay in the way of that extension be justly compensated both for the land that the street extension would cover and for any buildings that would have to be removed. Building ceased along the riverfront for several decades.

Post-Revolutionary Beaufort continued to be concerned with the defense of the town. A major component of the town's defense by 1800 was the arsenal. The legislatively appointed commissioners had contracted with Thomas Talbird to build an arsenal and laboratory in Beaufort. As was often the case, and still may be, the funds appropriated were insufficient for the costs of the job, especially the tiling. At the commissioners' insistence, Talbird completed the project with the understanding that he would be paid by the governor from the contingency fund. Governor Edward Rutledge was sympathetic to Talbird's plight, but demurred on making the payment in 1798 as there were "great & urgent demands" on the contingency account that year. The governor assured Talbird that he would be paid from the contingency account for 1799, but the governor died early in 1799; so, in December 1800, Talbird petitioned the General Assembly for the money due him for completing the arsenal.

In 1820, the Beaufort Volunteer Artillery Company was incorporated as the Beaufort Artillery Society. In 1824, the Beaufort Volunteer Guards were similarly incorporated.

In 1817, disaster struck the college and the town of Beaufort. An epidemic of yellow fever, a mosquito-born illness, swept the town. Between June and November, 120 of Beaufort's 600 white residents died, and another 240 were stricken with the fever. William Grayson commented that "[t]he whole village was a hospital." In the face of such suffering and uncertainty, the college closed. Within a few years, the trustees, adjudging the site unhealthy, sold the college buildings.

Yellow fever was a long-standing concern for South Carolinians. For example, between her founding in 1670 and the American Revolution, there were eighteen yellow fever epidemics in South Carolina. In 1739, a virulent outbreak of yellow fever struck Charles Town, killing up to ten persons daily. Such epidemics, apparently, were rare in Beaufort. The town enjoyed

a considerable reputation for the healthiness of her climate. See, for example, the earlier comments of General Prevost during the British occupation about the perceived healthiness of Beaufort.

In 1820, Beaufort College trustees built a new modest facility east of St. Helena rectory. Despite the smaller facility, the trustees invested much time and money to develop a first-rate library. The collection unfortunately was lost with the town library in 1861. Discipline was harsh and abusive in antebellum schools. John Fielding, elected superintendent of the college in 1841, was particularly ruthless. He frequently lashed his students with a buggy whip. The story is told that after Fielding seriously injured a student, the student's brother in turn disciplined the superintendent.

According to Jedediah Morse, a geographer, in 1802, the town of Beaufort had a population of two hundred and only fifty or sixty houses. If Morse were correct, this figure is considerably

Proposed Talbird Wharf, 1859. The ownership of the low-water lots, especially those blocking the river access of major north–south Beaufort streets, was a major concern for post-Revolutionary Beaufort. The issues of who can build on these lots, whether the structures can block the streets' access to the river and whether the street runs to the low-water lot plagued Beaufort throughout the nineteenth and twentieth centuries. Around 1859 Franklin Talbird petitioned to build a wharf at the end of Charles Street. He attached this plat to his petition. The plat illustrates the neap tide line, the regular low-water mark and the extreme low-water mark. Talbird erected a wharf opposite Lot No. 1, and Captain John Murray built another wharf next door opposite Lot No. 2. *Records of the South Carolina General Assembly, Petitions, ND No. 5538. Courtesy of the South Carolina Department of Archives and History.*

less than another visitor's estimate of seventy in 1788. Regardless of the size of the town, Morse was impressed with the hospitable nature of the inhabitants.

Founded in 1802, in 1803 the Beaufort Library Society petitioned the General Assembly for incorporation. The South Carolina General Assembly granted the request in 1807. Petitioning for the society were James E. B. Finley, Robert Screven, Robert Barnwell and Stephen Elliott. When chartered, Elliott was president of the society, and Milton Maxcy was secretary. Among other accomplishments, Elliott wrote a *Sketch of the Botany of South Carolina and Georgia*.

Milton Maxcy was the brother of Dr. Jonathan Maxcy, first president of South Carolina College, now the University of South Carolina, and had originally come to Beaufort as a schoolmaster. By 1819, the Library Society held six hundred books. In 1828, a building at the corner of West and Bay Streets may have housed the library. In 1854, many buildings on the south side of Bay Street burned, but the library books were saved. Scattered in many homes, the society's three thousand books were reunited in 1855 in the Beaufort College building. A new college building had been built on Carteret Street in 1852. The original site on Hamar Street had been sold after the deadly yellow fever epidemic in 1817.

Beaufort's position for commerce and easy access to the sea remained great advantages. These advantages also brought responsibilities. Cognizant of their vulnerability, during the turbulent years of the undeclared war with France and knowing that Great Britain was also preying on American shipping, area cotton planters lobbied the United States government to improve the area's defenses.

As a result, in 1808, Major Alexander McComb of the Army Corps of Engineers evaluated the defensibility of the town and its harbor. McComb commented on Beaufort's "considerable depth of water, sufficient to bring up a sloop of war as far as the town." As a caveat, McComb also noted that a skillful pilot was essential for such a trip as the river was obstructed with shoals. For the immediate defense of the town of Beaufort, McComb recommended that a new fort be built on Mustard Island off Parris Island. Funds were not forthcoming, and Fort Lyttelton was instead renovated. Renamed Fort Marion, the renovation process lasted until 1813. Intermittently garrisoned during the War of 1812, the fort saw no action.

The British blockaded Port Royal Harbor, and in August 1813, British troops landed on St. Helena and Parris islands, terrorizing the residents. Shortly thereafter, a major hurricane struck the area. The British fleet was forced to flee, and one ship was lost. In 1814, the British presence in Georgia, however, offered freedom to slaves who could reach British lines. Reminiscent of the days of the Spanish at St. Augustine, this situation produced fears of slave uprisings and unrest among the white residents of Beaufort and the Sea Islands.

Despite her fears, Beaufort prospered during the War of 1812. Prices and demand for sea-island cotton rose, and the town benefited from the payrolls for the regular army and militia troops stationed at Fort Marion (Fort Lyttelton). Again, that pattern of light and shadow is evident as adversity paid dividends for Beaufort.

With the end of the War of 1812, military interest in Beaufort and the vicinity waned. The harbor was magnificent, but the port's success was limited. For defense, an arsenal with portable cannons was established, and in 1824, the Beaufort Volunteer Artillery—a militia unit originally organized during the American Revolution—was reborn. The militia could roll out the cannons when needed. During the antebellum era, other militia companies were organized in Beaufort District. These companies included the Beaufort Artillery, organized in 1820; the Beaufort District Troop, organized in 1842; the Calhoun Hussars, organized 1834; the Hamilton Guards, organized in 1859; and the St. Helena Mounted Riflemen, organized in 1836. The Beaufort Artillery of 1820 and the Beaufort Volunteer Artillery of 1824 probably are the same unit incorporated under a different name. Both the Beaufort Volunteer Artillery and the St. Helena Mounted Riflemen were active during the Battle of Port Royal in 1861.

In 1814, the South Carolina General Assembly simplified the process for an individual to change his name. Rather than petition the legislature, the individual only had to petition a state court. One of the best-known instances of the use of this law involved the Smith brothers

Beaufort Harbor, 1972. In 1808, Major Alexander McComb noted that Port Royal Harbor was deep enough for a "sloop of war" to sail "as far as the town." Being so accessible to deep water was a two-edged sword for early Beaufort. The river and harbor made the site desirable for settlement but also made it strategically difficult to protect. *Courtesy of Ned Brown, photographer.*

of Beaufort who petitioned to change their surnames to Rhett. Robert Barnwell Rhett, a descendant, served in the United States House of Representatives and was known as the "Father of Secession." In 1844, at a dinner there, Rhett inaugurated the Bluffton movement, urging South Carolina to call a convention on the tariff.

The town of Beaufort's post-Revolutionary recovery hit a snag in 1816. The first steamship traversed the Savannah River that year. On 13 December 1817, the first steamboat—the SS *Charleston*—traveled from Charleston to Beaufort. The following day, the ship left for Savannah. The arrival of the steamboat changed Beaufort, according to S. G. W. Benjamin, "from a bustling sea-port to a quiet,...aristocratic retreat." The steamships regularly traveled between Charleston, Beaufort, Savannah and Augusta, Georgia. With improved access to Charleston, that port was more convenient for Beaufort-area planters to sell their crops and purchase needed materials there. The commercial scene changed for the town of Beaufort, but its connectedness with the outside world increased. Steamboat travel became more efficient and quicker in the years leading up to the Civil War. According to Lawrence Rowland, Dr. Henry W. Lubbock, son-in-law of Captain Francis Saltus, was the best known of Beaufort's early steamboat captains.

PRESIDENT MONROE'S VISIT

Between 6 and 8 May in 1819, President James Monroe visited Beaufort. Monroe was en route to view the territories of East and West Florida acquired from Spain by the Adams-Onis Treaty. Just as the inhabitants of Columbia had ridden out to welcome George Washington in 1791, Beaufort's citizens rode out on horseback to welcome Monroe as he passed onto Port Royal Island. Members of the president's entourage included Secretary of War John C. Calhoun and Monroe's private secretary, Samuel L. Gouvernour.

During his visit, Monroe addressed the residents of Beaufort, inspected Fort Marion (previously, Fort Lyttelton) and attended several receptions, including one at Beaufort College. Everywhere, the president met hospitality and love. Dr. Richard Screven, who represented Saint Luke's Parish in the South Carolina Senate, organized the festivities and gave the welcoming address. In his remarks, Screven echoed two often repeated themes—the value of Beaufort's port and harbor both to South Carolina and to her enemies, and the healthfulness of her climate. He also provided the president and his party with breakfast on 8 May. Following breakfast, in a large canoe furnished by the town, Monroe and company left for Savannah by way of Pinckney Island, where they visited with General Charles Cotesworth Pinckney.

In 1819, Beaufort still reveled in the euphoria of the Era of Good Feelings. Following the end of the War of 1812, there was a period of great nationalism and faith in America's future. Beaufort commemorated the Fourth of July that year with much jollity, many festivities and

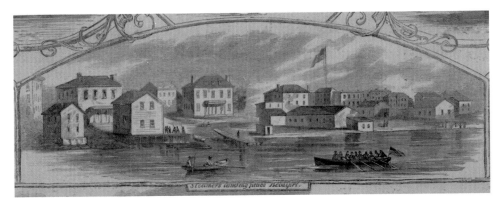

The Steamship Landing. Steamships were a major source of supplies for Beaufort, and carried passengers between Beaufort and Charleston as well as between Beaufort and Savannah. *Harper's Weekly, 14 December 1861. Courtesy of the author.*

thirty-one toasts. William Elliott presided over the affair. The toasts honored, among other patriotic offerings, the United States Constitution, American liberty, President James Monroe, former President George Washington and perhaps most ironically "the Federal Union—May it receive daily strength by an increasing unanimity of sentiment and feeling."

In the 1820s, Robert Mills noted Beaufort's location and her reputation for hospitality. The town, he wrote, was "regularly laid out in squares, some of which are handsomely improved." At fourteen miles (other sources say sixteen) from the sea, Mills commented on the town's "natural advantages for commerce" and the possibility of developing a naval station there.

In 1821, R. Means, intendant of the town, petitioned the South Carolina General Assembly on behalf of himself and the town wardens for an amendment to the town's charter. The town needed additional revenue and wanted to be able to add a new tax on carriages. According to her charter, Beaufort could tax only slaves and houses. The town's leaders argued "that a Tax on luxuries is more expedient than on the necessaries of Life" and that if carriages were taxed, the wealthiest residents would be the ones paying the tax. Despite the argument that houses and slaves were necessities and carriages luxuries (and thereby taxable), the General Assembly rejected the request.

The year 1825 was an exciting one for the town of Beaufort. Two Revolutionary heroes visited. One, Mason Locke "Parson" Weems died at Beaufort in 1825. Weems, once a pastor in Alexandria, Virginia, styled himself George Washington's chaplain. He published didactic pamphlets that he sold during his itinerant travels throughout the South. He is perhaps best known for his biography of George Washington that included the famous "I cannot tell a lie" tale of young George and the cherry tree. Ill and destitute, he landed in Beaufort where the

John Mark Verdier (Lafayette) House, Bay Street, 1940. The Verdier house built by Beaufort merchant John Mark Verdier was reputedly the scene of Lafayette's speech during his visit to Beaufort in 1825. *South Carolina National Register of Historic Sites, Beaufort County. Courtesy of the South Carolina State Historic Preservation Office, South Carolina Department of Archives and History.*

Reverend Benjamin S. Screven, a Baptist minister, and his wife cared for him until his death. Originally buried in Beaufort, his body was later moved.

LAFAYETTE ARRIVES

Another Revolutionary hero, Marie Joseph Paul Yves Roche Gilbert du Motier, the Marquis de Lafayette, paid a visit that Beaufort has never forgotten. Accompanied by his son, George Washington Lafayette, the elder Lafayette (1757–1834) and the rest of his party traveled through the South in 1825.

Journeying by steamboat from Charles Town to Savannah, Lafayette arrived at Beaufort about 10:30 p.m. on 18 March. Beaufort dignitaries—including Dr. James Stuart, John A. Stuart and Richard deTreville—as well as the Beaufort Artillery and Volunteer Guard greeted him. As his ship approached the town, a thirteen-gun salute was heard. A procession of carriages with martial music carried Lafayette and the other visitors, flanked by the Beaufort Volunteer

Artillery and attended by the St. Luke's Troop of Cavalry, through a specially illuminated arch to the home of John Mark Verdier on Bay Street. Beaufort Intendant William Elliott and other notables officially welcomed the general. Elliott was also the author of the celebrated *Carolina Sports by Land and Water* published in 1850. After a visit of three hours, the Lafayette party continued on its way to Savannah.

Chapter 6

Antebellum Beaufort, 1830–1860

Looking back, Lafayette's visit has the bittersweet quality of a military furlough. His visit coincided with the height of Beaufort's patriotic fervor. The Era of Good Feelings was poised to wreck on the shoals of sectionalism. The shadows again appear in different hues.

Nullification

In 1828, as the nullification crisis heated up, William J. Grayson and John A. Stuart founded Beaufort's first newspaper the *Beaufort Gazette*. During this crisis, South Carolina voted in convention not to enforce certain federal laws. Also in 1828 two South Carolinians took office. Waxhaw native Andrew Jackson was elected president and John C. Calhoun of Abbeville, vice president. Calhoun secretly penned the *Exposition and Protest* that argued that the protective tariff was unconstitutional. The South Carolina legislature adopted the document in December. Grayson helped organize the South Carolina States' Rights and Free Trade Party to protest federal tariff policies. In November 1832, the Nullification Convention met in Columbia and on 24 November adopted the Ordinance of Nullification that declared the tariffs of 1828 and 1832 "null and void." In 1833, the United States Congress enacted the compromise tariff of 1833 and the Force Bill that gave President Jackson the power to use force against South Carolina if necessary. On 15 March, South Carolina repealed the Ordinance of Nullification. When the crisis abated in 1833, the newspaper closed. Nullification was South Carolina's rehearsal for secession.

Revival

Although John Wesley had visited Beaufort and traveled in South Carolina, Methodism did not make significant inroads in South Carolina until after the American Revolution. In 1830, the

preaching of the Reverend Daniel Baker, a Presbyterian minister of Savannah, triggered a revival in Beaufort. From that revival, the Beaufort Methodist mission grew. Similar revivals swept the United States in a movement known as the Second Great Awakening.

In 1832, George W. Moore was charged with the Methodist Mission South of Charleston. The Mission South of Charleston included the Beaufort, Combahee and Pon Pon missions. In 1833, Moore was appointed to the Beaufort Islands. John R. Coburn had the Beaufort and the islands appointment in 1834 and 1835. In 1836, T. E. Ledbetter joined Coburn with the mission. In 1837, Ledbetter and Alex W. Walker were appointed to the Beaufort mission. The mission—targeting the slaves of St. Helena and adjoining parishes—prospered during the 1830s. The 1830s, however, were difficult times for Methodism in South Carolina. The Methodists were split between Whigs and Democrats, and lost membership due to the nullification controversy.

Daniel Baker was pastor of the Presbyterian Church in Savannah. In 1830, he held a series of revival meetings in Gillisonville and Bluffton. William Barnwell, a Beaufort lawyer, was converted at the Gillisonville meeting and entered the ministry. Barnwell's account of Baker's eloquence induced the Reverend Joseph Walker of St. Helena to invite him to preach in Beaufort. As there was no Presbyterian Church in Beaufort, Baker alternately preached at St. Helena and the Baptist Church of Beaufort. According to Baker, he normally preached three times a day.

The results were spectacular. According to Moore, the evangelical fervor was so great that "the stores were closed and business in the town suspended." The Episcopal bishop confirmed seventy new members at St. Helena's, and a similar number united with the Baptist Church of Beaufort. Many young men were converted, and eleven of them entered the ministry. Among those whose lives Baker changed from the parish of St. Helena were the Reverend William H. W. Barnwell, Robert Barnwell, Joseph Thomas Robert, the Reverend C. C. Pinckney, the Reverend Stephen Elliott Jr., William Johnson and the Reverend B. C. Webb. Richard Fuller, pastor of the Baptist Church of Beaufort, was another convert. Later, others joined this sacred assembly: James Elliott, another Stephen Elliott and Thomas Fuller Jr. A number of these men became ministers or missionaries to the slaves.

George W. Moore began his preaching in Beaufort at the Tabernacle, a Baptist facility. Meeting with success in Beaufort, the Methodists extended their outreach to the neighboring islands and the mainland. As Moore encouraged his converts to unite with a church of their own choosing, more than two hundred joined the Baptist Church. In 1840, the Reverend A. M. Chreitzberg joined the Reverend Thomas E. Ledbetter in Beaufort to preach to the slaves in Beaufort and on the surrounding islands.

The 1840s were a time of great spiritual growth in Beaufort. As a result, St. Helena Parish Church laid the cornerstone for an addition in 1841. The church grew greatly between 1831

and 1850. Also, Richard Fuller, converted in 1832 under the preaching of the Reverend Baker, united with the Baptist Church of Beaufort and shortly thereafter became pastor of the small congregation. During his fifteen years as pastor, he oversaw the construction of a new church building at the corner of Charles and King Streets, and organized outreach missions to the slaves. An eloquent and renowned preacher, Fuller left Beaufort in 1847 and became pastor of the Seventh Baptist Church of Baltimore, Maryland.

The Beaufort churches were biracial. In many, the white members sat downstairs and the black ones worshipped from the balcony. At the Baptist Church of Beaufort, the slave members could enter the balcony directly from two doors on either side of the front door. Discipline of church members in the Christian churches was a sensitive issue. Major points of concern included who was the final arbiter for allegations involving black members, what was the appropriate role for black lay leaders and how could Christians disciplining each other in faith avoid becoming slave owners policing their slaves.

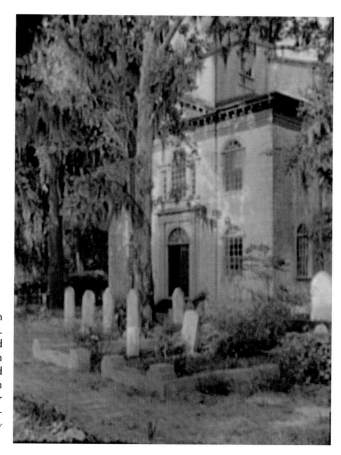

St. Helena Parish Church with gravestones, 17 April 1935. Among the notables buried in the churchyard are John "Tuscarora Jack" Barnwell and Brigadier General Stephen Elliott. *Gottscho-Schleisner Inc., photographer. LC-G623-23943. Courtesy of the Library of Congress.*

These were complicated issues, and the treatment of some altered over time in antebellum Beaufort. During the great revival of 1831–1832, not only were the residents of Beaufort affected by the evangelistic fervor, but also the black inhabitants of the islands. Slave owners' heightened awareness of their spirituality led many of them to seek religious instruction for their slaves. Some worked with the Methodist missions to the slaves and others reached out through such Beaufort churches as St. Helena Parish and the Baptist Church of Beaufort to include the converted slaves as members. Consequently, at the time of the Civil War, these churches had huge black majorities.

With more than three thousand black members and fewer than two hundred white ones, a church like the Baptist Church of Beaufort faced a major discipline dilemma. When the church had reached out and added the island slaves to her membership, she had attempted to downplay the role of their existing black religious societies. Church leaders feared that African practices had contaminated the societies' religious practices. However, facing the monumental task of so few to monitor the lives of so many, the Baptist Church reconsidered its position. According to historian Janet Duitsman Cornelius, the Baptist Church began to use the black

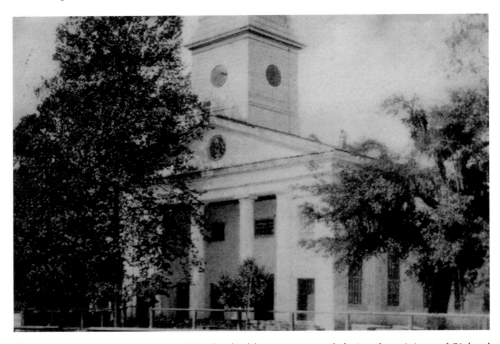

The Baptist Church of Beaufort, 1906. This building was erected during the ministry of Richard Fuller, later the pastor of the Seventh Baptist Church of Baltimore, Maryland. Remnants of the foundation of an earlier building may be seen in the church cemetery. *Copy photograph, Ned Brown, The Rotograph Company, New York City. Local History Collection, No. 2186365. Courtesy of the Beaufort County Library, Beaufort.*

religious societies as the primary contact point for the discipline of her black members. In the 1830s, the black leaders of these societies reported monthly to the church the infractions of their members. In the 1840s, the church attempted to exert more control over the societies by appointing white overseers. By the 1850s, the church had thirty-five hundred black members, and the black "watchmen" had expanded their positions; they not only oversaw the health of their societies, but they also held worship services and conducted mission outreach.

These discipline societies, therefore, exercised conflicting roles within the slave community. On one hand, the societies were avenues for their leaders and members to achieve a degree of autonomy, but on the other hand, white members used the discipline function of the church to enforce plantation norms excommunicating or suspending slaves for theft of goods or stealing themselves by running away. The bulk of the discipline cases, however, placed the system at odds with plantation management. A specific example was church discipline of slaves for sexual offenses related to marriage and family issues. The sticking point was that slave owners did not, as a group, recognize slave marriages. Thus, the slave owners were often the ones who violated the marital relations of their slaves either by selling family members or by denying spousal visits to neighboring plantations. So, it was somewhat hypocritical to discipline the slave for resulting immoral behavior. On the issue of undergirding slave marriages, the church's standards conflicted with the established norms of a slave-holding society.

Some missionaries and ministers advocated church-sanctioned slave weddings. Other ministers, such as Richard Fuller of the Baptist Church, contended that slaves should not be sold.

Archaeological exploration in 2004 of a Bay Street privy offered insight into the daily lives of the planters of Beaufort. Archaeologists Chester DePratter and James Legg of the South Carolina Institute of Archaeology and Anthropology estimated that the privy was constructed after 1805 and covered by 1840. From their preliminary investigations, Beaufort's elite ate chicken, oysters, and turtle; drank beer; and played dominoes.

SLAVE LIFE

In the 1940s, under the auspices of the Works Progress Administration, interviewers talked with black residents about their memories of slavery and its aftermath. Several of these interviews pertain to the daily life of Beaufort's slaves. For example, Rebecca Jane Grant remembered that as an eight-year-old, her duties included polishing brass and scrubbing floors. A particularly poignant recollection illustrated both the slave owner's obsession with maintaining the chasm between slave and free, and the perilous life of the slave. Grant's mistress sent her as a child to Wilcox's store to pick up a package. Upon her return, her mistress unwrapped a rawhide strip and beat the child. What offense triggered this response? The child had not been properly deferential to her three- or four-year-old master. She had not called the toddler "Master" Henry.

Born in the country, Grant came to Beaufort when Robert Oswald bought her mother Sarah and Sarah's four, soon to be five, children. In 1860, Oswald was a thirty-two-year-old planter who owned 24 slaves. Tom Willingham, another slave master, owned her father; so, the sale separated the family. Grant lived in Beaufort until she was fifteen. With freedom, her family was reunited near Lawtonville.

Grant described the life of a slave child. Slaves too old to work would watch the young children on the street where the slave houses were. The children ate peas or hoecakes off the ground. Sometimes, even at young ages, they worked shooing birds from the crops.

Moving to Beaufort was a traumatic event for Sarah and her children. Her experience not only illustrates the economic difficulties of maintaining a family under slavery but also the commercial opportunities a slave had in the town to hire out her time. An accomplished laundress, she worked during the day for her mistress washing and ironing, and then freelanced for other white clients in the evenings.

Concerning education, Grant contended that only prized craftsmen, such as bricklayers or seamstresses, were educated. Religious education, however, was stressed because, according to Grant, owners wanted their slaves to work as faithfully for them as for

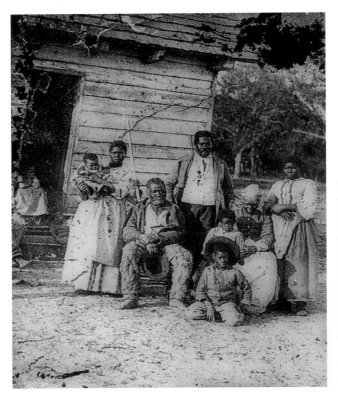

Five generations of former slaves at the John Joyner Smith Plantation, near Beaufort, 1862. In 1860, Smith owned more than 100 slaves. His plantation, Old Fort, was the site of a school for the freedmen, of the reading of the Emancipation Proclamation and of the presentation of colors to the First South Carolina Regiment.
Timothy O'Sullivan, photographer. LC-B171-152-A. Courtesy of the Library of Congress.

God. Despite the religious instruction, in Grant's memory, only the craftsmen and house servants, not field hands, attended church. Instead, black exhorters preached for the field hands and then reported the results of the service to his owner. Grant's master held Sunday school on the plantation house porch on Sunday evenings.

Chlotilde Martin interviewed Lucretia Heyward, another former slave. Heyward was born in Beaufort. Her father was Tony MacKnight who belonged to Stephen Elliott, and her mother was Venus MacKnight who belonged to Joe Eddings on Parris Island. Eddings sold Heyward's mother to Edward Blunt, an overseer who had saved enough money to buy a slave. Perhaps, Heyward's Blunt was Edward A. Blunt, aged fifty-four, a landless planter with $16,200 worth of personal property. Slaves were classified as personal property.

Dependencies behind the Berners Barnwell Sams House, 201 Laurens Street. Before the Civil War, the dependencies included the servants quarters, a laundry, kitchen and other support services. *HABS, SC,7-BEAUF,27A-3. Courtesy of the Library of Congress.*

Heyward, her mother and her siblings lived next door to the Baptist Church. As a child, she polished silver, did housework and studied to be a seamstress. She slept on the floor of Blunt's sister's room and ate leftover food. She and the Blunts attended the Baptist Church where Heyward sat upstairs and her owners, down.

Heyward remembered that slaves were disciplined for fighting or not working. For certain offenses, slaves were sent to the jail in Beaufort, and Mr. McGraw would whip them. Heyward was jailed once; hanged by her wrists and whipped twenty-five times. Following the Union victory, her master fled Beaufort, and she went to Parris Island. Eventually, Heyward returned to Beaufort and worked in one of the cotton gins. She saved the money she earned and bought land on Parris Island that she lost when the United States acquired the island as a naval station.

Slaves were not only jailed and punished in the Beaufort workhouse, but they were also sold. Several of the former slaves interviewed had heard or seen the banjo table, a portable platform on which the slave would stand to be examined during the sale.

ANTEBELLUM BEAUFORT

In 1833, Henry Barnard of New England visited Beaufort. He encountered the charm of Beaufort. He wrote: "Beaufort is a beautiful place—very quiet,—no commercial business going on here—but planters whose estates lie among the islands—the famous Sea Island cotton plantations"—had homes there. Barnard considered Beaufort District the wealthiest area in

Prison and slave market, Craven Street. *No. 10323.25. Courtesy of the South Caroliniana Library, University of South Carolina.*

the United States, if the large cities were excluded from the calculations. From his perspective, however, even the wealthiest planters complained of "hard times." That sentiment has a modern ring.

In 1836, the South Carolina General Assembly enacted legislation to move the courthouse and jail for Beaufort District from Coosawhatchie to Gillisonville. Gillisonville was considered a healthier choice. Work on the new courthouse began in 1839, and the completed building was ready for the December term of court in 1840.

Charles Lyell, an English geologist, toured the Beaufort area during his 1845 visit to America. Approaching Beaufort, Lyell marveled at the "novel and curious scene" of marsh and water. He found the town of Beaufort "picturesque" with her broad verandahs, live oaks and orange trees. He compared the oysters that were attached to the wooden dock with the barnacles he had seen in England's ports.

On 22 October 1845, another Beaufort resident wrote a very different letter. Isaac Step wrote his master from Beaufort. He reported upon the rice harvest at the Pon Pon plantation, and the potato and corn crops, praised the overseer there and lamented the drought-damaged cotton crop. Step had not sent his master's ship to Charleston due to the outbreak of yellow fever there. Step apparently enjoyed his master's confidence and exercised considerable discretion. He continued in his letter to report on his master's parents or in-laws who lived in Beaufort, and lamented that his master's children were not in Beaufort to enjoy the dinners and tea parties! This is a remarkable piece of correspondence. First, the responsibilities of

Orange Tree, 2808 Bay Street, c. 1959. Explorers and visitors were entranced by the semitropical climate of Beaufort. In 1845, Charles Lyell noted with wonder the orange trees growing in Beaufort. *Courtesy of George A. and Evelyn Jones.*

Step are varied and indicative of considerable latitude for independent action. Second, Step's literacy is unusual as South Carolina enacted legislation in 1834 making it a crime to teach a slave to read and write.

Step's letter, however, also illustrates the normal food crops raised on a cotton plantation—corn and potatoes. Other vegetables were grown in gardens, but corn and potatoes were the sustenance crops for man, beast and the market. The 1840s were a time of increasing dependence upon the cultivation of sea-island cotton. The surging price of the cotton buoyed many planters into a life of wealth and leisure. Others, however, languished as economic also-rans. Men such as Thomas B. Chaplin never achieved the success of the Fripps, Fullers, Barnwells, Jenkinses and others.

In 1846, Irish immigrant Michael O'Conner built St. Peter the Apostle Roman Catholic Church on Carteret Street. Finding no church when he arrived in 1822, O'Conner arranged for a priest to travel periodically from Charleston to hold Mass. In 1850, O'Conner, a native of Ireland, was a successful storekeeper in the town of Beaufort and owned $16,000 worth of real estate. Father James J. O'Connell was the first priest for the new church. Catholic work enjoyed a number of successful decades in the Beaufort area until the 1890s. Then—as a result of the economic dislocation caused by the hurricane of 1893, specifically the damage to the phosphate mining industry—the church entered mission status. Many of the church's communicants had been involved with the industry. In 1923, St. Peter's Catholic Church was reestablished with a resident priest. The influx of men associated with the activation and expansion of military training in the area created an increased demand for Catholic services.

During the 1850s, Beaufort saw a great construction boom. Her economy was soaring, and business was good. On the public side, Beaufort College and Beaufort Arsenal were completed. On the private front, her planters flaunted their wealth. They either added to their homes or built equally inspiring new ones. Among other structures dating from this period are Tidalholm (Edgar Fripp), the Oaks (Paul Hamilton) and the Castle (Dr. Joseph Johnson). Construction led to internal improvements. Intendant Edmund Rhett had the streets of Beaufort overlaid with seashells. In 1853, Rhett developed the Port Royal Road Company. That company acquired the Port Royal Ferry and created the Shell Road by lining the stretch of road between the ferry and Beaufort with seashells. The twelve-mile straightaway also made a fine racetrack.

The 1850s were not only a time of building but also a time of political dissension. Beaufort County's planters not only made money and built magnificent mansions in Beaufort, but they also continued to lead the state and perhaps the South in promoting secession. In 1851, The Beaufort Southern Rights Association, reflecting the views of Robert W. Barnwell, issued a statement of principle that left little room for negotiation. The association declared that the residents of Beaufort County considered "domestic slavery" to be "the great safeguard of

The interior of St. Peter's Catholic Church, 1966. Acolytes are (from left to right) Tommy DaCastro, Jim Miller and Ronny DaCastro. Father Ronald Anderson presiding. Under the leadership of Michael O'Conner, Catholics built St. Peter's in 1845. *Ned Brown, photographer. Courtesy of George A. and Evelyn Jones.*

political freedom," and that consequently, it was "the solemn duty of the Southern States...to unite in a slaveholding confederacy, maintaining as a fundamental principle, the perpetual recognition of that institution [slavery]." Despite Barnwell's best efforts, neither South Carolina nor the other Southern states were interested in secession in 1851.

In 1852, the Beaufort College trustees launched two initiatives. First, the trustees acquired a new site and built a new building to house the college. Major John Gibbes Barnwell designed and built the Greek Revival structure. Second, that same year, the college trustees asked the South Carolina General Assembly to incorporate the Beaufort Female Seminary in order to educate the young women of Beaufort. The female seminary opened south of St. Helena Parish Church.

In the 1850s residents of Beaufort District were caught up in the free-soil controversy engendered by the popular sovereignty, or "local option," clause of the Compromise of 1850. The South Carolina Bloodhounds, an armed company from Beaufort District, aided pro-slavery forces in Kansas. In 1856, the company participated in the pro-slavery raid of Lawrence, Kansas, the free-soil capital. Members of the company raised a Palmetto flag over the Free Soil Hotel.

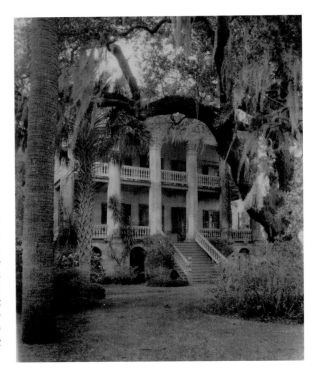

Joseph Johnson House (also known as Johnson-Danner or the Castle), 1970. Located at 411 Craven Street, Dr. Joseph Johnson built the house c. 1850 as a monument to Beaufort's golden age. South Carolina National Register of Historic Sites, Beaufort County, *Courtesy of the South Carolina State Historic Preservation Office, South Carolina Department of Archives and History.*

During the 1850s, Beaufort real estate increased in value. Captain George Parsons Elliott tried to sell his house at 1001 Bay for $11,000. The Reverend Charles Edward Leverett, his neighbor at 1301 Bay Street, did not think he would find a purchaser at that price, and since Elliott did not attend church, Leverett did not think he *should* find one. Leverett served as assistant rector for St. Helena Parish Church from 1856 until the evacuation of Beaufort in 1861.

In 1850, Beaufort boasted a number of educational opportunities. These included Beaufort College, a grammar school, a common school, three female schools, and one female academy. A common school was a public school and received public funding. Students paid tuition to attend a church-sponsored or other private school. A total of 196 students were enrolled. Beaufort had a weekly newspaper, the *Palmetto Post*, and ten churches (two Baptist, two Episcopal, one Methodist, one Catholic, two African Baptist, one African Episcopal and one African Methodist).

A high point of the 1850s was the visit of Captain David Farragut. Farragut commanded the SS *Brooklyn*. The citizens of Beaufort feted the naval officer and Farragut entertained the citizenry onboard his ship.

Yet, for the fiscal year ending 30 June 1850, the town of Beaufort reported little business activity. Only a few artisans had shops in the town. Beaufort had two bakeries operated by E.J. Durban and the Scot Thomas McMillan; a blacksmith, Joseph T. Barnett; and a German-born shoemaker named Charles Shultze. These were small establishments, and each employed only

between two and four individuals. Only the bakeries employed both men and women. The average monthly wage for a female employee ranged from $7 to $16, and for a male employee, $21 to $50. Some employees may have been slaves. Barnett had a white apprentice blacksmith named Andrew Farris in his household. Living in town were other independent craftsmen, such as Franklin Talbird, a bricklayer; a French gardener named Rene Roefandean; Robert Admas, a butcher; William E. Albergotti, a carpenter; William Howley, hemp maker; Peter Peterman (another German emigrant), cooper; and Thomas Gardner, a wheelwright. In addition, there were a number of shopkeepers as well as several physicians, lawyers, and ministers. Maria Cook, born in Scotland, was the lone midwife, and Samuel Catherwood, the druggist.

Beaufort on 1 July 1850 was a cosmopolitan small town. The planters were in residence. The requisite support systems were in place. But as a seaport, Beaufort's true cosmopolitan nature was seen in the ethnic diversity of her residents. In addition to Scots, Germans, and French, there were Irish, English, a Dane, and several born in the East and West Indies. Beaufort's connection with the sea is also seen in such residents as the Irish-born sea captain A. S. Cardwell and his family. The residents of Susan Morcock's boardinghouse offer a snapshot of those visiting, the temporarily employed, and those unable to afford or find housing in Beaufort. In addition to two young planters and their families, the Morcock boarders included John Cooper, a dentist; three teachers from New York, Salome Hafgood, Sarah Hafgood and Ann Terrell; several students; and the pièce de résistance, an Alabama-born portrait painter named J. A. Jackson. Morcock's husband was William A. Morcock, a planter. Morcock had the franchise to operate the White Hall Ferry that connected Beaufort with Lady's Island. He owned the land on the Beaufort side of the river where the ferry docked.

Ruth Jones managed the Beaufort Female Asylum (an orphanage) in 1850. Among her charges were S. A. Perryclear, L. Perryclear, Eliza Clark, Charlotte Stoman, Jane Reed, Sarah Reed, Adeline Buckner, Amanda Buckner, Georgina Ironmonger, Emma Ironmonger, Emily Taylor, Julia Taylor, Mary Masters and Sarah Stowman. On 29 November 1815, a number of Beaufort residents had petitioned the South Carolina General Assembly to incorporate the Beaufort Female Benevolent Society. The society was designed to provide "for relief of distressed and destitute female children." Incorporated in 1815, the society's charter was renewed several times, and the society continued its work throughout the antebellum period. The original petitioners were Margaret McKee, Elizabeth Fuller, Ann Barnwell, Mary Barnwell, Ann Cuthbert, Mary Stuart, Catharine Anna Campbell, Ann Stewart, Ann Brantley, Mary Means, Mary Fraser, Eliza M. Fripp, Ann Farmer and E. L. Bedon. In 1837, the legislature incorporated, at the request of Richard Fuller, a similar society for young men, but the census schedules reveal no group home managed by the society.

The 1850 population schedule lists thirteen free black persons living in the town of Beaufort: Will Phoenix, the Beaubien family (Jane, Mary, Matilda, George and William), Will

Phoenix Junior, Dora Blue, Sarah Houston, Phillip Ezekiel, John Houston, Doncin Houston and Ann Ezekiel. Beaufort's free blacks were artisans and craftsmen. Will Phoenix Junior was a carpenter. Sarah Houston was a pastry cook. Phillip Ezekiel, a future South Carolina state legislator, was a tailor, and Ann Ezekiel, a dressmaker. Two of the women, Dora Blue and Jane Beaubien, were laundresses.

In 1851, Richard Fuller, a Beaufort native and former pastor of the Baptist Church of Beaufort, proposed a radical solution to the race problem. Speaking to the American Colonization Society on its thirty-fifth anniversary, Fuller proposed massive repatriation of slaves to Africa, emancipation for all who would emigrate and compensation to their owners. Fuller's change of heart on the issue was surprising, as he had been a longtime supporter of slavery and, in 1844, had participated in a national debate on the subject with Francis Wayland. The fear of civil war had ameliorated Fuller's position. In Beaufort, Fuller's ideas were wholeheartedly rejected. Fuller became persona non grata to his former Beaufort congregation.

In 1852, as part of the town's economic upswing, banking came to Bay Street as Beaufort acquired the Beaufort Loan and Building Association. Among the new bank's trustees were John M. Baker; Thomas O. Barnwell; A. McNeir Cunningham, a planter born in Ireland; E. J. Durban; John A. Johnson; William B. Means; Edmund Rhett, a surveyor and planter born in North Carolina; and David L. Thompson.

In 1854, Beaufort resident and Southern apologist William J. Grayson (1788–1863) published his famous pro-slavery poem, "The Hireling and the Slave." The poem compared the desperate life of the Northern worker ("the hireling") with the secure existence of the Southern slave. According to Grayson, the hireling toiled "in doubt and fear, for food and clothing, all the weary year," while the slave "[s]afe from harassing doubts and annual fears,...dreads no famine, in unfruitful years." Grayson, a man of letters, was converted in 1832 during the preaching of the Reverend Daniel Baker. He edited the *Beaufort Gazette* and served in both the South Carolina House of Representatives and the United States Congress. Grayson was also an agriculturalist and unsuccessfully advocated crop diversification to the Sea Island planters. Reflecting upon his lifetime in Beaufort, as he composed his autobiography, Grayson identified what, to him, was Beaufort's most unusual quality—"the conservative property of standing still."

During 1858, the slave missions that had grown out of Beaufort's 1830s revival—part of the Second Great Awakening in the South—in turn were part of another great revival that swept the United States and the South: the Great Prayer Revival. This movement reaped great numbers of converts among the slaves. Hundreds, for example, joined the Presbyterian, Episcopal and Baptist churches. Both the Beaufort and Huspah Baptist churches saw great increases in slave membership in the period from 1858 to 1859.

Sea-island cotton, with its silky, unusually long fibers, seduced many Beaufort planters and made them rich—rich enough to build elaborate townhouses to escape the sickly island

The officers of the Women's Missionary Union, Baptist Church of Beaufort, 1962. From left to right are Hazel Williams, Ganelle Polk, Margaret Tuten, Mrs. Adam Powell, Elise Youmans, Evelyn Jones and Dru Graves. *Courtesy of George A. and Evelyn Jones.*

summers. The upper echelon of planters owned a hundred or more slaves. Professor Chalmers Davidson studied this elite sector of South Carolina planters in *The Last Foray*. Several of the planters covered by Davidson had, in addition to their plantations, townhouses in Beaufort. Some even had residences in other areas as well. Eleven of the planters studied lived, at least part of the year, in Beaufort. Beaufort was a summer haven with a rich social life.

The crème de la crème of Beaufort society were Colonel Robert Woodward, the Reverend Stephen Elliott, William Elliott, Edgar Fripp, Captain John Fripp, William Fripp, Dr. Thomas Fuller, Dr. William J. Jenkins, Henry McKee, Richard Reynolds and John Joyner Smith. All except one, William Fripp, were communicants of St. Helena Parish Church. Most were formally educated. Two attended medical school—one (Dr. Thomas Fuller) in Pennsylvania, and the other (Dr. William J. Jenkins) in Charleston. Three (Robert W. Barnwell, Stephen Elliott and William Elliott) were graduates of Harvard, and two (Henry McKee and Richard Reynolds) were graduates of the Partridge Academy in Connecticut.

While the town of Beaufort planters owned on average 188 slaves, holdings ranged from Henry McKee with 108 through Dr. Thomas Fuller who owned 362. McKee may have owned the lowest number of slaves, but he owned one—Robert Smalls—who would play an influential role in the history of Beaufort and South Carolina. These planters were civic minded, interested in education and active in their churches. Colonel Robert Woodward Barnwell served in the South Carolina House of Representatives and in the United States Congress. He was a delegate to the Nullification Convention, the Southern Rights Convention and the Secession Convention, as well as president of South Carolina College. The Reverend Stephen

93

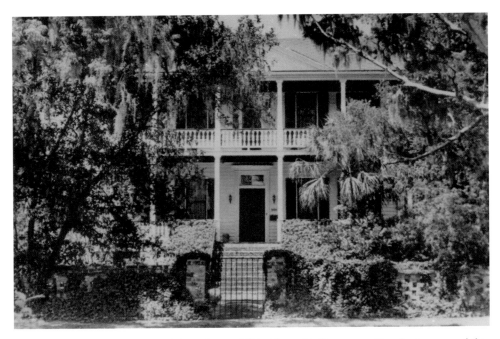

The Henry McKee House, 511 Prince Street, 1970. Henry McKee, a wealthy planter, owned this home and more than a hundred slaves at the time of Civil War. Among his slaves was Robert Smalls. Smalls later purchased the property at a direct tax sale. South Carolina National Register of Historic Sites, Beaufort County. *Courtesy of the South Carolina State Historic Preservation Office, South Carolina Department of Archives and History.*

Elliott was secretary-treasurer of Beaufort College Board of Trustees. William Elliott served in the South Carolina State Senate and House of Representatives, as well as intendant of Beaufort. Barnwell, both Elliotts and William Fripp were trustees of Beaufort College. Dr. Thomas Fuller was president of the college trustees. Edgar Fripp, Captain John Fripp and William Fripp were justices of the peace and commissioners of free schools. John Fripp was also a delegate to the Southern Rights Convention. Fuller was also a commissioner of free schools. Henry McKee and Richard Reynolds served as wardens of the town of Beaufort. Joyner, Barnwell and Edgar Fripp were vestrymen at St. Helena Parish Church. William Fripp was a deacon for the Baptist Church on St. Helena Island (the Brick Church).

These were literate, influential men. However, many, if not all, of these literate men believed cotton was king. Demand for cotton, and sea-island cotton in particular, seemed insatiable in the 1850s. Prices were steady, and many planters aggressively added acreage and slaves to cultivate them. Sea-island cotton, the gold standard of cotton, grows only on the Sea Islands of the Southern United States and on islands in the Caribbean.

Posed on the brink of cataclysmic change, in 1860, St. Helena Parish supported one college academy with fifty-five students, one female academy with fifty students, two female schools and one free school. Beaufort enjoyed a high reputation for the quality of her educational institutions and the high level of literacy enjoyed by her residents. In 1860, Ruth Jones was still matron of the Beaufort Female Asylum, but there were fewer young women in residence— Emma Ironmonger, Sarah Crosby, Anne Crosby, Harriet Crosby, Lezzie Gohagen, Florence Gohagen and Elizabeth Register. Only Emma Ironmonger had been in the home in 1850. The parish also had four Baptist churches, one Methodist, one Catholic and another Episcopal Church in addition to St. Helena.

For the calendar year that ended 1 June 1860, the Beaufort area reported a number of small businesses. There were four blacksmith shops operated by Joseph T. Barnett; J. A. W. Justi, a German; Edward Kehlhoff, a German; and Branch and Cockroft. The town enjoyed sufficient wealth to need the services of W. W. Rickenbacker, a carriage and cart maker. The area supported two bakeries, B. D. Lange and A. Fincken (also from Germany); one shoemaker, Alban Litschgi, a German; and a saddler, Charles Pointel of France. Only Barnett, one of the blacksmiths, had been in business in 1850.

The 1860 population schedules also listed several individuals who probably profited from Beaufort's building bonanza in the 1850s, specifically house carpenters John Zealy, James G. Busbee and William D. Cordy, and builder Franklin Talbird. In addition, Beaufort boasted two shipbuilders, Saxby Chaplin and John J. Rhodes; two ship captains, James Early and John Murray; and one pilot, John Murray Junior. Beaufort was also home to Anton Johnson, a native of Germany and a lighthouse keeper, and Richard Egan, a native of Ireland who operated the lightship. Beaufort supported the arts as there was a music teacher, A. J. Hoffman, a native of Germany, and an artist Edward B. Reynolds, who lived in the household of planter Kiven J. Pritchard. There was also an interest in viniculture as a French vinedresser F. E. Flory added his talents to the local scene. George W. Hall was the lone police officer.

In 1860, according to the census, 48 families owned the 141 plantations in the St. Helena Parish. That year, the Sea Islands produced 15 million pounds of prized cotton that sold for a record $.47 per pound. The parish was also home to forty-six hundred slaves whose labor produced the sea-island cotton that was the backbone of the Beaufort economy. In 1860, slavery was the way of life for the majority of the black residents of St. Helena Parish. In fact, only twenty-nine free blacks lived in the town of Beaufort in 1860. Only four of the 1860 residents had lived in Beaufort in 1850: Phillip Ezekiel, Sarah Houston, Ann Ezekiel and John Houston. Will Fenwick, a black carpenter, owned real estate valued at $1,400, the greatest of any of Beaufort's black residents. Phillip Ezekiel, the future legislator and tailor, was second with $1,000. In total, five of Beaufort's black residents were property owners. In addition to tailor and carpenter, other occupations listed included pastry cook, mantua (dress) maker, midwife, seamstress, laundress, bricklayer and laborer.

Civil War, Military Occupation, 1861–1865

T HUS, BEAUFORT STOOD POISED IN the sunlight, preening and satisfied. Life beneath the oak trees was good and the air redolent of flowers. There was order in the town, neat streets and a wide array of services. New houses lined her streets, and there was talk of the unusually high price of cotton. Few perceived the clouds in the sky or the shadow over the land.

CIVIL WAR

Following the election of Abraham Lincoln as president of the United States, the South Carolina General Assembly passed legislation calling for a special election to select delegates to the Secession Convention. St. Helena Parish returned Robert Woodward Barnwell and Joseph Daniel Pope. At first, the convention met in Columbia. But fearing a smallpox outbreak, the convention adjourned to Charleston. There, in Institute Hall, the delegates formally signed the Ordinance of Secession on 20 December 1860. Two other signatories also from Beaufort were Colonel Robert Barnwell Rhett and Richard deTreville, elected from St. Philip's and St. Michael's parishes.

In 1860, Beaufort District ranked fourth in South Carolina with a per capita wealth of $72,272. She was, however, second only to Georgetown in the percentage of black residents. More than 83 percent of persons living in Beaufort District were black. This population disparity had defined antebellum Beaufort as a plantation economy. After 1861, this black population was to make Beaufort the centerpiece of social and political experimentation. Black troops mustered in Beaufort in 1862. The Emancipation Proclamation was read near Beaufort in 1863. Northern teachers came to teach the former slaves and launched the Port Royal Experiment. Black residents were elected to political office, and despite great hurdles, many of Beaufort's enslaved population in 1860 would own their own stake in this land of opportunity by 1870.

The Big Shoot, as the Battle of Port Royal Sound was locally known, and ensuing evacuation of Beaufort by her white residents ensured that the wonderful houses of

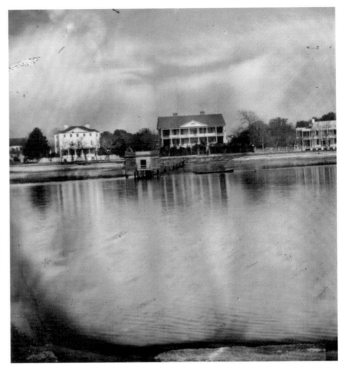

Beaufort from the waterfront (probably between December 1861 and April 1862). The Sea Island Hotel sits in reflected glory surveying the "pleasant expanse of water." The eerie calm of the image captures the sense of splendid desolation that engulfed the abandoned town when residents fled before Federal occupying troops entered in December 1861. *Timothy H. O'Sullivan, photographer. LC-DIG-cwpb-00753. Courtesy of the Library of Congress.*

Beaufort had an opportunity to survive the cataclysmic Civil War years. On 7 November 1861, the Union fleet sailed past Fort Walker and Fort Beauregard, guarding Hilton Head and Bay Point, to the entrance to Port Royal Harbor. The confrontation was short and one-sided.

With secession, the Beaufort Volunteer Artillery had joined other area militia units, such as the St. Helena Mounted Rifles, to defend Port Royal. The St. Helena Mounted Volunteer Riflemen was a militia group organized on St. Helena Island on 20 January 1861. Once again Beaufort's two-edged sword came into play as state and local efforts focused on preventing the United States from exploiting the capacities of Port Royal Harbor. Therefore, in 1861, the Confederates rushed to build two forts, Fort Walker on Hilton Head Island and Fort Beauregard on Bay Point, to defend the harbor. General Thomas Fenwick Drayton, a St. Luke's Parish planter, commanded the forts. Captain Stephen Elliott and the Beaufort Artillery were transferred from Fort Marion (Fort Lyttelton) to the still-under-construction Fort Beauregard. About that same time, James R. Stuart, who had returned to Beaufort after shots had been fired at Fort Sumter, thought the town "seemed strange and changed, like the face of a dying friend." The old Beaufort was passing away, and no one knew the future.

The Beaufort Arsenal. Thomas Talbird constructed the original arsenal before 1789 on the site of the old courthouse. Rebuilt in 1852, the arsenal housed the Beaufort Volunteer Artillery, a military unit that traced its lineage to the Revolutionary War. *No. WPA-PL-BFT-B-V-7. Courtesy of the South Caroliniana Library, University of South Carolina.*

Confederate concern was justified as the United States had selected Port Royal as the site for a naval station. For the 1861 expedition, Commodore Samuel F. DuPont was the flag officer for the seventy-ship Union naval force, and General Thomas W. Sherman commanded the fourteen-thousand-strong land force. On 7 November, the battle commenced. The DuPont fleet featured steam vessels with new guns, and Union firepower overwhelmed the cannons at Fort Walker and Fort Beauregard. The Confederates fled. Among the ironies of the Battle of Port Royal was the arrival of Captain Percival Drayton with the USN gunboat *Pocahontas.* Drayton was the brother of the Confederate commander Thomas Fenwick Drayton. Two Beaufort men went to war, but one wore blue and one wore gray.

When the news that the Federal fleet had entered Port Royal Harbor reached Beaufort, the Reverend Joseph Rodgers Walker interrupted his service at St. Helena church and suggested that his parishioners prepare to evacuate. So, when news of the surrender of the forts on Bay Point and Hilton Head came, the white population of Beaufort District, almost to a man, abandoned townhomes and plantations to flee inland. The residents fled by ship, on horseback,

by train and in wagons. They left for mainland plantations or the safety of such inland towns as Columbia and York, and other areas far from the coast and invading Union troops. The refugees packed quickly, and generally took only easily carried items and a few household servants. Like the ancient Pompeians fleeing the lava of Mount Vesuvius, the fleeing residents left dinner on the table, food in the larder and clothes in the cupboard. They streamed down the shell road from Beaufort to the Port Royal Ferry in confused disarray. Many of the fleeing refugees left behind the two main pillars of their wealth: their land and their slaves.

Edward H. Barnwell and others visited Beaufort after the exodus and before the Federal troops arrived. From the Old Castle, a tabby house built by Robert and Edward Barnwell before the American Revolution, Barnwell glimpsed the lights of the Union gunboats. The Old Castle later served as the courthouse for Beaufort County until it burned on 1 March 1881. A new courthouse was built there, and that renovated structure now houses the Beaufort Federal Court.

Federal troops proceeded slowly and occupied Hilton Head Island first. On 12 November, Commodore Samuel F. DuPont and General Thomas W. Sherman visited Beaufort. DuPont found the town "deserted...a city in perfect preservation, and bearing all the signs of the most recent inhabitation yet wanting the animation of ordinary life." While a raiding party destroyed armaments at the arsenal in the town of Beaufort and others toured the town, it was 5 December before Federal forces occupied Beaufort.

Union forces enlarged existing fortifications on Bay Point and Hilton Head, and built new ones to create a major Federal military installation. In addition to fortifications, there were naval repair facilities, signal stations and a foundry as the area became the headquarters for the South Atlantic Blockading Squadron.

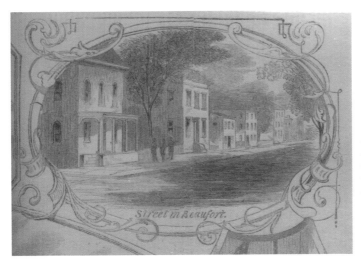

Street in Beaufort. Upon arriving in Beaufort and seeing Bay Street for the first time, Mrs. A.M. French noted the "desolation," "the eyeless windows" and the absence of other people. *Harper's Weekly, 14 December 1861. Courtesy of the author*

Decades later, D. C. Wilson, by 1891 president of the Sea Island Chemical Works, remembered the event. Wilson, part of the attacking squadron, remembered that "the *Wabash* the greatest war ship in the world at that time...sent its fiery balls like a volcano into [Fort Walker]."

With so many ships and guns, Wilson noted that "there never was such a hot battle fought."

According to Wilson, who claimed to be "the first man" to enter the fort, Federal troops suffered only twelve casualties. To Wilson, the sight of "broken cannons and the torn limbs of the fallen" filled him with sadness because the gallant rebels had endured such a "terrible bombardment" for five hours and only evacuated their position when their guns were disabled.

BEHIND ENEMY LINES

The Union military forces faced a formidable challenge—how to deal with the thousands of former slaves living in the occupied area and the daily arrivals of refugees from the mainland. Many of the former slaves lacked adequate food and shelter, as well as land and work opportunities. Most were uneducated. Many were old or young, or had health needs. Planters normally tried to evacuate their best field hands, as they were considered more valuable, and left the other slaves behind. Following the United States military occupation, the care of the former slaves devolved upon the Treasury Department. In addition, a number of philanthropic and religious organizations from the North, primarily Boston, Massachusetts; New York; and Philadelphia, Pennsylvania, sent missionaries and teachers to minister to the freedmen. On 3 March 1865, the United States Congress formally gave the responsibility for the freedmen to the Freedmen's Bureau.

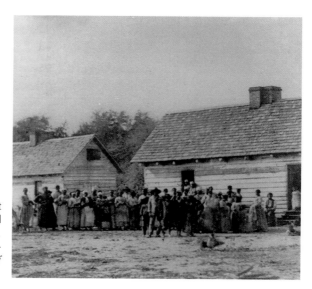

A large group of former slaves at John Joyner Smith Plantation (Old Fort) near Beaufort, 1862. *Timothy H. O'Sullivan, photographer. LC-US862-67810. Courtesy of the Library of Congress.*

In addition to slaves who were abandoned, there were hundreds of others who fled the Confederate-held areas for freedom behind Union lines. Many of the former slaves lacked food and shelter, and others reveled in the freedom of not working. With limited resources and increasing demand, on 6 February 1862, Sherman appealed to the philanthropic groups of the North to ease the misery of the estimated nine thousand former slaves living in the area.

Almost simultaneously, in December 1861, Secretary of the Treasury Salmon P. Chase dispatched Edward L. Pierce to Beaufort to assess the condition of the former slaves. Pierce was a young abolitionist who had worked as a clerk in Chase's law office. He was an experienced hand, having successfully managed the contrabands at Fortress Monroe in Virginia. Contrabands were fugitive slaves who fled to the Union lines for protection. General Benjamin F. Butler first used the term "contrabands of war" to describe fugitive slaves at Fortress Monroe. On 13 January 1862, Pierce left for South Carolina and completed his report by 10 February.

Pierce worked with Lieutenant W. H. Reynolds. Chase had sent Reynolds to Beaufort to collect the cotton and ship it to the North. Pierce and Reynolds surveyed the situation, identified the abandoned property and tallied the number of blacks involved. By February 1862, the agents controlled 195 plantations on which close to 12,000 former slaves lived. They organized the area into districts.

Pierce in his three-week study found no system of labor in effect for most of the occupied area and some of the former slaves confused about freedom. In his report to Chase, Pierce

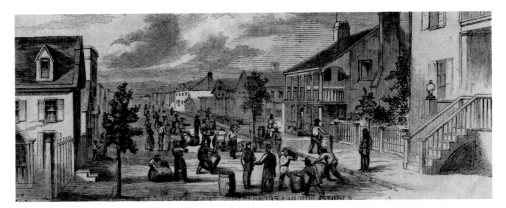

A street scene in Beaufort of contrabands landing stores. Contrabands were slaves who were abandoned or who had fled behind Union lines. Beaufort was a busy place during the Union occupation as hundreds, if not thousands, of slaves fled surrounding plantations. The status of the contrabands was uncertain as the Union had no clear policy at the time Beaufort was occupied. *Harper's Weekly, 11 January 1862. Picture Collection. Courtesy of the South Carolina Department of Archives and History.*

recommended that a superintendent be appointed to oversee the 195 plantations with the power to organize and educate the freedmen for citizenship, and that the government send teachers and encourage missionary activities. Pierce stressed the need for haste as planting time approached and the freedmen faced want if adequate food was not produced.

Pierce lobbied Chase, the United States Congress and President Lincoln, but could not get congressional or presidential action on his plan. Instead, on 19 February 1862, Chase made Pierce a special agent of the Treasury Department to supervise the plantations and laborers. Lacking an appropriation, a public-private collaboration evolved. Private philanthropic and religious groups would pay the teachers and plantation superintendents, and the government would provide food, housing and transportation.

By early 1862, Pierce's communications from the Port Royal area had led abolitionists in the North to organize the Educational Commission in Boston, the Freedmen's Relief Association in New York and the Port Royal Relief Committee in Philadelphia.

General Thomas W. Sherman, commander of the army in the Port Royal area, issued a call in February 1862 for managers to oversee the abandoned plantations and for teachers to train the freedmen. The United States Treasury Department and several charities, such as the Freedmen's Aid Society of Boston and the Pennsylvania Freedmen's Relief Association, solicited volunteers for the Port Royal project. Edward L. Pierce, the superintendent-general

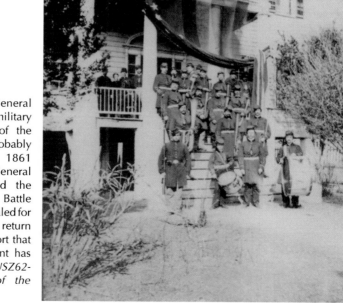

Headquarters of General T.W. Sherman, with a military band on the steps of the Sea Island Hotel (probably between December 1861 and April 1862). General Sherman commanded the land forces during the Battle of Port Royal. He appealed for the white residents to return but was forced to report that "every white inhabitant has left the islands." *LC-USZ62-102745. Courtesy of the Library of Congress.*

103

of the project, sailed with the first group of fifty-three volunteers on 3 March 1862. The Port Royal Experiment was underway.

The reformers, known as Gideon's Band, who came to the Beaufort area in 1862, wanted to educate the former slaves to be good citizens. These teachers included individuals such as Laura Towne and Charlotte Forten who devoted their lives to Penn School on St. Helena Island, as well as others who viewed the assignment as temporary. In addition to their concerns with promoting the civil rights of the former slaves, they were also interested in fostering economic independence and teaching basic educational skills.

On 15 March 1862, Federal forces announced the creation of the Department of the South. This new military department would encompass Georgia, Florida, South Carolina and General T. W. Sherman's command. General David Hunter, the new commander of the Department of the South, established his headquarters on Hilton Head Island. With this new department came institutions to educate and care for the newly freed slaves, and direct tax sales of confiscated property. The occupied area was not only strategically valuable but also economically important. The coast of South Carolina was one of the few sites in the United States where sea-island cotton could grow.

OCCUPIED BEAUFORT

Entering Beaufort on 9 November 1861 prior the full-scale occupation of 5 December, Federal troops commented upon the disarray—the abandoned homes, clothing and furnishings. With the possible exception of one white man, they found only slaves in residence. According to Beaufort resident Robert DeTreville, an elderly Northern shoemaker was the only white left in the town. Many of the slaves had moved into the empty houses. The former slaves ate, danced and celebrated their freedom. While accounts conflict as to which group, the former slaves or the Union soldiers, ransacked the town, evidence suggests there is blame to share. Years of oppression dissolved into widespread destruction as the field hands came to Beaufort. They dressed in the fine clothing left by their retreating owners. Some of the field hands looted the town houses before the Union troops arrived.

Thomas R. S. Elliott visited Beaufort on 8 November, the day after the attack. He found the plantation slaves in the houses, furniture gone and everything "topsy-turvy." According to Elliott, the "organs in both churches were broken up." The incoming Union troops then wreaked their own havoc upon the mute houses. They destroyed furniture and pianos, slashed paintings, and "liberated" other furnishings and items for use of the occupying troops and to send home as souvenirs. The commercial center was a ghost town. In 1862, Mrs. A. M. French, deeply moved, commented on the "desolation" of Beaufort—the broad street along the river with no bustle, no shoppers, no people.

A view of Beaufort Harbor. Shown are gunboats Ottawa, on the left, and McClellan. (Harper's Weekly, 14 December 1861.) The gunboat Ottawa was central to General Stevens's attack on Confederate earthworks near the Port Royal Ferry on the Coosaw River, 1 January 1862. *Courtesy of the author.*

Union forces heavily fortified the Beaufort area with redoubts along the shell road, and at various times, regiments camped in and around the town. The town was a veritable armed camp.

General Isaac Ingalls Stevens occupied Beaufort until he was transferred to Virginia in July 1862. Stevens had two responsibilities in Beaufort. First, he was to secure the Union lines from Confederate raids and second, he was to protect the thousands of slaves abandoned by their owners. Upon arrival, Stevens established a processing camp for the former slaves seeking refuge in the town. He then posted guards to protect the "fine public library, the pride of the town," and patrols to police the streets. General Stevens also set pickets at the landings on Port Royal and adjacent islands. For his headquarters, Stevens selected the John Joyner Smith House on the western end of Bay Street, a "fine mansion on the edge of town, in the midst of a luxuriant semi-tropical garden."

On 30 December 1861, the occupying forces of the Roundhead Regiment, the 100th Regiment raised in Pennsylvania, published Volume 1, Number 8 of the *Camp Kettle*—a newspaper. Although the editors speculated that the *Kettle* was the first newspaper ever published in Beaufort, William J. Grayson's short-lived *Beaufort Gazette* preceded it by a number of years. The *Camp Kettle* was a lively paper filled with daily events and personal news. Among the news reported in December 1861 was the first church service to be held in the Baptist Church of Beaufort since the Battle of Port Royal Sound. The Reverend William Dennison, formerly of Fortress Monroe in Virginia, preached. In honor of the historic moment, someone draped the flag of the steamer *Boston* across the front of the gallery with another behind the preacher. Church services in Beaufort were apparently well attended by the soldiers stationed in that place, as Colonel Daniel Leasure, their commanding officer, required his troops to attend church every Sunday. Even the editor of the newspaper noted that "Beaufort is not a bad sort of a place to go to church in" and quoted one of the soldiers as commenting that Beaufort "did not seem to be so far from Heaven, though it was in South

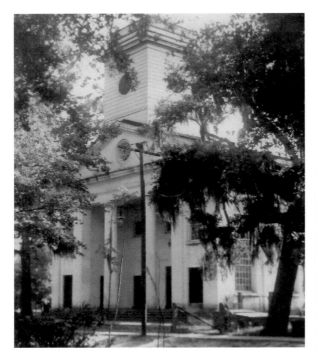

The Baptist Church of Beaufort, c. 1940. According to *Harper's Weekly* (14 December 1861), before the Union occupation of Beaufort, "the rebel lookout was in the belfry of the Baptist Church, which commanded a view of the town, river, shell road, etc. On being visited by our party [per the correspondent] an empty decanter, two glasses and a pitcher of water were found." *No. WPA-PL-BFT-B-C-1. Courtesy of the South Caroliniana Library, University of South Carolina.*

Carolina." A sentiment many have no doubt shared during the town's more than two hundred years of existence.

Brigadier General Rufus B. Saxton replaced Stevens in Beaufort. Saxton, a West Point graduate, was, by this time, a staunch abolitionist. After July 1862, Saxton had charge of the freedmen on the plantations. Saxton established his headquarters in the Lewis Reeve Sams House on Bay Street.

In May 1862, Beaufort's native son Robert Smalls, a slave of the McKee family and Charleston harbor pilot, successfully commandeered the *Planter*, a Confederate steamer. In the absence of the ship's captain, Smalls and the crew picked up his wife and other family members, and sailed the ship past the Confederate watch at Fort Sumter in Charleston Harbor to Beaufort and the safety of Union lines. The Union forces rewarded Smalls with the commander of the *Planter*.

Following the Union success in the Sea Islands, *Harper's Monthly* dispatched a correspondent to the Port Royal area. Impressed by Port Royal Harbor, Charles Nordhoff, the war correspondent, wondered "why this noble piece of water did not secure a share of the Southern trade and become more famous than either" Savannah or Charleston. This was a familiar refrain in Beaufort history and a question still without an adequate answer. Nordhoff found

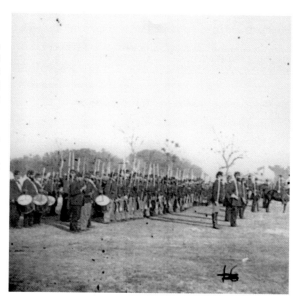

50th PA Infantry in parade formation, Beaufort, in February 1862. The 50th Pennsylvania was part of the Union forces that occupied Beaufort on 11 December 1861. Raised from Berks, Bradford, Lancaster, Luzerne, Schuykill and Susquehanna counties, the regiment was mustered into service in 1861. Nicknamed "Old Reliable," the regiment fought valiantly at Second Bull Run, Antietam, Vicksburg and the Crater. Before being mustered out, General Ulysses Grant asked the 50th to represent the army in 1865 for the laying of the cornerstone for the National Monument at Gettysburg. *Timothy H. O'Sullivan, photographer. LC-DIG-cwpb-00741 DLC. Courtesy of the Library of Congress.*

Beaufort "a pretty village" but bemoaned the treason planned there. Blaming the Rhetts, Barnwells and others for the thousands of fatherless children, Nordhoff cursed Beaufort with the wish that "whenever our soldiers leave it they will raze it to the ground." Thousands who have visited Beaufort since the 1860s rejoice that Nordhoff's wish was not fulfilled.

During the Union occupation of the South Carolina Sea Islands, on 7 November 1862, South Carolina's first black unit, the First Regiment of South Carolina Volunteers (Colored), commanded by Colonel Thomas W. Higginson, was mustered into service. The First South Carolina was also the first black regiment officially mustered into the service of the United States. In 1864, the regiment was renumbered as the 33rd United States Colored. General David Hunter had initiated recruiting operations that General Saxton endorsed. Saxton gave Higginson the command and from November 1862 until May 1864, Higginson had charge of the regiment. For a number of months in late 1862 and early 1863, this regiment bivouacked and trained on the grounds of the Old Fort Plantation, then known as Camp Saxton and now the site of the present naval hospital.

On New Year's Day 1863, hundreds of freedmen gathered at Camp Saxton on the Old Fort Plantation, formerly owned by John Joyner Smith, to celebrate the reading of the Emancipation Proclamation. The Reverend William Brisbane, a native of South Carolina, read the proclamation, and the Reverend Mansfield French, a Methodist Episcopal minister and army chaplain, presented the First Regiment of South Carolina Volunteers (Colored)— later the 33rd U.S. Colored—with its colors. The ceremonies lasted three hours. At their

conclusion, Higginson's regiment sang "John Brown's Body Lies A-Mouldering in the Grave," and the assembled guests adjourned to a barbecue. After dinner, the First Regiment paraded. According to Higginson, "The day was perfect." Hundreds, perhaps thousands, of slaves gathered for the ceremony. General Saxton had provided steamboats to transport the former slaves from the islands for the occasion.

On Emancipation Day, the Reverend Dr. Solomon Peck, the senior pastor of the Baptist Church of Beaufort, wrote President Abraham Lincoln on behalf of his congregation. The church met in the Tabernacle, a building owned by the Baptist Church. By late 1862 , the church sanctuary on Charles Street was probably already being used as a hospital for black soldiers. Peck forwarded resolutions drafted by a committee of the church members and approved by the congregation of more than eleven hundred. Peck emphasized that the words of the resolutions were the words of the newly freed men. The forwarded resolutions first gave "thanks to God for this great thing that He has gone for us: that He has put it into his [Mr. Lincoln's] mind [to free] all the colored people." Second, they thanked the president and promised to pray for him. In addition, the freedmen noted that, "We have gathered together

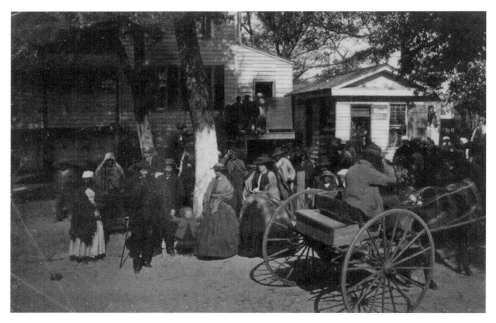

Issuing rations at the John Joyner Smith plantation near Beaufort, c. 1866. Black soldiers camped on the Smith plantation—Old Fort, now the naval hospital grounds. Thomas Wentworth Higginson, on his first glimpse of Camp Saxton, noted "the decaying house and tiny church amid the woods." Elizabeth Hyde Botume ran a school for the contrabands there. Upon her arrival, she wrote that "[a] large number of...refugees had been brought there." *No. 10076.7. Courtesy of the South Caroliniana Library, University of South Carolina.*

two or three times a week for the last five months to pray that the Lord might help you & all your soldiers,...and crown you with a crown of glory & a palm of victory." Thirteen freedmen, the members of the committee that had drafted the resolution, signed it: Jacob Robinson, Daniel Mifflin, Joseph Jenkins, June Harrison, January, Harry Simmons, Caesar Singleton, Thomas Ford, Kit Green, Charles Pringle, Peter Reed White, Elias Gardner and Thomas Simmons.

Kit Green was an entrepreneurial freedman. By 1870, he lived on St. Helena and owned real property valued at $3,300. He acquired more than nine hundred acres of land and his descendants followed his footsteps. Of interest is the fact that Green was the only one of the thirteen committee members who could sign his name to the resolutions. The other twelve made their marks. The illiteracy of the Baptist freedmen illustrates a basic challenge of freedom for the former slaves and Pastor Peck's insistence that the wording was theirs. By 1870, most of the thirteen had dispersed to other parts of the county or out of state. At least three of the thirteen resided in Beaufort in 1870. Two of them, Charles Pringle and Thomas

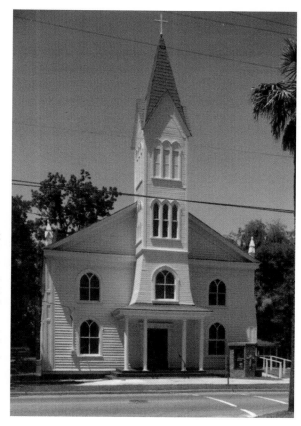

The Tabernacle Baptist Church, 911 Craven Street. Owned by the Baptist Church of Beaufort before the Civil War, the Tabernacle housed a school during the Federal occupation. A congregation of black Baptists met there during the war and eventually purchased the church building. Robert Smalls is buried in the churchyard. *South Carolina National Register of Historic Sites, Beaufort County. Courtesy of the South Carolina State Historic Preservation Office, South Carolina Department of Archives and History.*

Ford, each owned $550 worth of land and listed farming as their occupation. Thomas Simmons also was a farmer, possessing $500 in real property. One of the possible Beaufort residents in 1870 was the sixty-nine-year-old Peter Reed White whose occupation was preacher. White also owned land valued at $400.

According to one estimate, four thousand Lowcountry blacks joined the United States Army or Navy in the Port Royal area. Contrabands, conscripts and refugees from the mainland enlisted in the regiment. This vast people movement occurred despite the force and intimidation some plantation owners employed to keep their valuable slaves on the plantation. Some told horror stories of what the Yankees would do—for example, sell the slaves to Cuba. Others set cotton houses afire with slaves inside and executed those who refused to evacuate with them. A few St. Helena Parish planters, such as the Reverend J.R. Walker, were able with state assistance to evacuate their slaves in 1862. Walker signed a note in the amount of $520 in order to remove twenty-six slaves from Beaufort to Columbia. The State of South Carolina had enacted an ordinance on 2 January 1862 to encourage South Carolinians to remove their slaves and other property "from portions of the State which may be invaded by the enemy." With the money advanced, Walker was able to relocate the following slaves: John, Clemshoe (1), Sally, Clemshoe (2), Bella, Lucy, Maria, Sammy, Jacob, Louisa, Carolina, Robert, Morsey, Johnny, Betty, Edmund, Virgil, Juliana, Annie, Peggy, Phoebe, Stephen, Thomas, Jane, Boston and Elijah. At least one St. Helena owner is known to have explained the situation to his slaves and advised them on how to survive until the Federal troops arrived. But, Captain John Fripp was the exception and not the rule.

Later in 1863, Higginson and his men were camped at a plantation seven miles from Beaufort and two miles from the Coosaw River Ferry along Shell Road, the land access to Beaufort. Noah Brooks, visiting in 1863, described the camp as neat and "on a level grassy plain." Brooks was "astonished at the perfection of the drill" of these black soldiers "dark with their regulation uniform and darker faces." To Brooks, the soldiers of the First South Carolina were uniformly black with no mulattos. This was not the case with the 54th Massachusetts Regiment. As a trained observer, Brooks was a news reporter; he contrasted the styles of Higginson who commanded the First South Carolina Regiment with that of James Montgomery, the commander of South Carolina's other black regiment—the Second South Carolina Regiment. Higginson used moral suasion and praise to instill duty and reward good behavior. Montgomery, on the other hand, was strict in his demands for obedience.

On 2 June 1863, Harriet Tubman, an escaped slave, led a Union raid up the Combahee River. This was the first time a woman led American forces into battle. In addition, Union forces organized unsuccessful attacks on Pocotaligo, Coosawhatchie and Ridgeland. When their mainland forays were unsuccessful, the Union forces dug in and fortified the Sea Islands until General William T. Sherman passed through on his way to bring the hell of war firsthand to the inhabitants of South Carolina's interior.

In 1863, a letter to the editor of *Free South* provided a partial guide or directory for occupied Beaufort. To facilitate travel, the author listed the streets parallel with Bay Street as Port Royal, Craven, North, King, Prince, Hancock, Lake, Washington, Green and Congress Streets as well as Shell Road. Perpendicular to those streets from Fripp's Point were Pinckney, Hamilton, East, New Carteret, Scott, West, Charles, Newcastle, Church, Harrington, Wilmington and Monson.

Brigadier General R. Saxton commanded the Union forces that occupied Beaufort. Many of Beaufort's homes and churches were pressed into Federal service. At first, Saxton established his headquarters in the Lewis Sams House "at the foot of Bay street [sic]." (Saxton later moved his headquarters to the Heyward House.) The Heyward home at the corner of Newcastle and Bay Streets housed the post commandant Brigadier General Seymour and the post adjutant Lieutenant Stevens. The Fripp House on Bay (opposite the entrance to Wharf Brannan) and the Chisholm House on the corner of Bay and West Streets housed the post commissary and the post treasurer respectively. The post and brigade quartermasters had their offices in the Cockroft and Porteous houses in front of Dock Dupont. The Fuller House at the corner of Bay and Carteret Streets housed the adjutant, quartermaster, commissary and provost marshal of the governor's staff. The United States Direct Tax Commissioners operated from rooms in the Edmund Rhett House on Bay Street.

The arsenal, council house, market and jail stood on Craven Street on the north side of Castle Square. The council house housed the superintendent of contrabands "in the service of the Military Department." The general superintendent of contrabands and plantations had his offices in the Fuller House on Bay Street. The newspaper the *New South* was published in the former home of Stephen Elliott Jr. on Bay Street, next door to the home of General Saxton.

The Baptist Tabernacle (now Tabernacle Church) stood on Craven between Charles and Newcastle Streets. The Baptist Church of Beaufort built the Tabernacle in the 1840s as a lecture room and meetinghouse. The Baptist Church occupied the square bounded by King, Prince, Charles and Newcastle Streets; the Baptist Praise House stood on New Street near Prince. The Methodist Chapel stood on Prince Street between Scott and West; the Catholic Chapel was found at the corner of Lake and Carteret Streets. The Episcopal Church had the square bounded by North, King, Church and Newcastle streets.

By 1863, Union forces used both the Episcopal and Baptist churches as hospitals. Black Baptists then began meeting in the Tabernacle, now Tabernacle Baptist Church, and in the prayer house, now First African Baptist Church. With the advent of African Methodist Episcopal missionaries, former slaves turned St. Helena's Chapel into Grace AME Chapel. The Brick Church on St. Helena's Island, a mission of the Baptist Church of Beaufort, served an educational role in conjunction with the Penn School during the Port Royal Experiment.

111

Craven streetscape, 2004. The arsenal is on the left. Craven has a long history as the town's governmental center. During the Union occupation, the arsenal, council house, market and jail were located on Craven Street. *Courtesy of Ned Brown, photographer.*

Also in 1863, Beaufort had three school districts. The school for the first district met in the Baptist Praise House. The Methodist Chapel was home to the school for the second district, and the third district school met in the Tabernacle.

Many of Beaufort's fine homes were used as hospitals. For example, the Hamilton House on Prince Street was Military Hospital No. 1. Hospital No. 2 was the Edward Means House; No. 3 was a group of buildings that included the John Archibald Johnson House (at the corner of Pinckney and Hancock Streets) and the Thomas Talbird House as well as a house that belonged to Dr. Lewis Reeve Sams. No. 4 was the William Wigg Barnwell House (at the corner of Scott and Prince); No. 5 was the "late residence of Bishop Barnwell" (Barnwell Castle on the corner of Bay and Monson). The Robert Barnwell House (at North and Hamilton Streets) was an officers' hospital, and the Sams House (at the corner of Craven and New Streets) was a hospital for African American patients. Tidalholm, built by Edgar Fripp, was Hospital No. 7. The John Joyner Smith House became Hospital No. 9. William Elliott's house on Bay Street (later the Anchorage) was Hospital No. 11. The Lewis Reeve Sams House became Hospital No. 13. Hospital No. 15 was the George Parsons Elliott House, also on Bay Street. Two of the hospitals—Nos. 9 and 13—had, at one time, housed the military commanders stationed in

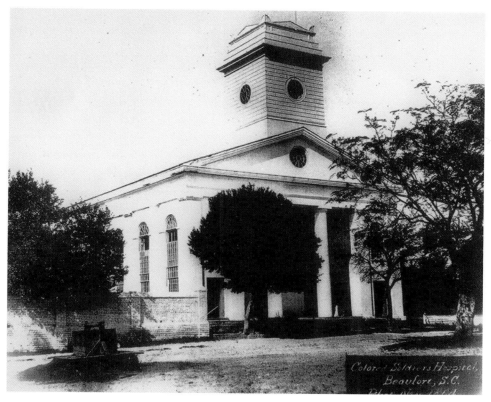

During the Federal occupation of Beaufort, the Baptist Church of Beaufort served as a hospital for black troops. *Courtesy of the National Archives and Records Administration.*

Beaufort. St. Helena Parish Church was another hospital—No. 12—and the Baptist Church of Beaufort also served as Hospital No. 14 for black soldiers.

The town bustled under Federal occupation. The docks were busy with supplies coming in and cotton being shipped out. Bay Street featured a post office, bank, general store, commissary and John Lilly's Magnolia Hotel. Other enterprises included C. G. Robbins and Douglas and Company. On 7 January 1863 the United States government established the Beaufort post office on Bay Street. Henry Shears was the first postmaster.

Valentine Cartwright Randolph with Company I, 39th Regiment, Illinois Volunteers, visited the town, rejoicing that a dollar could buy ham, eggs, baked beans, apple pie, hasty pudding, coffee, and bread with butter and molasses! Perhaps he dined at the Lincoln House restaurant operated by Henry Bram. Northern teachers arrived to open schools for the former slaves, and the Freedmen's Bureau staff set up quarters to provide physical, educational and occupational

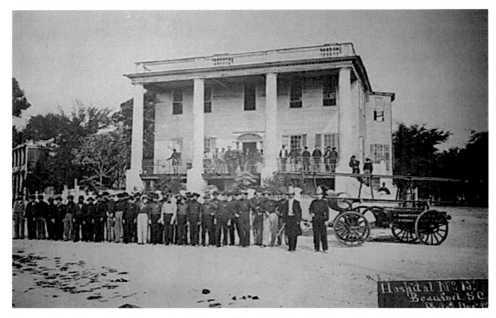

Firemen lined up with a fire engine in front of Hospital No. 15, December 1864. Hospital No. 15 was housed in the George Parsons Elliott House on Bay Street. *War and Conflict Number 218 [ARC Identifier 533116]. Courtesy of National Archives and Records Administration.*

assistance. The Freedmen's Bureau operated schools, negotiated labor contracts and managed plantations. Many of the former slaves enlisted in one of the two black regiments—the First and Second South Carolina Regiments—that were raised on Hilton Head Island. Hilton Head was the headquarters of the Department of the South. Laura Towne was one of the teachers who came to Beaufort after its surrender to educate the former slaves. While many teachers came and went, some devoted their lives to equipping their students for the free life. Charlotte Forten and Ellen Murray taught at the Penn School on St. Helena Island until their deaths.

In 1863, news reporter Noah Brooks toured Beaufort. Brooks found the town "embowered in groves of orange and magnolia trees," but showing the strain of occupation and abandonment. According to Brooks, the large houses were "partially dismantled" and the gardens "ruined." Brooks took a certain perverse pleasure that the United States Tax Commission not only occupied the former home of Robert Barnwell Rhett, but also that the commission was actively engaged in selling Southern land to Northern investors. Despite the occupation and the troops stationed in Beaufort and the vicinity, Brooks echoed earlier and later visitors in commenting on the "sabbath-like" stillness of the town. He appreciated the irony of the former slaves loitering on the street corners and living in the houses where Beaufort's white elite formerly ate, drank and took their leisure.

Beaufort Bank c. 1864. Before the Civil War, the bank building had been the home of Michael O'Conner, a merchant, who built St. Peter's Catholic Church. When Federal troops first occupied Beaufort, the Prevost Marshall used the building. *Hubbard and Mix, Beaufort. No, 12224.1. Courtesy of the South Caroliniana Library, University of South Carolina.*

Brooks in his tour of the town noted that United States governmental agencies and officials occupied many of the old mansions. He claimed to have roomed in the only house held by a Union supporter at the time the town was abandoned. A Mr. Fyler toured St. Helena Parish Church and noted the memorials inside and the monuments in the churchyard. He was particularly impressed by the stones honoring soldiers, such as Brevet Captain James Stuart, who had died in the service of the United States. Brooks noted the vandalized state of the church in 1863 and the ruthless destruction of its organ, destroyed, according to Thomas R. S. Elliott, before Federal troops entered the town.

A particularly valuable portion of Brooks's account concerns the records of the town of Beaufort. When Brooks toured the town in 1863, the records of the Beaufort City Council were intact. He reviewed the records of the wardens and Intendant Edmund Rhett. According to Brooks, most of the cases entered concerned men who had avoided patrol duty or slaves who disturbed the peace of the town. Patrol avoidance brought a fine of $2, but a slave who disturbed the peace could receive "ten, twenty or thirty lashes." In August 1861, Brooks noted an entry stating that the wardens had not held their regularly scheduled meeting because they were all drilling at Bay Point. The city councilmen were personally involved in the city's defense. The last entry in the records was dated October 1861 and detailed plans for welcoming

the First South Carolina Regiment. The council had designated a camp area for the regiment on the "southern edge of the town."

Brooks, with his ironic sense of humor, wondered if Higginson's First South Carolina Colored Troops had actually camped in the same area where the First South Carolina Regiment, a white Confederate unit, had earlier established its campsite.

Black congregations worshipped in the former white churches where many of them had been members. Of the 3,500 members the Baptist Church of Beaufort had in 1860, fewer than 200 were white. After the Civil War, fewer than twenty total members returned. The former black Baptists moved to Tabernacle and in 1867 purchased the property from the Baptist Church of Beaufort. In 1865, other Baptists who had been meeting in a prayer house owned by the Baptist Church of Beaufort established the First African Baptist Church on New Street. The Reverend Arthur Waddell was the first pastor of First African Baptist Church.

With Beaufort and the South Carolina Sea Islands in Union hands, slaves from the mainland eluded Confederate forces to reach freedom. For example, in Beaufort, the *New South* reported that five blacks had successfully rowed for several miles and past Confederate sentinels to reach a Union naval vessel. Beaufort continued to be a magnet for blacks seeking freedom, and later economic opportunities, until the turn of the century.

In 1864, Elizabeth Hyde Botume, under the auspices of the New England Freedmen's Aid Society, sailed from New York to teach the newly freed slaves in Beaufort. Botume lived in the old Smith plantation house that had once been used as a hospital. Her school was on Old Fort plantation, the former home of Captain John Joyner Smith. The hurricane of June 1866 destroyed the school. The New England Freedmen's Aid Society also established schools on St. Helena and Hilton Head islands.

In January 1865, the left wing of General William T. Sherman's army came to Beaufort from Savannah. On 15 January, General Sherman promulgated his famous Field Order No. 15 that reserved the Sea Islands for the former slaves.

According to Botume, the first soldiers who arrived did not realize that Beaufort was in Union hands and proceeded to loot the town for several hours. Within a few hours, their commanding officers restored order. However, the town was off limits even to Botume and the other relief workers for forty-eight hours. Even after that time, they needed special permits to enter Beaufort. The troops brought two challenges; a large number of contrabands to feed and house along with limited supplies. The army's needs practically exhausted the available food and created anxious days for the relief workers, who were glad when the troops left. From Beaufort, Sherman's troops marched inland to rendezvous with the other wing of his army en route to the capital city of Columbia. As Sherman's troops moved north and northeast into the heartland of South Carolina, one of their first stops was to burn the Old Beaufort District Courthouse at Coosawhatchie.

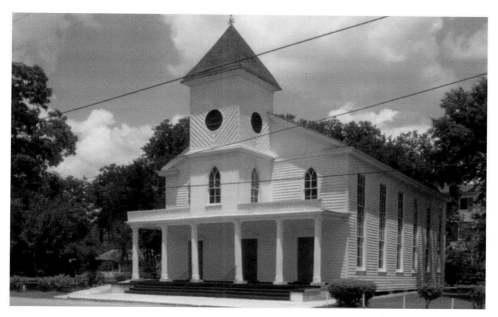

The First African Baptist Church, c. 1865, 601 New Street, shown in 1997. *South Carolina National Register of Historic Sites, Beaufort County. Courtesy of the South Carolina State Historic Preservation Office, South Carolina Department of Archives and History.*

Another Beaufort emigré was Abbie Holmes, later Christensen (1852–1938). In 1864, Christensen moved to Beaufort with her Massachusetts-born parents. By 1870, Holmes was teaching black children. In 1875, after her graduation from Mount Holyoke College, she married Captain Niels Christensen in the Baptist Church of Beaufort. Christensen, a former Union military man, was instrumental in Beaufort's post-war recovery. A surveyor and entrepreneur, Christensen was the superintendent of the National Cemetery and launched many business undertakings. His wife established an agricultural school for black students, and was active in the woman's suffrage movement and its sister reform movement—temperance.

Among the casualties of war was the Beaufort Library. When General Isaac Stevens, commander of the Union forces in Beaufort, reached Beaufort in 1861, he found the library in great disarray. His aide Lieutenant Abraham Cottrell had the books from the public library and many of the private libraries catalogued, shelved and opened for use by the occupying troops. Cottrell and the others who had worked on the project intended the library to be returned to the citizens of Beaufort. Unfortunately, treasury official Colonel William H. Reynolds with an order from the secretary of the treasury demanded the books in order to sell them as confiscated rebel property. Stevens objected to the order and appealed to his superior for assistance. Eventually, he had to relinquish the books.

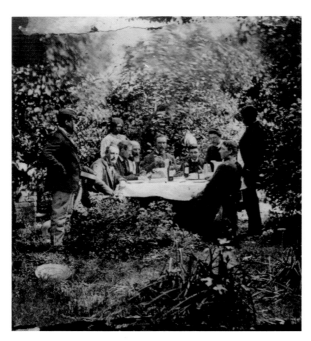

"Our mess." Friends dined al fresco, possibly on Old Fort Plantation in April 1862. The man on the right in uniform may be Lieutenant Colonel W. M. Beebe Jr. The other guests may include Dr. and Mrs. Wakefield, Joe Kendall and Mr. Robinson. *Timothy H. O'Sullivan, photographer. LC-DIG-cwpb-00801. Courtesy of the Library of Congress.*

The books were shipped to New York where Hiram Barney, the collector of the port, put them at public auction in November 1862. Secretary of the Treasury Salmon P. Chase stopped the sale stating, "We do not war on libraries." In January 1863, the books were forwarded to Washington, D.C., and deposited in the Smithsonian Institution for safekeeping until "the authority of the Union should be reestablished in South Carolina." Unfortunately, a fire there in January 1865 destroyed the books. The sale catalog listing the books that were to be sold reflected the sophistication and Catholic tastes of antebellum Beaufort. Among the titles were the *Encyclopedia Britannica, the Encyclopedia Americana, Broughton's Dictionary of Religions* (1750), *Miller's Gardener's Dictionary* (1859), *Hope's History of Architecture and Plates* (1835), *James' Medical Dictionary* (1745), *Worcester's Dictionary* (1860), *Duane's Military Dictionary* (1810) and *Postlethwaites's Dictionary of Trade and Commerce* (1774). Beaufort eventually received a token compensation.

THE DIRECT TAX

On 5 August 1861 the United States Congress had levied, per its constitutional authority, a direct tax of $20 million annually on states and territories of the United States. The tax was needed to pay the costs of the Civil War. The states liable for the direct tax included South Carolina, whose

share of the tax was $363,570.66. Beaufort and the occupied Sea Islands were therefore liable for a prorated share of the tax levy. On 7 June 1862, Congress appointed direct tax commissioners to collect the tax from the rebellious states. The direct tax commissioners for South Carolina were Henry Brisbane, A. D. Smith and W. E. Wording.

The commissioners set up office in the former home of Edmund Rhett and, using an old plat, developed an alpha-numeric numbering system for Beaufort's town lots. In November 1862, they assessed each property in the town and surrounding areas a direct tax. The property owners were allowed sixty days in which to pay the tax. With the landowners absent behind enemy lines, the United States Treasury Department seized 187 plantations and most of the town lots in Beaufort.

Initially, the Treasury Department dispatched superintendents to manage the lands, negotiate labor contracts and produce crops. By the end of 1862, however, many in the department wanted to sell the property for the taxes due. Others wanted a plan that would enable the freedmen to acquire land at a reasonable price, so they could not only become self-supporting but also be economically and physically free. Supporters of land for the freedmen were divided about the best approach.

Several groups arose with differing ideas on the lands and their possible sale. Brigadier General Saxton, the leader of one faction, influenced by Laura Towne, lobbied for land sales at reasonable sums to the former slaves. The Reverend Mansfield French, a Methodist minister, involved in the religious education of the freedmen, supported Saxton's efforts. James G. Thompson, editor of Beaufort's *Free South*, ardently advocated a new labor system for the South and the redistribution of land to the former slaves. Thompson also advocated free integrated schools and the development of a political organization capable of electing a pro-Union governor in South Carolina.

The Treasury Department's direct tax commissioners in South Carolina wanted to sell the confiscated properties on 11 February 1863. Myriad speculators who wanted to cash in on the price of sea-island cotton supported this action. The land in question lay in St. Helena and St. Luke's parishes, and included the then-occupied town of Beaufort.

E. S. Philbrick, one of the land superintendents, held the middle ground. While a proponent of black land ownership, he thought the freedmen needed a transitional educational period prior to acquiring land. He was also concerned with the validity of the tax titles as well as the fate of the freedmen and their land, when the army left the area.

The commissioners planned a public sale in February 1863. Saxton complained to his superior, and the sale was delayed. Regardless, the commissioners proceeded with the sale of forty-seven tracts. Blacks (often with pooled resources) bought six of the plantations, and Philbrick's faction acquired eleven that were later sold to black purchasers. Speculators acquired title to the remaining plantations.

Around 150 plantations remained. Most of these were under Saxton's control. Still seeking to divide the land among the black workers, in November 1863 per orders issued by President Abraham Lincoln, Saxton urged the blacks to preempt lands on certain plantations. On 6 December 1865, part of the land was sold to the freedmen—first in ten- or twenty-acre plats to black veterans, and then to all freedmen at $1.50 per acre.

In all, thousands of acres in Beaufort District and elsewhere in South Carolina were seized and sold for nonpayment of the tax. Many, if not all, of the homes in Beaufort were similarly affected. Sales of Beaufort town lots began in March 1863, with between seventy-five and eighty houses to be sold. Several lots, including a cemetery and the site of the poorhouse, were excluded from the sale. The United States government purchased most of the lots and later resold them in January 1864. Purchasers, usually military personnel, paid between $40 and $1,800 for the lots and houses. Among the military personnel who were successful purchasers were Captain William James, S. Hall, J. Cromwell, H. W. Cass, Colonel Henry Moore and Lieutenant J. S. Gibbes. Civilian purchasers—often of Bay Street commercial properties— included S. C. Millette, Gabriel Haynes, the Sylvanus Mayo firm and A. W. Hall.

Robert Smalls bought the former home of his master Henry McKee. Other black purchasers of Beaufort houses and lots were June Harris—a deacon of Tabernacle Baptist Church (also, Robert Smalls's church) and one of those who wrote President Lincoln on Emancipation Day—and Prince Rivers—a color sergeant of the First Regiment of South Carolina Volunteers (Colored), Higginson's regiment. Rivers later represented Edgefield County in the South Carolina House of Representatives. The Freedmen's Association bought the house where Rachel Mather later lived.

Mary S. Hamilton, a descendant of former Secretary of the Navy Paul Hamilton, and her family returned to Beaufort just in time to bid on their home offered at a tax sale in November 1866. In 1871, the United States Congress advised that property that had not been sold should be returned to its former owners if the previous owners paid the back taxes and penalties. Lands that had already been sold were subject to, at times, extensive litigation. Usually, the courts only recognized the prewar claims of minor owners.

Generally the lands that were returned were those that had stayed in Federal hands. On the islands, claimants might recover all or part of the tracts into which the plantation had been subdivided. Beaufort town lots, on the other hand, were usually returned as whole entities and not subdivided. For example, in 1874 the Fullers reclaimed $8,000 worth of Beaufort property. The DeTrevilles attempted to reclaim a Beaufort home purchased by Robert Smalls. This dispute, *DeTreville v. Smalls,* went all the way to the United States Supreme Court. William J. DeTreville challenged the validity of the tax certificate and the sale, and raised a number of constitutional points. In 1878, the Court supported the lower court decision confirming the validity of Smalls's title to Lot B, in Block 23 of the commissioner's plat, which he had

purchased for $15 on 13 March 1853. The Court also set guidelines for former owners who wanted to regain their lost lands. According to historian Jennie McGuire, only 32 of the 145 St. Helena Parish plantations sold for taxes were ever even partially restored. Other owners, such as Joseph A. Johnson, opted for monetary compensation.

Robert Smalls was one of several blacks who purchased property in the town of Beaufort after the Civil War. His son-in-law Samuel J. Bampfield bought the William Johnson House on New Street. Other black purchasers included the Reverend Arthur Waddell and attorney Julius I. Washington.

Standing as a permanent reminder of Beaufort's Civil War occupation is the National Cemetery on Boundary Street. The cemetery covered twenty-nine acres.

General Robert E. Lee met General Ulysses S. Grant at Appomattox and the Civil War ended. The unique qualities of the town of Beaufort are reflected in her occupied status during the war and in her role in the great effort to education and to equip the freedmen for citizenship. There is the darkness of dead dreams and lost lives contrasted with the light of emancipation and the possibility of a new racial harmony.

Chapter 8

Reconstruction and its Aftermath, 1865–1889

Hᴏᴡ ᴡᴇʀᴇ ᴛʜᴇ ʀᴇᴛᴜʀɴɪɴɢ ᴏᴡɴᴇʀs, the freedmen and the new man—the foreign or Northern-born incomer—going to share political and economic power? Who would be the winners and losers in this time of transition?

RECONSTRUCTION BEAUFORT

Beaufort's black majority flexed its political muscle in the post-war years. Beaufort was one of three bastions of black and white Republican power. Charleston and Columbia were the other two. In Beaufort County, the black/white population ratio was nine to one. In 1870 the town of Beaufort had 1,274 black inhabitants and 465 white inhabitants. Candidates in Beaufort and in other South Carolina precincts followed the time-honored antebellum tradition of lubricating their supporters with whiskey. Candidates also hosted barbecues and picnics. Robert Smalls sponsored torch-lit parades at night and had a brass band.

During Reconstruction, blacks held elective office serving in the State Senate and the South Carolina House of Representatives. Black representatives elected from Beaufort County were Samuel J. Bampfield, John B. Bascomb, Phillip E. Ezekiel, Hastings Gantt, Samuel Greene, Thomas Hamilton, Thomas E. Miller, William C. Morrison, Nathaniel B. Myers, George A. Reed, Benjamin Simmons, Robert Smalls and William J. Whipper. Smalls, Miller and Greene also served in the South Carolina Senate. All of Beaufort's legislators except Whipper had been born in South Carolina. Beaufort County's black legislators had varied backgrounds and careers. A brief look at their lives illustrates the diversity of political opportunity in Beaufort during the post-war years. Whether educated or uneducated, slave or free before the war, professional and laboring men held elective office in Reconstruction Beaufort County. Several of these political leaders, including Smalls, Bampfield, Reed and Eziekel, were residents of the town of Beaufort.

Bampfield, Ezekiel, Miller, Morrison and Whipper were free men before the Civil War. Bampfield and Miller were both graduates of Lincoln University in Pennsylvania. Bampfield,

born in Charleston, also served as clerk of court for Beaufort County, worked as postmaster for the town of Beaufort and edited the *New South* in the 1890s. An elder in the Presbyterian Church, Bampfield was closely allied with Robert Smalls and married his daughter Elizabeth in 1877.

John Bascomb represented Beaufort in the South Carolina House of Representatives, 1870–1874. A former slave, born in South Carolina in 1827, Bascomb was a merchant who owned no real property in 1870.

Phillip E. Ezekiel was a longtime resident of the town of Beaufort. According to the United States census, he was working as a tailor in Beaufort in 1850. Ezekiel, a trustee of the Reformed Episcopal Church, served in the South Carolina House of Representatives, as a deputy and later as the postmaster for Beaufort.

Hastings Gantt was born into slavery and represented Beaufort County in the South Carolina House of Representatives for two terms. A successful farmer, he owned an eighty-four-acre farm and in 1871, the St. Helena Planter's Society elected him president.

Samuel Greene, also born a slave in South Carolina, served in the South Carolina House of Representatives and in the South Carolina State Senate. He owned a farm on Lady's Island and worked as a carpenter.

This cottage at 1818 Congress Street was built c. 1870, and represents the style and size of post–Civil War housing for freedmen. *South Carolina National Register of Historic Sites, Beaufort County. Courtesy of the South Carolina State Historic Preservation Office, South Carolina Department of Archives and History.*

Thomas E. Miller, born free in Ferrebeeville about ten miles from Hilton Head, had a long and distinguished career. His father was white, and his mother claimed descent from Thomas Heyward who had signed the Declaration of Independence. Miller attended schools in Charleston and New York, and studied at Lincoln University in Pennsylvania. Miller served in the South Carolina House of Representatives, in the South Carolina State Senate, as a school commissioner and as a customs official. An officer in the state militia, he was an unsuccessful candidate for lieutenant governor in 1880. Elected to the United States Congress in a contested election, Miller was also a delegate to the Constitutional Convention of 1895. The first president of the Colored Normal, Industrial, Agricultural and Mechanical College of South Carolina (now South Carolina State University), he served from 1896 until Governor Cole Blease forced him to resign in 1911.

William C. Morrison, born a free person in Beaufort District, was a tinsmith by trade. His family probably was part of a large settlement of free persons that lived in St. Luke's Parish before the Civil War. Morrison was also a United States soldier during the Civil War and served one term in the South Carolina House of Representatives.

Nathaniel B. Myers, a colonel in the South Carolina Militia, served two terms in the South Carolina House of Representatives. A farmer, Myers and fellow Beaufort Representative Thomas Hamilton supported the Democratic Party during the Hampton-Wallace controversy of 1876–1877 when South Carolina had two rival governments. Hamilton was a native South Carolinian and farm owner. Myers and Hamilton were two of the four defectors who helped the Democrats gain control of the South Carolina state legislature in 1877.

George A. Reed, a minister and resident of the town of Beaufort, served two terms in the South Carolina House of Representatives. Elected sheriff of Beaufort County, Reed served in that position from 1888 to 1896. In 1897, the town of Beaufort elected Reed a town warden.

Little is known of Benjamin Simmons (or Simons). He lived in Beaufort County and served two terms in the South Carolina House of Representatives. The 1870 census lists a Benjamin Simmons, a forty-three-year-old farmer who with his family lived in Beaufort in 1870. According to the census, that Simmons did not own real property. Benjamin Simmons, Thomas E. Miller and Hastings Gantt, all of Beaufort County, were the only three black Republicans elected to the South Carolina House in 1878.

Robert Smalls, born a slave in Beaufort, and his mother were owned by Henry McKee. Hired out in Charleston in 1851, Smalls became an accomplished harbor pilot. In 1862, he commandeered a Confederate ship the *Planter*, picked up his family and sailed to Union lines. Smalls published the Beaufort *Standard* and invested in a number of Beaufort businesses, including the Enterprise Railroad. Smalls and R. H. Gleaves were business partners in Beaufort. Gleaves was chairman of the South Carolina Republican Convention in 1867 and served as lieutenant governor of South Carolina, 1872–1877. Accused of taking a bribe in the

Republican Printing Company scandal, Smalls was convicted in 1877 but later pardoned. He opposed Martin R. Delany's proposed black exodus to Liberia. Smalls worked to provide educational and economic opportunities for the black residents of the area, and was the major black political figure in Beaufort County and perhaps the Lowcountry until his death in 1915. Among other properties, Smalls purchased the Henry McKee House and later maintained his former mistress there until her death. Republican voters also sent Smalls to the United States Congress, where he served for nine years.

In 1864, while Smalls was serving with the Union Navy, a Philadelphia streetcar conductor refused Smalls a seat. The public protests that followed led to the desegregation of Philadelphia's public transportation. While in Congress, Smalls worked with others to establish a naval station on Parris Island. Smalls was also a delegate to the South Carolina

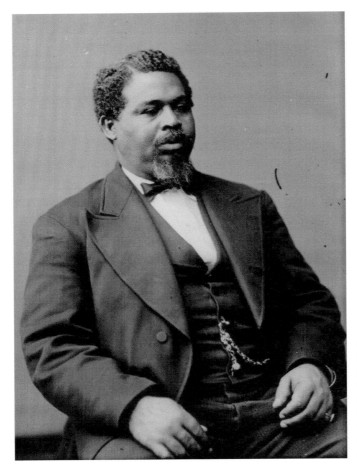

Robert Smalls. Smalls was born in Beaufort c. 1839 and achieved fame during the Civil War for sailing the *Planter* into Union hands. Later, Smalls served in the United States Congress. *LC-DIG-cwpbh-03683. Courtesy of the Library of Congress.*

Constitutional Convention of 1868 that drafted the most progressive of South Carolina's seven constitutions and to the Constitutional Convention of 1895 that worked to limit black suffrage. In protest, the five black delegates to the Constitutional Convention, Smalls, the rest of the Beaufort representatives and the lone black delegate from Georgetown County refused to sign the South Carolina constitution of 1895.

William James Whipper was born free in Pennsylvania. Whipper served in the United States Army during the Civil War and was twice court-martialed—once for insolence and once for gaming. An attorney, he served in the Constitutional Conventions of 1868 and 1895, and also served three terms in the South Carolina House of Representatives. While in the House, Whipper led an effort to impeach Governor Robert K. Scott. Whipper was, according to historian Thomas Holt, the "life-long political enemy" of Robert Smalls. Whipper was the probate judge of Beaufort County, 1882–1888.

In 1866, the Presbyterians attempted to reorganize in Beaufort. That year, William E. Clark on behalf of the First Presbyterian Church of Beaufort bought Lot B in Block 80. The effort was short-lived as, unfortunately, this congregation also later disbanded. So, from 1866 to 1912, there was no organized Presbyterian Church in the town of Beaufort.

Also in 1866, William A. Morcock petitioned the South Carolina General Assembly to have the White Hall Ferry rechartered. In his petition, Morcock mentioned that he had lost the Beaufort terminus of the ferry due to the direct tax. A number of residents of Beaufort and the surrounding area supported Morcock's petition: Joseph Hazel, Shepard D. Gilbert, Edward B. Santell (signature illegible), George Holmes, Frank F. Fyler, H. M. Stuart Jr., R. Means Fuller, William J. Verdier, A. S. Gibbes, W. J. Trenholm, M. M. Sams, J. D. Chaplin, S. Read Stony, D. L. Thompson, F. F. Sams, Franklin Talbird, Sam. A. Cooley, B. B. Sams, Jos. T. Porter, Nathaniel B. Fuller, William Thomson, Paul Hamilton, William Fripp, A. V. Chaplin, S. Elliott, James R. Verdier and Robert Randolph Sams.

Under the constitution of 1868, Beaufort District became Beaufort County and the town of Beaufort became the county seat. At the time of secession, the Beaufort District Courthouse had been at Gillisonville on the mainland. With this change, Beaufort acquired the trappings of county government. Barnwell's castle served as the Beaufort County Courthouse until it burned. The 1870 census included a jail, a poorhouse and a number of Federal governmental employees. The latter ranged from the superintendent of the national cemetery to a postmaster.

Around 1868, Rachel Crane Mather, a widow from Boston, organized a school in Beaufort to educate black women. The school was later known as Mather School. The Woman's American Baptist Home Mission Society agreed to support the school in 1882. The school continued to educate black men and women until it closed in 1968. The school became coeducational in 1955. One man—Hyland Davis, admitted by mistake—was permitted to take classes and was graduated in 1910. At the time of the school's closing, the trustees—according to

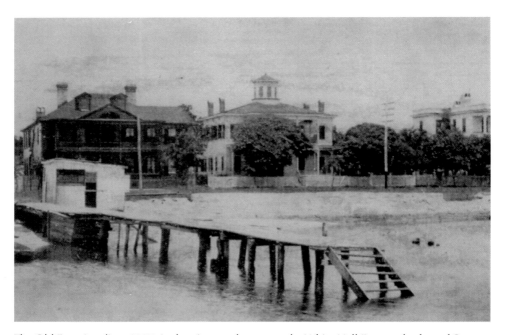

The Old Ferry Landing, 1907. In the nineteenth century, the White Hall Ferry at the foot of Carteret Street connected Beaufort and Lady's Island. Before and after the Civil War, William A. Morcock operated the ferry. Ferries provided access to Lady's and St. Helena islands until 1927 when a bridge was built across the river. The fire of 1907 destroyed the middle house, and William J. Thomas erected a new one at that location in 1909. The Lewis Reeve Sams House, later owned by George Waterhouse, stands to the right. *Copy photograph, Ned Brown, Local History Collection, No. 2200695. Courtesy of the Beaufort County Library, Beaufort.*

Dr. George A. Jones, who served on the Mather Board for twelve years—were split on the subject. The local trustees favored keeping the school open, or selling the property and donating the money to Benedict College in Columbia, a sister institution. The out-of-state trustees prevailed, and the American Baptist Convention released the property to become part of the South Carolina technical college system. The Technical College of the Lowcountry uses four of the Mather Buildings—Moor Hall, Anderson Hall, Owen Hall and Coleman Hall. In 2000, Romona Gaither, a former teacher, remembered that students at Mather studied not only academics but also how to live in "the real world."

Commercial opportunities in Beaufort were primarily confined to the three blocks of Bay Street between Charles and Carteret Streets—the historic prewar business center of the town. The number of groceries and retail establishments had more than doubled in the decade since 1860. The 1870 United States Census of Industry enumerated only seven businesses. Four of the businesses listed, owned by Moritz Pollitzer, S. M. Wallace, H. M. Stuart and

George Waterhouse, ginned cotton. A. Bushhart owned the sole gristmill, and D. C. Wilson & Company and W. W. Markle operated Beaufort's two sawmills. Pollitzer and Wallace were the only concerns that employed children younger than sixteen years of age—eleven and two of them, respectively. All the cotton gins reported women employees: Waterhouse listed fifteen, Stuart and Wallace reported twenty women apiece, and Pollitzer, thirty. Women and children outnumbered male employees in all the cotton concerns. In 1870, the Pollitzer gin produced goods valued at $17,450, the most of any of the Beaufort enterprises.

St. Helena Parish and the town of Beaufort had a diverse and cosmopolitan population in 1870. The white population in the parish had declined from 1,062 to 600 in 1870. There were 29 free black persons and 7,644 slaves living in the parish in 1860. In 1870, the parish's black residents numbered 11,063. According to the 1870 census, eighty-one

Rachel Mather established the institution that became Mather School in 1868. The school operated until 1968. *No. 10171.6. Courtesy of the South Caroliniana Library, University of South Carolina.*

129

G.W. Woodman's store, Pier no. 2, 1866 (John Cross Tavern). Woodman, a native of Maine, and his family moved to Beaufort after Beaufort was occupied by federal troops. *South Carolina National Register of Historic Sites, Beaufort County. Courtesy, South Carolina State Historic Preservation Office, South Carolina Department of Archives and History.*

of Beaufort's six hundred residents were born abroad. Among the birthplaces listed were Canada, the British Isles, Switzerland, Austria, France, a number of the German states (Prussia, Bremen, Baden, Hesse-Darmstadt, Hanover and Bavaria), India and Barbados. The percentage of foreign-born was roughly analogous to the population of the town of Beaufort in 1860. The big difference between 1860 and 1870 in Beaufort's population was the increase in the number of residents who had been born in the United States but not in South Carolina. Of Beaufort's 600 residents, 348 fit this category. The state of Massachusetts claimed fifty-five of Beaufort's citizens. New York and Maine rounded out the top three Northern states to have sent immigrants into South Carolina.

The ten years between 1860 and 1870 saw a great Southern migration of professionals, businessmen, artisans and others into Beaufort. This immigration altered the economy of the parish. There were more small farmers and fewer large plantation owners. There was a greater variety in the occupations listed. The number of teachers had grown, but the number of physicians and lawyers had declined. There were changes in the social, religious and intellectual life of the parish. The new residents assumed political and economic power in post–Civil War Beaufort. Niels Christensen, native of Denmark and former

The National Cemetery in Beaufort was established in 1868. Captain Neils Christensen was superintendent of the cemetery from 1870 until 1876. *National Register of Historic Sites, Beaufort County. Courtesy of the South Carolina State Historic Preservation Office, South Carolina Department of Archives and History.*

Union officer, began life in Beaufort as the superintendent of the National Cemetery. He parlayed that beginning into retail sales, real estate and local politics. George Waterhouse of Maine also became a successful businessman in post–Civil War Beaufort. The 1870 census also listed H. Von Harten, grocer, and August Scheper, dry goods clerk, both from Hanover, now part of Germany.

According to the 1870 census, of the 1,274 black residents of the town of Beaufort, only 112 had an occupation listed. The occupations listed ranged from public officials to domestic service. As a point of comparison, 191 of Beaufort's 465 white inhabitants listed an occupation. In 1870, there were seventy black property owners in Beaufort and fifty-eight white ones. Of these 128 individuals, only 22 owned property whose value exceeded $4,000. Of the twenty-two, there were three white South Carolinians (Dr. Joseph Johnson, Mary Rhett and H. Stewart) and one black South Carolinian (Robert Smalls).

Despite other decreases, the number of churches increased as the former slave members organized independent worship centers. In 1870, the area reported thirty Baptist churches,

131

twelve Episcopal churches, twenty-four Methodist churches, two Presbyterian churches and one Catholic church. Following the Civil War, Beaufort's black residents worshipped in Tabernacle Baptist Church, First African Baptist Church, Grace Chapel African Methodist Episcopal Church, Wesley United Methodist Church South and Berean Presbyterian Church.

The *Beaufort Republican* with a circulation of four hundred was, according to the census, the only newspaper in the town. The library situation most graphically reflected the intellectual cost of the war. As of 1 June 1870, Beaufort had no town library, no court library, no church libraries and no college libraries. Beaufort and St. Helena Parish were adapting to a new-world order, socially, economically and politically.

The troops left, and some of the old families returned. The homecomings were bittersweet. Some came and left; others tried to make sense of the new order. Many never returned. All found a new atmosphere and new attitude among Beaufort's black citizens. Among the antebellum families that returned to Beaufort after the Civil War were the Talbird, Barnwell, Hazel, Stuart, Sams, Rhett, Fripp and Jenkins families.

The trustees of Beaufort College attempted to reopen the college and the seminary for women. They reclaimed part of the property, consolidated the seminary with the college and struggled for several years. Increasingly, the college became involved with the new system of public schools created by the South Carolina constitution of 1868. In 1871, there was an offer to employ R. B. Fuller, the school's commissioner, as superintendent of the public schools—if Fuller would open his school without fees. The college, the public schools and for a time, the Freedmen's Bureau, cooperated to pay Fuller's salary. Between 1882 and 1892, Peabody funds, established in 1867 to provide funds for school construction, teacher salaries and scholarships for former slaves, contributed to the operation of the school.

A transportation revolution hit Beaufort in 1872. The South Carolina General Assembly chartered the Beaufort Horse Drawn Railroad Company. Originally, the company had the right of way to run horse-drawn cars only from East Bay Street to Port Royal. In 1873, the charter was revised, and the company had unlimited access to Beaufort County roadways. The Port Royal and Augusta Railroad offered a nearby rail connection. By 1896, the Charleston and Western Carolina Railroad planned to build a passenger and freight depot in Beaufort.

In 1874, in a late show of defiance against the creeping tentacles of Democratic resurgence, W. M. French founded the Beaufort *Tribune*, a Republican newspaper. French was a native of Delaware and listed no occupation on the 1870 census.

Edward King visiting Beaufort that year found Bay Street so quiet that it seemed "the town was asleep." Buzzards slept in front of the Sea Island Hotel and "the silence of the grave reigned everywhere." Economically, the county floundered, and the town of Beaufort was not immune to the vicissitudes of political and economic uncertainties.

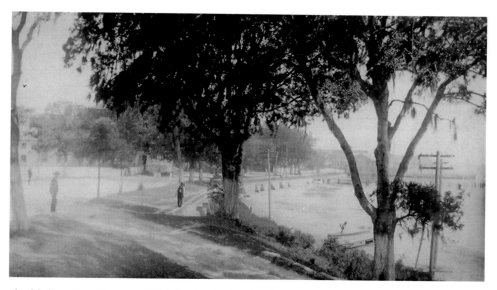

The bluff on Bay Street, c. 1875. By 1882, Beaufort had a mile-long shell-laid road that curved along the river bluff bordered by a grassy promenade with large oak trees. *Courtesy of the South Caroliniana Library, University of South Carolina.*

In 1876, the Hays-Tilden presidential election provided the opportunity for Congress to end Reconstruction in the South. Federal troops remained in only two Southern states—South Carolina and Louisiana. In a hard-fought, legally contested, sometimes violent election, South Carolinians had elected the Democrat Wade Hampton governor of South Carolina. In October 1876 prior to the election, Hampton addressed an unsympathetic gathering in Beaufort at a stand near the clubhouse. After dinner, Alfred B. Williams, a reporter covering the Hampton campaign, departed over the Shell Road, "perhaps the one beautiful stretch of road in South Carolina at the time." Hampton was elected without carrying Beaufort County.

The winds of change were blowing. Republican strength vaporized. In the election of 1878, the only Republicans, black or white, elected to the South Carolina House of Representatives were three men from Beaufort County. During the 1880s, Republicans and Democrats in counties such as Beaufort and Georgetown attempted fusion politics. Under this umbrella, the two parties split the local and state offices under an agreed formula. These agreements gave black office holders a tenuous toehold on political power that often lacked substance. Republicans in Beaufort bucked the statewide trend and continued to hold local positions into the 1890s.

Yet, economically, the white citizens still held the power. Despite the efforts of the Freedmen's Bureau, General Saxton, the educators and ten years of ballot power, the majority

of Beaufort's black citizens worked at manual labor. A few were lawyers, and several prewar tailor shops persisted. Others were carpenters or hack drivers. One operated a harness-making business. The white citizens held the economic clout.

STATUS QUO ANTEBELLUM

By 1879, Beaufort once again was a resort community, but with a difference. The Sea Island Hotel reopened in 1872 with more rooms for visitors who wanted to enjoy the quiet "melancholy" beauty of Beaufort. Visitors came, but the population did not shift with the seasons. The town appeared to be well equipped to combat the fires that periodically broke out in Beaufort. She had a number of white fire companies—two fire engines and two hose-reel companies, one hook and ladder, and one black hand-engine company. For spiritual edification she boasted seven churches plus two Masonic lodges, a New England Society, a Bible Society, a bank, an artillery company, two newspapers, a yacht club and a drama society. Visitors had a choice of two hotels, the Sea Island Hotel or the Beaufort House.

Sea Island Hotel, 1906. George M. Stoney built the house c. 1820. For many years the hotel was a popular tourist destination. The building was razed, and the Sea Island Motel built on the site in 1960. *Copy photograph, Ned Brown. The Rotograph Company, New York City. Local History Collection, No. 2164958. Courtesy of the Beaufort County Library, Beaufort.*

One of her newspapers, founded that year, was the *Sea Island News*. For many years, under the leadership of her editor, P. B. Morris, the *Sea Island News* was the primary Republican paper in South Carolina and one of the leading black newspapers in the South. This situation ended with Morris's death in 1891.

For the period 1 June 1879–31 May 1880, the town of Beaufort was recovering and supported a large variety of large and small commercial enterprises. A survey of these businesses shows the effect of Federal occupation, the influx of Northerners and foreign-born immigrants into the county, and the few black South Carolinians who had carved out an economic niche.

Silas M. Wallace ran the sole gristmill and employed four. There were three meat-packing operations: John Franz with four employees; Jenkins & Alston with two; and James H. Tomkin with two. Franz was a native of France and listed his 1880 occupation as grocer, wholesale and retail. But Jenkins & Alston was a black-owned firm. Mingo Jenkins was a farmer and William Alston was the butcher. Both had been born in South Carolina.

William H. Calvert, a native of New York, with six employees, produced tin, copper and ironware. There were four cotton-ginning concerns: Silas M. Wallace with 30 employees, George F. Ricker with seventy-two employees, Moritz Pollitzer with sixty and George Waterhouse with seventy-five. All of the cotton concerns, except for Wallace's, employed men, women and children. Wallace employed only adults. Wallace was born in Ohio. The others had been born in the North or abroad: Waterhouse in Maine, Pollitzer in Austria and Ricker in Massachusetts. Waterhouse's mill stood near the river opposite the entrance to Charles Street; Pollitzer's on the north side of Bay Street; and Ricker's mill on the corner of Port Republic and West.

Constant Bero with two employees and James Odell with five ran the two bakeries. Odell, the father of the actress "Tillie" Odell, was a native of New York. In 1880, his occupation appeared as baker, while his wife Alice was listed as a confectioner. Richard N. Wright, a black South Carolinian, operated a saddlery; John Knecheli bottled mineral and soda water. Joshua A. Whitman, originally of Maine, was a machinist; B. P. Cuttino made boots and shoes. D. C. Wilson & Company operated a sawmill and lumberyard. Duncan C. Wilson, a New York native, and only twenty-two years of age in 1880, had the lumber business. His father, Duncan C. Wilson, a native of Scotland, was president of the railroad. Of all this entrepreneurial talent, only Wallace, Waterhouse and Pollitzer had been in business in Beaufort in 1870. Jenkins, Alston and Wright were Beaufort's black businessmen.

In 1882, Beaufort had a population of 2,549. The town had a mile-long shell-laid road that curved along the river bluff bordered by a grassy promenade with huge oak trees. Beaufort had twenty-seven miles of streets that were between forty and sixty feet wide. Laid out with streets running east to west and north to south, the town was divided into 137 blocks. Beaufort had a number of small parks, and used wells and cisterns to furnish water for her citizens. Surface

Everyday scene, c. 1880. Whether by oxcart, by horseback or on foot, patrons frequented Beaufort's Bay Street merchants and purchased the "Fancy Goods" offered by John Cooper. *Wilson and Havens, Savannah. No. 12539. Courtesy of the South Caroliniana Library, University of South Carolina.*

and underground drains collected the sewerage and emptied it into the Beaufort River at the low-water mark north and south of the town. Besides the Sea Island Hotel, Beaufort had a number of boardinghouses for visitors and long-term residents. In addition to such public buildings as the arsenal (then used as a courthouse), Beaufort had a town hall, the Steam Fire Engine House and Hall, and two hand-operated fire engine houses. The town had an indebtedness of $5,000 borrowed to cover the cost of buying a steam fire engine, constructing

the engine house and installing the brick sewer. More than seventy-five hundred Civil War casualties (Union and Confederate) were buried in the thirty-acre National Cemetery on the outskirts of town. President Abraham Lincoln established the Beaufort National Cemetery in 1863. In 1989, in a special ceremony, the remains of nineteen Union soldiers from the 55th Massachusetts Regiment, a black unit, were interred there.

According to the South Carolina Board of Agriculture, Beaufort was a church-attending town in 1882. Or at least, the opportunities for church attendance were great. Her white citizens had an Episcopal Church, a Baptist Church and a Catholic Church. Her black residents had two Baptist Churches, two Methodist Churches and one Reformed Episcopal Church. Sixty students were enrolled in the white school and one hundred in the black school. Also, The Presbyterian Church in the United States of America organized the Beaufort Presbyterian Academy in 1882. The academy, located in the William Wigg Barnwell House, 1883–1909, functioned until the 1920s.

More than one thousand of Beaufort's black residents belonged to a charitable society. Some of the societies functioning in 1882 were the Benevolent Society of the First Baptist Church, the Workers of Charity, the Shekinah Society, the Sons and Daughters of Zion, the Rising Sons and Daughters of Benevolence, the Rising Sons and Daughters of Charity, the Mary and Martha Society, the Olive Branch, the Sisters of Zion, the Knights of Wise Men and the Independent Order of Odd Fellows. Robert Smalls, for example, was a member of the Odd Fellows and a Mason.

Beaufort had a three-man police department but, at that time, probably did not need it. According to the report, Beaufort was "remarkable for quiet and good order; for twenty years past, not a single individual has been killed or seriously injured in any disturbance within the corporate limits."

The town had forty-three stores in 1882 retailing groceries, hardware and dry goods. Other businesses included three steam gins, two sawmills and three manufacturing plants that processed phosphate rock into fertilizer.

In 1883, construction began on the Beaufort County Courthouse (now the Federal District Court Beaufort) overlooking the Bay. The building opened in 1884, and was substantially remodeled and given an art deco facade in 1936.

Visitors then, as in the past, focused upon the town's healthy climate and its attraction for sportsmen. On the verdant islands of Beaufort County, hunters pursued the fox, deer and wild turkey. Ducks and other waterfowl of the rice fields of the Ashepoo and Combahee Rivers provided rich harvests.

In addition to hunting, Beaufort with its many and winding waterways was a mecca for fishermen. A perennial favorite was drum fishing in early April. Drum fish ranged from thirty to more than eighty pounds. The sea bass was the angler's fall attraction.

The Beaufort County Courthouse, 1501 Bay Street. Robert McGrath of Augusta was the architect for the original brick courthouse in 1883. In 1936, the courthouse was remodeled and given an art deco exterior. In 1994, the building began a new life as the Beaufort District Federal Courthouse. *South Carolina National Register of Historic Sites, Beaufort County. Courtesy of the South Carolina State Historic Preservation Office, South Carolina Department of Archives and History.*

A visitor wrote of his impressions from a window of the Sea Island Hotel. He noted the "pleasant expanse of water, where sloops floated lazily in the morning sun" and the black laborers loading phosphate onto flatboats at low tide. He found Beaufort "interesting" because the town was "ancient" and "[a] melancholy interest attaches to the fine and stately old mansions which border the water front, for here war has made sad havoc."

The visitor's glimpse of the phosphate flatboats was a visual reminder of the industry that brought Beaufort and the Port Royal area new prosperity after the difficult Civil War years. The phosphate industry flourished in the area between 1880 and 1899. Analysis of rock in Beaufort County found that the rock in the Coosaw River and Chisolm Island area was particularly rich in phosphates. The 1880 census of industries listed the following phosphate companies operating in Beaufort County: Coosaw Mining Company, Farmer's Phosphate Company, Pacific Guano Company, South Carolina Phosphate Company and W. G. Tripp.

At first, companies mined the rock either on land or in the river by hand, but later, they mechanized river mining with steam-powered engines and dredges. The later forms of extraction required greater capital outlay. The Farmer's Phosphate Company, for example, had two dredges in St. Helena Sound in 1886. The mining produced tricalcium phosphate that was

The seawall, 1882, with the Lewis Reeve Sams house in the background. The Sams House, built by a Datha Island planter c. 1852, sits on a point of land where the Beaufort River turns northwest and rounds the Point. *Wilson and Havens, Savannah. No. 12592.1. Courtesy of the South Caroliniana Library, University of South Carolina.*

treated to create a rich fertilizer desperately needed by the depleted cotton fields of the South as well as by overused farmland nationally and internationally. For example, poor cotton land produced a poor cotton yield and lower prices. So, the development of an adequate supply of fertilizer was essential for the economic future of agriculture. Commercial phosphate mining began in the Charleston area in 1868 and spread into Beaufort County in the 1870s.

The phosphate market was unstable as much of the rock was sold directly to Europe and not processed in the United States. Consequently, there were periods when the overseas markets paid less than the cost of producing the rock. By the late 1880s, only the largest companies were regularly mining and exporting phosphate rock. By the 1890s, largely due to competition from the Florida fields, the price per ton had dropped from an average of $6 in the 1880s to less than $3. Yet, by 1889 phosphate-mining operations in Beaufort had shipped 2,180,506 long tons of phosphate rock. Not all rock was shipped, as some was processed into fertilizer at the Port Royal Fertilizer plant.

Phosphate mining was dangerous and unhealthy work, but it pumped dollars into the Beaufort economy. The majority of Beaufort County's black residents worked in the phosphate mines or on the docks. Ships transporting the rock needed pilots in order to safely sail into the harbors. According to state regulations, each of the affected ports, Beaufort, Charleston and Georgetown, had a Board of Pilot Commissioners. Foreign ships also needed clearance from a

The phosphate wharf, June 1874. Mining of phosphates began in Charleston County and spread to Georgetown and Beaufort counties. The Hurricane of 1893 dealt a severe blow to the industry. *No. 13204. Courtesy of the South Caroliniana Library, University of South Carolina.*

quarantine station. There were two quarantine stations in the Beaufort area. One was the St. Helena Station on Buzzard Island in the Bull River. The other was the Port Royal Station on Parris Island. The Port Royal Station stood near the Officers' Club on Parris Island and had a six-bed hospital.

Despite this seemingly idyllic picture of Beaufort and environs, the winds of reaction were sweeping the state of any the last vestiges of black political power. In 1882, the South Carolina General Assembly adopted the so-called Eight Box Law, devised by historian and former Confederate General Edward McCrady Jr. of Charleston. The Eight Box Law authorized separate ballot boxes for each office. Voters then had to deposit their ballots in the correct box, or the ballot was void. The law also designated 1 June 1882 as a voter registration/reregistration cutoff date. Anyone of voting age failing to register by that date would never be able to vote in South Carolina. Beaufort County Senator Thomas E. Miller challenged the motives of McCrady and the bill's supporters. Miller understood that the law was intended not to improve the literacy of South Carolina's voters, but to limit the number of black voters who could vote. His assessment was correct as the act disenfranchised roughly three-fourths of South Carolina's black voters.

Washington Street. Beaufort Album c. 1895. The scene looks eastward down Washington Street from its intersection with New Street toward the Point. *Courtesy of the South Caroliniana Library, University of South Carolina.*

In 1883, thanks to the efforts of United States Senator Matthew Calbraith Butler, the United States Navy established a modest naval station at Port Royal. United States Senator Benjamin R. Tillman also lobbied for the station, but Port Royal lacked a railroad and few sailors welcomed an assignment there. Congress voted to close the station in 1900, but Tillman salvaged something for the Lowcountry when he successfully persuaded the Congress to build a larger naval station at Charleston.

Chapter 9

The Nineties, the Storm and Jim Crow, 1890–1899

B EAUFORT IN THE 1890s WAS looking forward with occasional glances over her shoulder. The great upheaval of Reconstruction had settled. White citizens were picking up the pieces and some of those pieces were quite profitable. With the income from phosphate mining, the county was prosperous. The relocated Northerners and immigrants had invigorated the Beaufort economy. There were new businesses and shoppers with money to spend. The new decade looked hopeful.

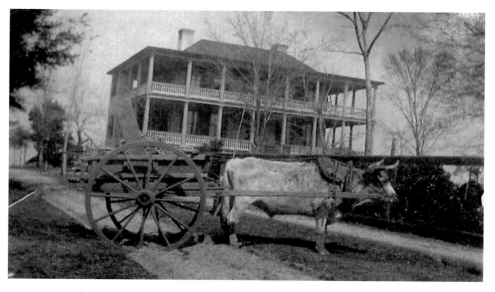

An oxcart in front of the Niels Christensen House, 411 Bayard Street c. 1895. The Reverend Thomas E. Ledbetter, a Methodist minister, built the house c. 1840. *Beaufort Albums, c. 1895. Courtesy of the South Caroliniana Library, University of South Carolina*

THE "GAY" NINETIES

The year 1890 was a crucial one for the state of South Carolina. Styling himself a reformer, Benjamin R. Tillman won the gubernatorial race in South Carolina. With no active Republican Party functioning at the state level, his only opponent was A. C. Haskell, a supporter of Governor and former Confederate General Wade Hampton III, who ran as an independent. His campaign rhetoric targeted the black leadership in Beaufort County. Tillman carried thirty-two of South Carolina's thirty-four counties. Only the counties of Beaufort and Berkeley cast a majority of their votes for Haskell.

Decorated altar at St. Helena Parish Church, c. 1890. *Christensen Family Papers, Folder 39. Memory Book, Christensen Family Papers, Folder 39. Courtesy of the South Caroliniana Library, University of South Carolina.*

Nevertheless, the nineties began auspiciously for Beaufort. In April 1891 when the Vanderbilt Benevolent Association of Charleston visited, its members noted the "golden sunshine." Major W. H. Lockwood, president of the Bank of Beaufort, met the eighty society members and their wives at the depot. Society members marched in ranks to St. Helena Church to honor the graves of two of their departed members—B. B. Chaplin and Henry A. Cunningham. After dinner at the Sea Island Hotel, the Reverend J. B. Campbell of Carteret Street Methodist Church preached on the subject of benevolence.

The visitors were duly impressed with the harbor that stretched twenty miles to its entrance at Hilton Head. From an upper-story window at the Sea Island Inn (probably Sea Island Hotel), Beaufort appeared as a "forest, with beautiful broad, triangular streets." The visitors estimated a population of four thousand with a black/white ratio of three to one. Beaufort was the most important town in the Seventh Congressional District, noted for its overwhelming black population. From the viewpoint of these visitors, "northerners and foreigners" ran the businesses in Beaufort. The Germans, perhaps because a number of the society's members were of German origin, were singled out for special commendation of their "well-to-do colony." The "Vanderbilts" left Beaufort with thoughts of its "better future" and hopes that it "will be a great town one of these days." "One of these days" was going to be a while in arriving.

Still, a harbinger of Beaufort's future was on the horizon. On 26 June 1891, the United States sent a small detachment to Parris Island in connection with the naval station. The detachment assisted island residents during the hurricanes of 1893 and 1898.

TERROR IN THE NIGHT

A small notice in the Savannah *Morning News* announced the third cyclone (or hurricane) of August 1893. Having weathered many storms, the inhabitants of the Sea Islands of Georgia and South Carolina had little idea what lay ahead. By the time the sun shone again, hundreds were dead and unaccounted for, ships were wrecked, businesses and homes flooded and or destroyed, and economic and personal disaster loomed. The hurricane of 1893 was a Category 3 hurricane with winds of 120 mph and a storm surge of between 10 and 12 feet.

The isolation of the islands precluded press coverage for the terrible suffering of the islanders who lacked food and shelter. Telegraphic communication with Charleston was severed. One observer wrote that "No section of the broad country ever suffered a worse fate than that around Beaufort and Port Royal." While Charleston and Savannah lost few of their citizens, Beaufort and Port Royal lost at least 752 of the 18,100 who lived in the area. The town of Beaufort with a population of thirty-five hundred lost only two. St. Helena Island and the Savannah River plantations accounted for 350 of the known dead that August.

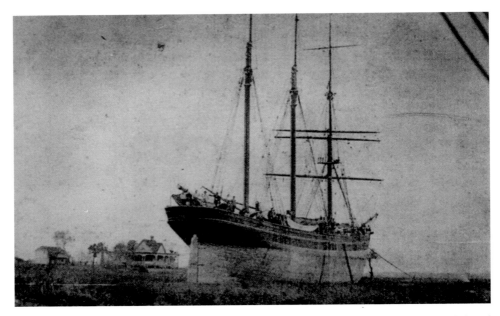

A ship aground following the hurricane of August 1893. The Hurricane of 1893 grounded and wrecked ships, demolished homes and destroyed crops. According to the Savannah *Morning News* of 29 August, the rice crop was "almost a total loss." *Copy photograph, Ned Brown, Local History Collection. Courtesy of the Beaufort County Library, Beaufort.*

With homes, crops and families lost, the residents of Beaufort County faced starvation. For example, 75 percent of the houses on Lady's Island were destroyed. Reports from St. Helena described housetops "resting in trees" and "not a dry spot on the island." With starvation imminent for many, the residents of Beaufort appointed a relief committee. The members were George Holmes, the intendant of Beaufort; William H. Lockwood, a banker; Robert Smalls, collector of the port and former United States congressman; Captain Niels Christensen, former captain of a black regiment during the Civil War and hardware storekeeper; Thomas F. Walsh, dispenser (chemist); E. F. Convonsieur, railroad agent; and George W. Ford, another leader in the black community. In August 1893, this committee estimated that eight hundred had died in the storm and six thousand desperately needed assistance. Later estimates numbered the death toll as between fifteen hundred and three thousand.

While the town of Beaufort sustained major property damage, the primarily black residents of the county lost homes, jobs and families. The enormity of the human losses, the misery on the islands and the slow pace of assistance created racial tensions in Beaufort.

The hurricane's winds uprooted trees, and Senator W. J. Verdier described the water damage. According to Verdier, the normal high tide was at 10:30 p.m., but at midnight, the

water had not gone down. Rather, the water "suddenly rose 2½ feet and in upon us with a sudden rush...like a tidal wave." At its peak, the tide was eight feet above a normal spring tide and water levels rose even higher with the rain and the churning water. In the town of Beaufort, the waves were twenty feet high.

Most of the damage in the town came when the storm winds shifted from a southeasterly path to a southern one. Two of Beaufort's black residents—an elderly man and wife seeking shelter—died the night of the storm. According to resident Mabel Burn, thirty people—brought on three trips of the ferry—found shelter in the Burn home the night of the storm. Homes, wharves, and businesses were damaged and destroyed. The waves destroyed the seawall and demolished the docks. The storm destroyed F. W. Scheper's warehouse, and then picked up the pieces of the building and dumped them near the courthouse. Waterhouse & Danner lost cotton gins and warehouses filled with sea-island cotton and groceries. The receding water deposited two great boilers from the Waterhouse gin in front of the Sea Island Hotel. Senator Verdier lost his home, library and personal papers.

The Beaufort House, a boardinghouse, lost its roof and top story. T. F. Walsh's store sustained damage as did Mrs. Johanna E. Ohlandt's building. J. H. Harrison lost buildings and his wharf. R. A. Long lost not only his gristmill but large quantities of hay and grain. Long rebuilt his mill, adding an ice factory, and by 1899 there was an electric light company on the premises. William R. Bristol's jewelry store, William E. Hilton's furniture store, Aaron M. Greenfield's jewelry store and Constant Bero's bakery all were greatly damaged from the storm. Dr. A. P. Prioleau's property was damaged and his store flooded. The young merchant, H. F. Von Harten, suffered a major loss as his home, store and wharf were severely damaged and his cellar flooded. Among the goods lost to that flood were thirty barrels of

C. E. Danner & Company, a mercantile establishment, c. 1903. Begun in 1876, the store continued as Wallace and Danner until it closed in 1970. *Courtesy of George A. and Evelyn Jones.*

rice. Water covered the store and wharf of W. P. Roberts. Wallace & Danner's dry goods establishment lost "at least $1,000 worth of goods." All the businesses south of Bay Street sustained great losses. The estimates for total damage from the storm of 1893 topped $10 million. The storm damaged both the Beaufort College building and the Female Seminary. That bright dream was fading.

This account of damages offered a slice in time view of commercial enterprise in Beaufort in 1893. From its inception, the town of Beaufort has always had an orientation toward the sea. Without the sea, there would have been no Beaufort. The number of wharves and warehouses damaged reflect Beaufort's importance as a trade entrepot. Her commercial enterprises related to trade. Her merchants were cosmopolitan in background and ethnically diverse. The residents of Beaufort were wealthy enough to support a variety of stores with a wide array of merchandise, and the town was also strategically placed to be the primary source of provisions for the island residents.

In September, Clara Barton and the American Red Cross came to aid those whom Barton would eventually term her "30,000 friends." Governor Benjamin Tillman had written Barton requesting assistance and Senator Matthew Calbraith Butler of South Carolina accompanied her to Columbia. Tillman met their train, and together they proceeded to Beaufort. Relief

Stranded vessels near Beaufort after the hurricane of August 1893. Three storms struck the Sea Islands in August 1893. *Copy photograph, Ned Brown, Local History Collection. Courtesy of the Beaufort County Library, Beaufort.*

donations were small and of short duration. Tillman recognized the disaster but vacillated on the extent of the damage. He feared providing too much assistance and, consequently, gave too little. Without the Red Cross, the suffering in Beaufort County would have been greater. Tillman entrusted the recovery effort to Barton, the "Angel of the Battlefield" during the Civil War. According to Barton, in the first ten days of her stay in Beaufort, it was impossible to walk the streets of Beaufort for the mass of distressed humanity that crowded near the warehouses. Barton described her Herculean task thusly:

The submerged lands were drained, three hundred miles of ditches made, a million feet of lumber purchased and houses built, fields and gardens planted with the best seed in the United States and the work all done by the people themselves.

Not all Beaufort residents were impressed with the efforts of the Red Cross. The editor of the *Palmetto Post* alleged that Miss Rachel Mather, who had founded Mather School in 1868, "did more real good work among the [storm] sufferers than the vaunted Red Cross" with four times the funds. The editor in March 1894 also commended the relief efforts of local citizens J. J. Dale, George Holmes, Captain Niels Christensen and Elizabeth Hyde Botume, as well as the Beaufort Relief Committee, then composed of White, Gibbes, Talbird and Dr. A. P. Prioleau. Dr. Prioleau operated a drugstore and advertised buttermilk soap, Simmons Liver Regulator and Bromo-Seltzer.

The steamer *Clifton* that ran between Beaufort and Savannah was blown into the bluff near the courthouse. During the storm, the steamship *City of Savannah* ran aground on a sandbar three miles off Hunting Island. Her passengers and crew safely made their way to shore. Some were taken to Coffin Point, but all survived. Days later, the last stragglers made their way home to Savannah. The action of the waves eventually broke the ship apart, leaving only its steam engine and rudder. Today, fishermen anchor at the site of her boiler, angling for sheepshead and drum. The wreck of the *City of Savannah* is, according to Pierre McGowan, "one of the premier saltwater fishing drops along the South Carolina coast." McGowan, longtime postal deliveryman from St. Helena Island, wrote from personal experience.

The accompanying tidal wave not only damaged the bay-front stores and wharves in the city of Beaufort, but also, with one fell swoop, destroyed the phosphate mining industry and the commercial production of rice. The hurricane and tidal wave disrupted mining operations, decimated the work force, and damaged or destroyed dredges, equipment and watercraft. Efforts to resume mining were limited and taxes were high. The few companies who were left after 1893 closed their doors by 1914.

The storm also flooded the rice fields, destroyed the crop, washed out the dykes and damaged trunk lines. Though damaged, planters struggled on until another storm hit on

"Pilot Boy Aftermath of the Storm of 1893." Taken after the hurricane of August 1893 struck Beaufort, this is a view of Bay Street in front of the residence of the Honorable William Elliott. The clubhouse is barely visible to the right. The steamer *Pilot Boy* lists on the left. The vessel in the middle is the *Reliance,* and the *Juno* lies on the right. The SS *Pilot Boy* plied the waters between Savannah and Charleston. *Copy photograph, Ned Brown, Local History Collection. Courtesy of the Beaufort County Library, Beaufort.*

29 September 1898. After that South Carolina planters only grew rice on the Combahee and Edisto Rivers. Even that limited growing area disappeared with the storm of October 1910 that sealed the fate of South Carolina rice production. In addition, new areas, such as Louisiana, were growing rice less expensively with mechanized equipment that could not be used in South Carolina fields. Between competition and the cost of restoring the fields, rice production in the Carolina Lowcountry never recovered.

With one tragedy, two of Beaufort County's rungs in the economic ladder of post–Civil War recovery were, if not "gone with the wind," seriously impaired. As late as 1964, the *State* newspaper in Columbia termed the Hurricane of 1893 the "worst disaster" to strike South Carolina. The arrival of Hurricane Hugo in 1989 relegated this deadly storm to second billing statewide, but it still ranks as number one in the annals of Beaufort and of Beaufort County.

Susan J. Rice survived the storm of 1893, but lost her beloved brother, Dr. Gowan Hazel who was drowned at the pier on Parris Island trying to save two young black men. Hazel was a Civil War veteran who had owned a plantation on St. Helena Island before the war. At the

time of the storm, he was the quarantine doctor for the naval station on Parris Island and was much loved for his ministering to the community.

Rice's diary captures the pathos of daily survival and the poignancy of enduring loss. On Sunday 27 August she noted that the wind had blown all Saturday night and continued on Sunday. A dinner guest could not return to Port Royal because of the hard rain and wind, but remained with the Rice family. That night the water rose, and saltwater covered everything. Rice and other Beaufort residents lost their freshwater as the tidal wave had overrun cisterns and saltwater permeated wells. Maintaining an adequate supply of freshwater was a major challenge for storm survivors. Dr. Hazel's body was recovered at the end of the Parris Island pier. As Rice described Hazel's homecoming, "He does not look natural but is a small comfort to be able to look upon his poor discolored face once, but to think I shall never hear him speak again is too much for me to bear."

Beaufort had barely recovered from the storm of 1893 before another dangerous storm arrived on 29 September 1896. A number of homes lost roofs and porches, and some residences on Bay Street and the Point were totally demolished. Among the homes damaged on the Point were those of Niels Christensen and Dr. A. P. Prioleau. According to the *Palmetto Post*, "Every window on the south side of the Courthouse is bursted and the glasses gone," and there was "ruin and devastation" on every side.

The Hurricane of 1893 is justifiably the most famous of Beaufort's storms, but in reality, it was only one of a number of hurricanes that have visited the Beaufort area. Recessed from

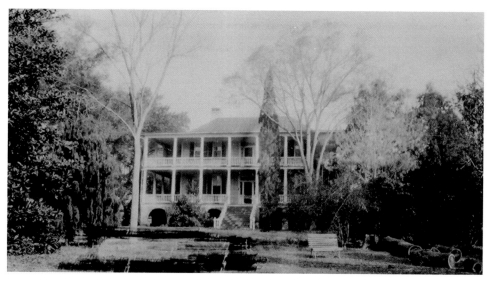

Christensen home, Bayard Street, with trees damaged by the storm of 1896. *Christensen Family Papers, Folder 43. Courtesy of the South Caroliniana Library, University of South Carolina.*

the coast, Beaufort enjoys a natural protection from most tropical disturbances. The "right" combination of wind currents and high pressure can produce deadly results. The earliest recorded hurricane struck Beaufort in the eighteenth century. The last one was Hurricane Gracie that visited in 1959.

CHANGING OF THE GUARD

In addition to the devastation wrought by the Hurricane of 1893, the black residents of Beaufort and of Beaufort District faced other challenges. The shadow of Jim Crow lengthened as laws limited black access to public accommodations and the political process. To limit black voting strength, Governor Benjamin Tillman and other state leaders lobbied for a new constitutional convention. Convened in 1895, the convention produced a constitution more reactionary than the one of 1868. South Carolina's 1895 constitution contained several provisions that severely restricted the rights of her black citizens. Beaufort resident Robert Smalls spoke heatedly against the proposals, and Thomas E. Miller stirringly recounted the black contributions to the history of South Carolina and the United States of America. But with a white majority in the convention, especially one committed to the ideology of Ben Tillman, the voices of these black representatives were not heeded. In protest, Smalls and the other black delegates, representing Beaufort and Georgetown counties, the last bastions of black political power, refused to sign the constitution. In addition to Smalls, the delegates from Beaufort County were Thomas E. Miller, William J. Whipper, James Wigg and Isaiah R. Reed. Robert B. Anderson was the only black delegate from Georgetown County.

Smalls did challenge one of South Carolina's little-discussed social interactions—the intimate relationships of white men and black women that dated from the earliest days of slavery. Delegates to the constitutional convention wanted to include a prohibition against miscegenation in the constitution. So, Smalls proposed an amendment to the motion that would ban any white person intimately involved with a black from public office. Smalls's amendment also would have given any child born of such a union the right to bear his father's name and an interest in his father's estate. The amendment failed, but the audience was discomfited.

By 1899, the Presbyterian Board of Missions had established a school for freedmen in Beaufort. The school was called the Harbison Institute.

In 1899, Judge Christie Benet, sitting at Beaufort, noted that blacks and whites were sitting together on the courtroom benches. Benet then ordered the whites to one side of the room and the blacks to the other, because he said, "God Almighty never intended that the two races should be mixed." Segregation had returned to Beaufort.

With federal patronage, black leadership survived in Beaufort into the twentieth century. Robert Smalls, Civil War hero and one-time United States congressman, lost his seat in the

election of 1887, but served as the collector of the Port of Beaufort, 1889–1893 and 1897–1913. Smalls died in 1915 and was buried at Tabernacle Baptist Church. A moving testament to his character is his statement of 1 November 1895: "My race needs no special defense, for the past history of them in this country proves them to be equal of any people anywhere. All they need is an equal chance in the battle of life."

The United States Army honored Smalls by naming a logistics support vessel in his honor. The LSV-8, the MG *Robert Smalls*, was christened 21 April 2004. The *Robert Smalls* was the first army ship named for a Civil War veteran and the first named for a black American. Substantive efforts toward interracial cooperation and power sharing would not surface again until the 1960s.

Yet, Beaufort's black citizens remembered. Celebrations born in the early years of emancipation continued to affect the lives of Beaufort's black residents. According to the *State*, in 1897 Beaufort hosted a major celebration of Decoration Day (30 May, also known as Memorial Day). Blacks traveled from Greenville by train, and from Savannah and Charleston by steamer. Residents from Lady's and St. Helena islands came by ferry. Military units came from Columbia and Augusta. The newspaper estimated that more than ten thousand people were in Beaufort eating and drinking lemonade. There was a parade to the National Cemetery and speeches. Then, the attendees placed flowers and small United States flags on the graves. The day concluded with dances and other social activities. One of the most remembered of the Decoration Day speakers was Booker T. Washington. As former slave Sam Mitchell stated, Washington "wasn't no president, but he was a great man." Lucretia Heyward remembered that Washington made a "beautiful speech." J. E. McTeer also remembered the music of Decoration Day, especially a local band rivalry that produced strong competitive play between the Ropers of Beaufort and the Warsaw Band from the islands.

As late as the 1950s and into the 1960s, Beaufort's Memorial Day, or Decoration Day, drew celebrants statewide. The participants decorated the graves of Union soldiers in the National Cemetery, listened to speeches and thronged the streets to see the parade. Booths selling food lined Boundary Street. The parade, a highlight of the celebration, featured the Robert Smalls High School Marching Band as well as bands from Savannah and other towns. While Beaufort was the center of the Memorial Day celebration, the Fourth of July and Emancipation Day were celebrated on St. Helena Island.

Just as many veterans retired in Beaufort in the second half of the twentieth century, many veterans of black Union regiments chose to remain in the area after the Civil War. These veterans organized the David Hunter Post No. 9, Grand Army of the Republic, and in 1896 built a meeting hall on Newcastle Street.

In 1897, the Beaufort Knitting Mills opened. The mill employed black women and opened with a work force of twenty. The 1890s were a time when factory owners across South Carolina investigated the possibilities of using black labor.

Blacks celebrating the Fourth of July at Beaufort, between 1935 and 1945. The Fourth of July and Decoration Day (Memorial Day) were major holidays celebrated by the black citizens of Beaufort. *Marion Post Wolcott, photographer. LC-USF34-051958-D. Courtesy of the Library of Congress.*

The Spanish-American War of 1898 brought new life to the naval station on Parris Island. Residents of Beaufort anticipated that the government would expand the navy yard. In 1899, plans were afoot to connect Parris Island to the mainland by rail and construct two dry docks. But once again, the political winds blew toward Charleston. With the construction in 1900 of the new Charleston Naval Yard, Parris Island's importance diminished.

During the 1890s, truck farming came to replace the fading phosphate mining. Without the phosphate industry, Beaufort County's economy became almost totally dependent upon agriculture. Cotton continued to be grown—especially by small producers. Some Beaufort residents profited from the timber industry that gained steam during the 1880s and 1890s. Niels Christensen operated a lumberyard on the Point (corner of East and Port Republic streets), and by 1899, R. R. Legare had a sawmill south of Bay Street near Hamar. Clinton C. Townsend's foundry was located at Bladen and King Streets.

The Grand Army of the Republic Hall (c. 1896), 706 Newcastle Street. The Grand Army of the Republic was a fraternal, charitable, patriotic and political organization of veterans who had served in the United States armed forces. *South Carolina National Register of Historic Sites, Beaufort County. Courtesy of the South Carolina State Historic Preservation Office, South Carolina Department of Archives and History.*

Chapter 10

Beaufort in the Twentieth Century, 1900–1957

B EAUFORT ENTERED THE TWENTIETH CENTURY looking ahead. The Census Bureau reported 4,110 persons living in the town in 1900. During the first half of the twentieth century, hunting preserves and truck farming, "organized gambling" as one newspaperman dubbed the industry, brought relative economic stability. By 1905, the economic output of truck farming had grown to half that of cotton production. By 1912, a Coca-Cola bottling plant had joined the mills, foundries, stores and warehouses that lined Beaufort's waterfront. The First World War saw an increased military presence in Beaufort, and residents reeled from their losses during the influenza epidemic of 1916.

Bay Street, c. 1900. The bathhouse stands to the right, and a steamship landing, a warehouse and the Waterhouse cotton gin are visible in the distance, framed by the trees. *Christensen Family Papers, Folder 47. Courtesy of the South Caroliniana Library, University of South Carolina.*

Snow on the bluff. This image could represent the unusual snow of 1914. Snow in Beaufort is a rare treat. Even a light dusting often closed schools and suspended business. *Memory Book; Christensen Family Papers, Folder 39. Courtesy of the South Caroliniana Library, University of South Carolina.*

The boll weevil came to South Carolina in 1918, destroyed the sea-island cotton crop and plunged cotton growers into agricultural depression in the 1920s. The cotton-dependent South knew of the Depression before the Wall Street crash of 1929. But truck farming offered hope, especially to the Lowcountry farmers. In the sixties, Beaufort County was justifiably famous for her tomato crop. In the 1920s, she was the "Lettuce City." The economic dislocation of the 1920s also brought racial tension as the Ku Klux Klan flourished in Beaufort and Beaufort County.

A NEW CENTURY

The century began on a bright note. In 1901, the Clover Club, an educational organization for women, organized a lending library. The Knights Templar allowed the Clover Club Circulating Library to use without charge one of its rooms in F. W. Scheper's building. Scheper's building stood on the south side of Bay Street at the corner with Carteret. Annual dues of $1 were used to purchase books. The club also provided a traveling library in order to make the books available throughout the county.

But gray clouds gathered. Politically, by 1903, black power, despite the group's numerical superiority, had waned. The white citizens who controlled the voter registration process prevented the number of black registered voters from exceeding the number of white registered

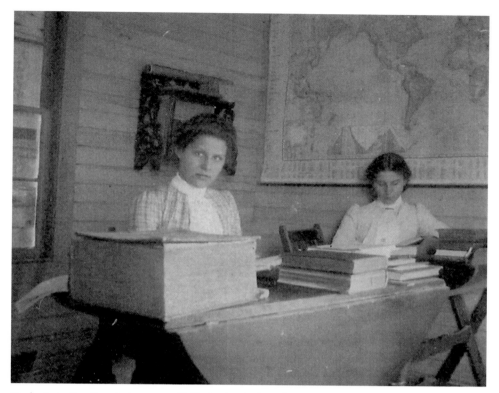

Students in the Beaufort area c. 1900. In 1901, Beaufort completed a major expansion of the public schools. *Beaufort area album, No. 10188. Courtesy of the South Caroliniana Library, University of South Carolina.*

voters. Economically, in 1903, Parris Island, having lost the navy yard war to Charleston, was once again a coaling station. By 1908, most navy activities on the island had ceased—the proverbial lull before the storm.

In 1904, Beaufort College trustees transferred the college building and lot in fee simple to Beaufort School District No. 1. Many of Beaufort's white students attended grammar school in that building. The original dream of the Beaufort College trustees to provide quality educational opportunities for the young men and women of Beaufort continued to live.

THE FIRE OF 1907

On 19 January 1907, disaster again struck Beaufort. The fire alarm sounded in the early hours of the morning. Three boys under the age of eight were smoking in the stable of Scheper's

159

building. They accidentally set the stable afire. From the stable, the blaze spread to the Scheper building on the corner of Bay and Carteret Streets. The three-story grocery and merchandise establishment burned, and the gale-force winds scattered the embers until at least three fires were burning in Beaufort's downtown business district. In addition to the grocery and mercantile sales, the Scheper building housed the Clover Club library on the second floor and two Masonic groups, Harmony Lodge, AFM and Rabboni Chapter, RAM.

The fire also moved to the west and devoured the Peoples Bank, of which F. W. Scheper was the president; Mrs. Johanna E. Ohlandt's store; the laundry of Ah Li; two restaurants; and the dispensary. N. Christensen & Sons Hardware and J. M. Crofut's crockery stores also burned. While the residences of W. J. Thomas and J. N. Wallace were lost, heroic efforts saved the homes of Mrs. H. L. Waterhouse, Mr. Shatswell and Mr. Damon.

A residence on the Bay owned by George Holmes caught fire, but the tabby construction slowed its spread, saving the Hutching building and offices of the *Beaufort Gazette*. Those fighting the fire tried to remove household goods and furniture from affected properties.

The second blaze spread along the western side of Carteret Street and burned the fire engine house and several residences before crossing the street to consume attorney Thomas Talbird's

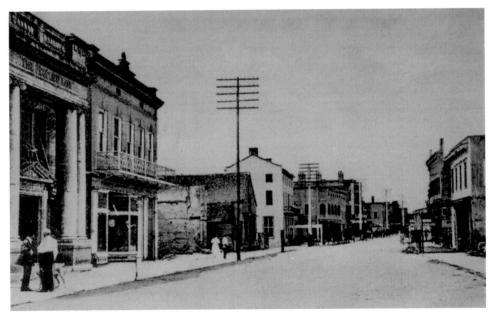

Bay Street with the new bank building. The Peoples Bank burned in 1907. *Copy photograph, Ned Brown. Charles G. Luther. Local History Collection, No. 2186803. Courtesy of the Beaufort County Library, Beaufort.*

offices and the town market. The fire then jumped Craven Street and burned the Town Hall, a hook and ladder company hall and engine house. Firefighters saved the arsenal, but not the Carteret Street Methodist Episcopal Church. Lon Brooks, chief of the fire department, worked tirelessly with his men to contain the blazes and was soundly congratulated by the town for his efforts.

Fireballs spread northward and eastward through the town, igniting roofs as they went. Fires destroyed the historic Talbird residence an eighth of a mile from where the blaze began, the homes of W. F. Sanders and Mrs. Mount, and threatened the home of Robert Smalls. Mrs. Rachel Haynes was one of the blacks whose homes were burned.

In all, the fire destroyed between forty and fifty-four buildings, and caused an estimated $175,000 in damages. High winds hindered the efforts of the firefighters to contain the blazes; so, it was fortunate that the flames encountered several tabby structures, such as the Talbird home. The tabby material did not burn as well or as quickly as wooden buildings. As a result, the tabby structures actually slowed the spread of the flames until the fires could be contained.

A squad from Fort Fremont on St. Helena Island joined a naval contingent to guard the affected area from looters. Also, Captain C. C. Townsend, a native of Maine and intendant of Beaufort, telegraphed Fort Screven on Tybee Island near Savannah for assistance. Colonel R. W. Patterson, the fort commander, sent a forty-five-man detachment under the command of Captain Joseph Wheeler. The Fort Screven troops patrolled from Sunday through the following Tuesday. An article in the *Beaufort Gazette* estimated losses at $175,000 with only $20,000

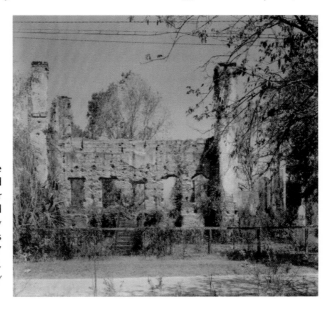

The Talbird House ruins on the northeast corner of Hamilton and Hancock Streets, 9 September 1940. Colonel Thomas Talbird built this three-storied tabby structure c. 1800. The house was destroyed during the January 1907 fire. *C. O. Green, photographer. HABS, SC,7-BEAUF,5-. Courtesy of the Library of Congress.*

161

covered by insurance. The Savannah *Morning News* contradicted that account with losses of $125,000 and an assertion that most of the affected property owners carried insurance.

On Saturday, a human catastrophe compounded the natural one. That evening, on the Bay, an unknown person shot and killed one of Beaufort's black citizens, William Bennett. Bennett, a member of the Allen Brass Band, had worked during the day to contain the fires. The Savannah newspaper reported that a guard had killed Bennett, whom the guard had found in the ruins of the Peoples Bank. According to that paper, the coroner's jury had returned its verdict of "death at the hands of parties unknown" because no one knew which guard had fired the shot.

On Monday, fifty or so black and white citizens gathered at the arsenal for a public meeting. The mayor attempted to explain why he had requested military assistance and what their role was in Beaufort. Some questioned the need for troops, and others condemned the article that had appeared in the Savannah *Morning News* as inflammatory and misleading. The article alleged that the troops were needed to protect the white citizens of Beaufort. The newspaper contended that racial tensions were high due to the shooting of Bennett.

Three of Beaufort's leading black citizens, Robert Smalls, James Riley and Samuel Green, addressed the gathering. None saw any difficulty with the behavior of Beaufort's black or white residents. Smalls, the "king of Beaufort County," thanked God that he lived in Beaufort where no "lady [black or white] is afraid to walk the streets night or day."

F. H. Christensen offered a resolution condemning the article. The concerned residents adopted the resolution. Intendant Townsend assured the assembled audience that the troops would leave the following day and that he would forward a copy of the resolution to the Savannah paper. A photographer's insensitivity also offended those in Beaufort who had lost so much. He alleged that the citizens he had interviewed thought the fire would prove a blessing—possibly through opportunities to rebuild. Many did rebuild. Some, such as Townsend, changed careers. The 1910 census indicated that he and his son Howard operated a basket factory. Prior to the fire, Townsend had owned a foundry and machine shop located at the corner of Bladen and King.

TOWN LIFE

Although Scheper's building burned in the fire of 1907, the library books were saved. Beaufort did not again lose her library to the flames. The club found new facilities, and between 1910 and 1917, the Clover Club operated the library from the Beaufort Female Benevolent Society's house on Scott Street.

Established in 1814, the Beaufort Female Benevolent Society worked to care for needy children. The society built the Scott Street house in 1895 and used the rent to fund

162

The old fire station. Several serious fires destroyed much of Beaufort's commercial district in the early twentieth century. In 1886, Beaufort had five volunteer fire companies. *South Carolina National Register of Historic Sites, Beaufort County. Courtesy of the South Carolina State Historic Preservation Office, South Carolina Department of Archives and History.*

philanthropic projects in Beaufort. In 1982, the society sold the house, but the proceeds continue to benefit the underprivileged citizens of Beaufort.

The City of Beaufort erected two civic buildings in 1911. The new City Hall and Municipal Meat Market replaced the market that had occupied the corner of Craven and Carteret Streets.

Through the efforts of state Senator Niels Christensen, the Carnegie Foundation agreed to assist with the construction of a library building in Beaufort. The outbreak of World War I delayed construction, but on 7 June 1917, the cornerstone was finally laid. In 1918, the new Beaufort Township Library assumed control of the books so lovingly collected and managed by the Clover Club. When the library officially opened on 2 March 1918, Adeline Scheper was named to serve as the first librarian.

On another positive note, in 1907, Beaufort's Jewish community began construction of Synagogue Beth Israel. The congregation traced its origins to c. 1895 when a number of Jewish families moved to Beaufort. According to the 1910 census, Aaron Greenfield immigrated to the United States in 1876; Morris Levin in 1886; Moses Lipsitz and Joseph B. Keyserling in

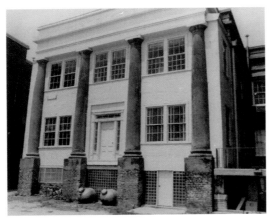

The Beaufort Customs House, 920 Bay Street, between West and Charles Streets. While the building was probably built before the Civil War, it was 1899 before it was identified as the customs house on a Sanborn Fire Insurance map. According to the National Register nomination, the building has not only housed the customs house, but also the library, the United States Quartermaster Corps, the telephone office, the Farmers' Produce Exchange and the First Federal Savings and Loan Association. *South Carolina National Register of Historic Sites, Beaufort County. Courtesy of the South Carolina State Historic Preservation Office, South Carolina Department of Archives and History.*

1890; David R. Schein in 1891; Max Lipsitz in 1903; Rabbi Jacob Silver in 1905. The immigrants listed Russia, Germany and Austria as their native countries. Moses Epstein was born in Maryland, but his parents were Austrian.

When there were enough families, Aaron M. Greenfield, president of the congregation, rented a hall for services. By 1907, there were twenty-two families and a new congregation was organized and chartered. Under the direction of Morris Levin and the Building Committee, Synagogue Beth Israel was finished in 1908. The new building was dedicated 18 June 1908. At that time, the officers of the congregation were Moses S. Epstein, president; Joseph B. Keyserling; and Morris Levin. Epstein and Levin were merchants in Beaufort, and Keyserling, a bookkeeper. Rabbi Jacob Silver officiated at the first wedding in the new synagogue when Bertha Rubin was married to Max Lipsitz. According to the 1910 census, both had been born in Russia. Synagogue Beth Israel added a cemetery in 1910 and was incorporated in 1916.

In 1924, there were forty-two Jewish families in Beaufort. The officers for that year were Joseph B. Keyserling, president; Moses L. Lipsitz, vice president; Samuel E. Richman, secretary; and David R. Schein, treasurer. Schein and Richman were also merchants in Beaufort. In 1938, Morris Neidich came to Beaufort and found the synagogue an "empty scheul." Under his leadership, Beth Israel changed from an orthodox congregation to a conservative one.

One of Governor Benjamin R. Tillman's pet projects had been the establishment of a dispensary system to regulate the sale of alcohol. Under that plan, only state-controlled dispensary stores could retail alcohol. In 1907, the state closed the state dispensary and gave the counties the option of adopting prohibition or operating their own distribution system. By 1909, only six South Carolina counties, including Beaufort, were still wet. The progressive movement may have come to South Carolina, but Beaufort County was not in the vanguard.

The Keyserling Building, Bay Street, c. 1885, is one of Beaufort's historic late-nineteenth century commercial structures. *South Carolina National Register of Historic Sites, Beaufort County. Courtesy of the South Carolina State Historic Preservation Office, South Carolina Department of Archives and History.*

Bay Street looking eastward and showing the two-story bathhouse. As Thomas Wentworth Higginson described Beaufort in 1862, "the pretty town…with stately houses amid Southern foliage." *No. 10327.13. Courtesy of the South Caroliniana Library, University of South Carolina.*

Coping with Jim Crow laws, hurricanes and fire took their toll. By 1910, the population of the town of Beaufort was 2,486, a 39.5 percent decrease since 1900.

A sample of the 1910 census entries for Bay Street offered a snapshot of Beaufort's commercial vitality. There were two professional men: Herbert McDowell, a medical doctor, and the Reverend Theodore Clift, an Episcopal minister. Other residents included Middleton Elliott, a bookkeeper for a cotton gin; Henry M. Stuart, a druggist; and merchants John and his brother Emil Lengnick. The 1910 census also documents the varied nationalities of people living in Beaufort—for example, Russian, German, Danish, Greek, Spanish, Chinese and Japanese.

In 1912, the Presbyterian Church reorganized in Beaufort. The first pastor of the new church was Dr. N. Keff Smith who served from 1913 to 1916. The Reverend Arthur Prioleau Toomer, a native of Beaufort, served as the congregation's pastor from August 1920 until his death on 20 February 1925. On 28 April 1929, Dr. Alexander Sprunt, a native of Scotland and a Presbyterian minister in Charleston, conducted the first services in the new Presbyterian Church building on the corner of Church and North Streets. A new day had dawned for the Presbyterians of Beaufort.

Marine officer training came to Parris Island in 1909 and a recruiting depot in 1911. The depot was moved, and the facility became the United States Naval Disciplinary Barracks— the navy brig. In 1915, the recruiting depot returned to Parris Island; in 1917, the entire island came under military control. World War I brought forty-one thousand recruits to Parris Island for training.

Until the Horse Island bridge and causeway to the island opened in 1929, men and materials reached the island by boat from Port Royal. Marines on leave who wanted to see Savannah caught a steamship in Beaufort. There was no bridge across Battery Creek until the 1930s.

In January 1913, the *Beaufort Gazette* hailed the election of Beaufort's first (perhaps since before the Civil War) all-white town council. The Beaufort Democratic Club organized and oversaw the election. This election represented a dramatic break with Beaufort's post–Civil War past. R. R. Bristol was the new mayor with a vision of expanding Beaufort's borders to include Pigeon Point and other adjacent areas. Beaufort would not again see biracial city government until 1967. Also by 1913, another trend had developed. Winter visitors began acquiring permanent part-time homes in Beaufort. This trend continued and even escalated in the twentieth century.

As part of the revamping of city government, Beaufort changed from the mayor/council form of government and hired a city manager in 1915. During the first year of the new plan, the city's budget showed a surplus instead of a deficit. Several departments, including water and sewer, were more efficiently managed, and the new tree department had planted palmettos near the arsenal. Beautification efforts continued into the 1930s with plantings of oaks, crepe myrtles and oleanders.

The post office, built in 1917 at 302 Carteret Street, replaced an earlier structure on Bay Street. J.A. Wetmore was the supervising architect for the project. *South Carolina National Register of Historic Sites, Beaufort County. Courtesy of the South Carolina State Historic Preservation Office, South Carolina Department of Archives and History.*

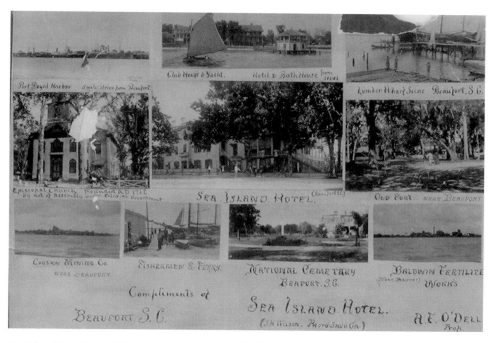

Sea Island Hotel card. Hotel owner A. E. Odell published this card to promote the hotel and advertise local attractions. J. N. Wilson was the photographer. From left to right, images show Port Royal Harbor, yacht clubhouse, hotel and bathhouse, lumber wharf, St. Helena Parish Church, Fort Frederick, Coosaw Mining Company, fishermen at the ferry landing, the National Cemetery and Baldwin Fertilizer works. *No. M-PL-BFT-B-4. Courtesy of the South Caroliniana Library, University of South Carolina.*

The United States post office on Carteret Street opened in 1917. This building replaced the Bay Street location where the post office began in 1863.

In 1918, the Sea Island Hotel, managed by Mrs. A. F. Odell and her son James Odell, advertised its "modern and homelike" atmosphere and promised guests dancing, oyster roasts, as well as fishing and bathing at the Bay Point beach. The hotel also boasted its own bathing pavilion. The Chinese Charles Chin Sang bottled Chero-Cola on Bay Street, and residents could read the *Beaufort Gazette*, visit the library or travel with the Sea Island Steamboat Company on one of its weekly runs to Charleston. Morrall's Furniture Store offered "everything for the home," home delivery and "quality at lowest prices." The Beaufort Sojourners' Club located in the arsenal testified to Beaufort's role in the World War I war effort. The club was open for enlisted men—marines and

Beaufort County Training School (Shanklin School). Founded in October 1901, the Port Royal Agricultural and Industrial School opened its doors with seven pupils. Among the black and white residents of Beaufort who worked to establish the school for former slaves were Niels and Abbie Christensen. Joseph and India Shanklin devoted most of their lives to educating black youth in industrial arts. In 1919, the school trustees deeded the school and its property to Beaufort School District One. Consequently, the Port Royal Agricultural School became the Beaufort County Training School in 1920 and added the training of teachers to its curriculum. *WPA-PL-BFT-B-S-3. Courtesy of the South Caroliniana Library, University of South Carolina.*

sailors—stationed at Parris Island, offering a canteen, pool tables, piano, easy chairs and magazines, among other amenities. Oscar Beckman, detailed by the Navy Department Commission on Training Camp Activities, directed the "activities of the war-camp community-recreation service."

Under the philosophy of "separate, but equal," Beaufort operated segregated schools until 1970. Figures for 1919 illustrated how the system worked in Beaufort. That year, there were 538 white children in school and 550 black students. The school board, on average, expended $24.25 per white child and $2.76 per black one.

In 1920, there were 2,831 people living in the town of Beaufort. According to the recollections of Judge James G. Thomas, the Bay Street offices of the *Beaufort Gazette* burned in the 1920s. Niels Christensen owned the *Gazette,* and the Christensens also operated the Christensen Hardware Company and the Christensen garage. Among other commercial enterprises on the north side of Bay Street were Morrall's Furniture Store, Katie Levin's Beauty Parlor, the Beaufort Hardware Company, a yarn shop, Blocker and Monson's Barber Shop, Sheppard's Barber Shop, E.W. Bailey's store, the Brown Furniture Company (later B. B. Breedon's Ten Cent Store), the Chero-Cola Bottling Plant (Lipstiz Building), Levin Clothing Store, Western Union, Jim Pappas' Busy Bee Café, Junker's

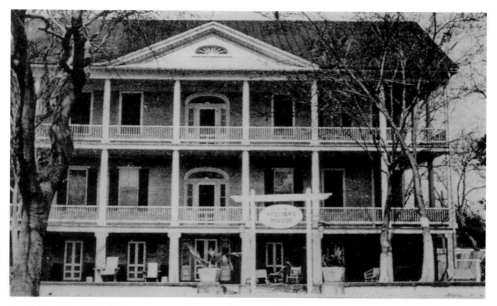

Sea Island Hotel building, corner of Bay and Newcastle Streets, being used as a Visitors Center. The Sea Island Hotel also briefly operated as a Catholic outreach ministry for military personnel. *Copy photograph, Ned Brown. Crescent Drug Company, Beaufort. Local History Collection, No. 2164925. Courtesy of the Beaufort County Library, Beaufort.*

Meat Market and Schein's Department Store. The Sea Island Hotel operated briefly as a Catholic outreach ministry for military personnel but then returned to ministering to Beaufort's voluntary visitors. The hotel's bathhouse in the Beaufort River was a popular recreational outlet for Beaufort's white population. Former Sheriff J. E. McTeer humorously remembered Beaufort's youth learning to swim by being dropped into the river from the Sea Island bathhouse. The Lady's Island Ferry, the island's link with the town, ran to the island from the foot of Carteret Street.

On the south side of Bay Street, among other businesses, were the Peoples State Bank, W. H. Ohlandt's Grocery, Wall Motor Company, the South Carolina Power Company, the Oakland-Pontiac Car dealership, the Rudiwitz Shoe Store, the Crescent Drug Store and Nicodemus Colevinus's fruit stand. Behind the businesses were warehouses and wharves. Several docks—including the Beaufort-Savannah Line Dock, the Beaufort-Charleston Line Dock and the Gulf Oil Dock—lined the river. Beaufort also had a bicycle repair shop, two cotton gins (Waterhouse's at the foot of Charles Street and McDonald-Wilkins), dentists, doctors and lawyers. At the courthouse was a bandstand where the Parris Island Band occasionally played.

A major civic issue during the 1920s involved the public suppliers of water and electricity. On 29 June 1926—after several years of unpredictable service, including frequent outages and brownouts—the electorate voted to sell the electric company and the waterworks. The

The Shell Road, the main avenue into Beaufort, lined with palmettos. Planted by Mayor Bray, the palmettos were removed when the roadway was widened to four lanes and became part of U.S. Route 21. In 1950, visitor Samuel Hopkins Adams commented on his entrance "between a long double row of royal palmettos." *No. WPA-PL-BFT-B-V-2. Courtsey of the South Caroliniana Library, University of South Carolina.*

Edisto Public Service Company bought the two companies. Beaufort later repurchased the waterworks but not the electrical plant. The Edisto Public Service Company in time became part of South Carolina Electric and Gas Company. Also in 1926, Beaufort's new sewer system ended swimming in the river. The sewer emptied into the Beaufort River, and made swimming unsafe and endangered the river shellfish.

A twenties cause célèbre was the arrest and trial of Richard V. Bray. Bray had allegedly punched an Internal Revenue Service agent because the agent had questioned the veracity of Bray's mother-in-law during an audit. In 1923, Bray was convicted, fined, and sentenced to serve a year and a day in the federal penitentiary in Atlanta, Georgia. Before his imprisonment, the citizens of Beaufort expressed their outrage by electing Bray mayor. In June 1923, Mayor Bray began serving his sentence. After many petitions and negotiations, President Calvin Coolidge authorized his release in November 1923. According to Judge Thomas, a brass band greeted Bray's return at the train depot. Bray served several terms as mayor and was responsible for planting the palmetto *allée* along Boundary Street. The

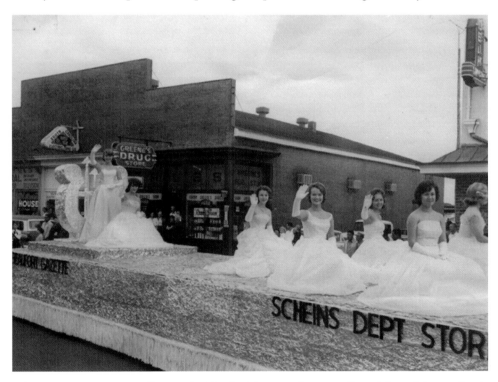

Schein's Department Store float in the Thanksgiving parade, 1963. From left to right are Candy Dobyns (standing), Mary Webb Greene (seated), Martha Jones, Nancy Nicholson, Marilyn Young, Anne Knight and an unidentified person. *Martha Jones Denka.*

palmettos were removed in the 1950s when the former Shell Road and Boundary Street were widened into four lanes and became part of U.S. Route 21.

Three major fires, as Judge Thomas remembered, struck Beaufort's business district during the twenties. One of these was the fire of May 1925. The first blaze cost Beaufort the River View Hotel, Lengnick's Store and a three-storied building. Two years later, a fire at Bay and Charles destroyed the building occupied by the *Beaufort Gazette*. The third fire in 1928 burned Schein's Department Store, but David Schein rebuilt and modernized his store. Moses Lipsitz had renovated his Bay Street department store in 1922, raising the bar for the other merchants.

Also, in the early twenties, the first automobiles appeared on the streets of Beaufort. The streets in the town were shell, cobblestone, or dirt and sand. H. C. Eve recalled that "the dust was awful." Others noted that the cars frequently got stuck in the sand.

On the dark side, the 1920s also saw increased activity of the Ku Klux Klan. The *Beaufort Gazette* of 1 May 1924 reported a public initiation, or "naturalization," in Port Royal near the

A row of cars in 1925. In the early twenties, automobiles appeared on the streets of Beaufort—raising dust and scaring horses. *Christensen Family Papers, Folder 46. Courtesy of the South Caroliniana Library, University of South Carolina.*

172

school. The Klan staged a rally on 8 May of that year with a parade through the streets of Port Royal. Three thousand attended the rally, and ninety new members were inducted. According to the paper, a high-ranking Klan official was present for an inspection visit.

On 12 June 1924, the Klan paraded in the town of Beaufort. Although the town had an ordinance forbidding such activities and had in 1921 assured her black residents that the Klan would not parade in Beaufort, the recently elected mayor and city council had amended that ordinance to permit parades by special request. The Klan complied, submitted a request and was issued a permit. The Klan parade in June had high drama and great spectacle, two hallmarks of the public Klan. One hundred forty-six members paraded before, according to the press, "one of the largest outpouring of citizens in recent history." A lone knight led the procession. Two Klansmen mounted on horseback followed him, and then came an automobile draped with an American flag. Following the automobile that carried Klan officials, marched one Klansman with an American flag and one carrying the group's "blazing emblem," a fiery cross. After these had passed, the rank and file marched by, each with his arms folded across his chest. The parade proceeded from Boundary Street to Carteret Street and on to Prince Street, and then to Charles, to Craven and to Bay Street. The parade terminated at the courthouse with a rousing address, "masterly presentation," by a Klan leader from the balcony of the courthouse. Vigorous applause greeted the address. Sheriff J. E. McTeer watched the parade and heard the speech. Years later, in *Beaufort Now and Then* he wrote that since there were few black voters in Beaufort County, a man "could only be elected [to political office in Beaufort] by joining the Klan." Given the tenor of McTeer's remarks and his wonderful story of a man named Brooks banishing the Klan with a double-barreled shotgun and a chamber pot, McTeer the raconteur may have written tongue-in-cheek. Regardless, McTeer identified the rally speaker as M. O. Dunning, and his remarks raise ugly questions about the racial climate of Beaufort in the 1920s.

On 14 June 1927, Beaufort hosted a "Klonverse"—an annual Klan convention in the town of Beaufort. A specially chartered train from Columbia brought 200 Klan members and their spouses to town. Prominent Klan leaders statewide were present. A few days later (27 June), an editorial in the *Beaufort Gazette* complimented the assemblage. The editorial stated that "The Lettuce City" (that is, Beaufort) was to be complimented for the "excellent manner" in which the town had handled the Klan visitors. The editorial went on to state the town welcomed "opportunity to hold conventions and gatherings in her borders" and was "ever ready to cooperate and to assist in all possible ways." The writer also noted that "The Beaufort spirit, friendliness, and cooperation can not be found elsewhere." To this editorial writer, Beaufort was the perfect site for Klan meetings!

In 1922, a group of investors under the aegis of the chamber of commerce had purchased the *Gazette*. In 1927, Beaufort Press Incorporated bought the *Gazette*. The officers of the Beaufort

Beaufort Gazette office, middle building. The *Gazette*'s offices at Charles and Bay Street burned in 1927, the same year that Niels Christensen sold the paper. *Christensen Family Papers, Folder 45. Courtesy of the South Caroliniana Library, University of South Carolina.*

Press were A. S. Morrall, president; E. L. Wilson; L. A. Hall; and Calhoun Thomas. R. R. Legare was a member of the board. Under the Beaufort Press, William Cormack was the editor of the paper. The date of the sale in 1927 would indicate whether Cormack wrote the editorial welcoming Klan and other conventions to Beaufort.

It is clear, however, that with the election of 1913, Beaufort's black citizens were excluded from city government. White businesses continued to dominate Beaufort's commercial neighborhood, and the boll weevil had seriously eroded the agricultural economy of Beaufort County's black farmers. Political and economic powerlessness can lead to other social and educational inequities.

The bridge over Beaufort River, 1972. In 1971, the Richard V. Woods Memorial Bridge replaced the Beaufort–St. Helena Bridge that opened 7 July 1927. *Courtesy of Ned Brown, photographer.*

On the plus side, Beaufort experienced a major transportation breakthrough that enhanced service for her black and white residents. On 7 July 1927, the "long and costly" Lady's Island Bridge opened, providing land access to St. Helena and the island beaches. Even before the Europeans had arrived, water transport had been the primary mode of travel between the islands. Also in 1929, Beaufort County acquired an airport, and one opened on Lady's Island in 1932.

In 1930, Beaufort's population dipped slightly from its 1920 total—from 2,831 to 2,776. Beaufort's population, like the U.S. economy, was stagnant. Until 1926, Beaufort had two banks: the Peoples State Bank and the Bank of Beaufort. On 10 July 1926, the Bank of Beaufort closed, never to reopen. Its failure was unexpected with a wide-ranging effect. Individuals' savings disappeared, as did business accounts and credit opportunities. The bank closing cost several of the Beaufort churches their savings and checking accounts. According to Judge Thomas, the bank failure plunged Beaufort into a depression that lasted until 1939.

Yet, according to the South Carolina Department of Agriculture's handbook for 1927, truck farming was still the main economic engine for the area. Truck farming was the major component of Beaufort County's economy from 1913 into the 1950s. Beaufort's lettuce was a source of pride as it sold for a better price than California lettuce. So, Beaufort had the lettuce bragging rights. The Beaufort area also produced other vegetables, including potatoes, tomatoes, cucumbers, radishes, cabbages and peas. Beginning as a local market enterprise,

175

Youngbloods in front of J. O. Youngblood Cannery, near the air station, c. 1956. Pictured (from left to right) are Pat, Joy and Daisy Youngblood. Standing behind Pat is their father, Otis Youngblood. The cannery processed tomatoes, and sometimes beans, under the Real Joy label. The brand was available at the Beaufort Piggly Wiggly grocery store and other local stores stocked by Thomas and Howard. *Courtesy of Pat Youngblood.*

Beaufort County's vegetable production had grown and the markets for her produce expanded. Trucks and railroad carloads of vegetables frequently left Beaufort for Northern markets. The period that followed the First World War into the 1950s was the heyday of truck farming in Beaufort County.

In addition to truck farming, which had its ups and downs during the Depression, Beaufort County had other industries during the 1930s. The Port Royal area was home to several oyster-canning facilities, sawmills and shrimping. By the late 1930s, seafood was a major component of Beaufort County's economy.

Beaufort was one of the first counties to join South Carolina's "Good Roads" movement—a movement that focused on improving farm-to-market roads. The Shell Road that ran from Beaufort to Port Royal was one of the first paved roads in South Carolina.

Once again the sun shone on Beaufort. Natural disasters and economic upheavals appeared to be past. Better roads and improved transportation would augment her economic

Shrimping on Beaufort River at Bay Street, c. 1940. Shrimp, crab and fish are mainstays of Beaufort cuisine. *No. WPA-PL-BFT-B-V-1. Courtesy of the South Caroliniana Library, University of South Carolina.*

recovery. Better days lay ahead, or so it seemed. Sunlight always casts shadows unless the sun is directly overhead.

Consequently, in 1928, Beaufort seemed, to some, to be on the "brink of the greatest development boom" in the city's history. For the truck farmers, the tomato crop's success had mitigated the damage to the potato crop. Beaufort was famous as a producer of early tomatoes. Money circulated "freely," and "[m]ore strangers from every section of the country"—that is, tourists—were noticed on the streets. That year also saw more new housing constructed in Beaufort than any year since the great fire of 1907. Mather School had new facilities—a classroom and dormitory building. Two bridge projects—the Parris Island Bridge and a bridge to Bay Point—were under consideration.

Then another storm in 1928 downed communication lines and isolated Beaufort for two days. Winds of 75 mph tore roofs from buildings, spreading wreckage and debris throughout the city.

A highlight of 1930 was the opening of the Gold Eagle Tavern (later Hotel) at New and Bay Streets in March. The hotel as renovated featured a concrete tower that reminded onlookers of a medieval castle. The marine corps band serenaded first-night guests. Mr. and Mrs. L.

Beaufort Street in 1925—a quiet street in a quiet town. *Christensen Family Papers, Folder 46. Courtesy of the South Caroliniana Library, University of South Carolina.*

E. Wilder operated the hotel. Miles Brewton was the first owner of the property. Daniel DeSaussure acquired the land and passed it on to his son Henry William DeSaussure. Henry William DeSaussure was the director of the United States Mint at the time the first gold eagle dollars were minted in 1795. The name of the hotel commemorated that connection.

Kate Gleason (1865–1933), a banker, business executive, and philanthropist from Rochester, New York, owned the house that became the Gold Eagle. Gleason pioneered standardized low-cost poured-concrete housing. A supporter of women's suffrage, Gleason was the first woman member of the American Society of Mechanical Engineers (1914) and the first woman appointed a receiver by a bankruptcy court. In the 1920s, she began to winter in Beaufort, and invested in the Sea Islands as a resort for writers and artists. The perspicacious Gleason saw the tourism potential of the Beaufort area. When she died, Gleason left a $1.4 million estate to benefit the Kate Gleason Fund and other charitable enterprises. The Kate Gleason Memorial Park on the grounds of Beaufort Memorial Hospital commemorates her generosity.

Many famous individuals stayed at the Gold Eagle Hotel. The hotel's illustrious visitors included Clark Gable, king of the silver screen, as well as a number of literary and political figures. Among the literary figures who visited the Gold Eagle were Dorothy Canfield Fisher, Francis Parkinson Keyes, Archibald Rutledge and Francis Griswold. Fisher, who wrote under the name of Dorothy Canfield, was the author of novels and children's stories. Keyes penned a number of best sellers, including 1948's *Dinner at Antoine's*. Rutledge was South Carolina's first poet laureate whose writings include *Home by the River* and *Life's Extras*, and Griswold wrote *A Sea Island Lady*, a novel set in Beaufort. Some of the prominent political figures that enjoyed the hospitality of the Gold Eagle were perennial Democratic presidential candidate Adlai Stevenson of New York, Congressman L. Mendel Rivers and Olin D. Johnston, United States senator and former governor of South Carolina. A favorite South Carolinian, James F. Byrnes, was another famous guest. Byrnes had served as governor, United States congressman, one-time United States Supreme Court justice and head of the World War II Office of War Mobilization and Reconversion. The hotel closed in 1961, and the Norman-style building was demolished in the late sixties.

The Cherry Hill Sunday school, 1919. A Sunday school class from the Baptist Church of Beaufort built the Cherry Hill Chapel in 1919. The chapel ceased operations in 1924. Among those pictured are Mabel Burn, Mrs. Clyde Helms, —Wells and — Morrall. *Courtesy of George A. and Evelyn Jones.*

DEPRESSION, DISLOCATION AND WAR

The 1930s brought yet another time of transition and adjustment for Beaufort County and her county seat. The spectre of poverty floated in the air and gripped many of her citizens. The contrasts of the era are striking. Despite truck farming and sparks of light, such as the opening of the Gold Eagle, by 1930 much of Beaufort County's agricultural sector was already deep in depression. Bank closings and the worsening federal and state economies exacerbated the local situation. Due to her mounting fiscal crisis, the state of South Carolina paid her teachers with scrip. Beaufort County was one of seventeen South Carolina counties with more than 30 percent of their population unemployed. In September 1932, two residents of Beaufort County died from starvation. The Red Cross had begun to send aid to the blighted county, but for some, it arrived too late.

Yet, all was not gloom. In 1932, the Beaufort County Library Board opened the J.I. Washington Branch. Thanks to the efforts of attorney Julius Irving Washington, Beaufort's black residents finally acquired a separate branch library on Carteret Street. In the years before integration, the races did not share schools, libraries, water fountains or other public facilities in Beaufort. The Washington Branch was located at 602 Carteret in a building that had once housed a black Presbyterian congregation. Washington did not live many years after the library opened. After a long illness, he died 18 January 1938. He had read law with J. J. Whipper and been admitted to the bar in 1878. He practiced law, worked in the customs house and served in the South Carolina House of Representatives from 1886 to 1889.

During the 1930s and 1940s, Beaufort's Greek community grew. There was a close connection between the Greek families of Beaufort and those of Augusta and Savannah, Georgia. By the 1950s, the Cocklins operated Cocklin's Motor Court on Highway 21. Achille D. Cocklin, born in St. Peter's, Greece, came to Beaufort from Augusta where he was a member of Holy Trinity Greek Orthodox Church. George D. Cocklin, also of St. Peter's, migrated to the United States in 1906. For forty years, he was a wholesale merchant with Cocklin Banana Company in Augusta. His sister Xanthippe Cocklin married John P. Economy. A native of Sparta, Greece, Economy immigrated to the United States in 1910. Prior to moving to Beaufort, he managed a restaurant in Allendale. Economy was a Beaufort businessman, and at the time of his death, he was, among other affiliations, a member of the Harmony Masonic Lodge, Omar Shrine, Beaufort Yacht Club and St. Paul's Greek Orthodox Church in Savannah. His obituary also stated that he was past president of the Economy Non-Political Club of Beaufort.

Franklin D. Roosevelt's New Deal brought new programs that affected the lives of Beaufort, town and county. The WPA, the Works Progress Administration, paid artists to teach in Beaufort's public schools and folklorists to interview her former slave inhabitants. The agricultural programs brought economic possibilities to the area's black and white

farmers. Black South Carolinians were the recipients of a number of programs, but in one area, they were also participants. The Agricultural Adjustment Act of 1933 crop reduction program necessitated the cooperation of farmers, myriad committees and county agents to be successful. Officials needed the farmers to vote to participate, and then to encourage and monitor participation. To increase participation, many counties had black assistant county agents or developed grassroots committees composed of black farmers.

In some of these elections to determine compliance with the Agricultural Adjustment Act of 1933, the black voters were critical. For example, black farmers in Beaufort outnumbered white farmers, and their votes were essential to the program's success. In such black majority counties, black farmers also served as the local contacts to collect signatures on the acreage reduction agreements. Such opportunities to be part of the process raised black expectations and confidence, and facilitated opportunities for cooperation.

However, not all Beaufort residents in the 1930s were in favor of the New Deal. Many feared the intrusion of government into areas that had once been state-managed. To others, even limited black participation raised the specter of political equality or miscegenation. During these years, South Carolina had a particularly colorful United States senator named Ellison Durant "Cotton Ed" Smith. Smith represented South Carolina in the United States Senate from 1908 to 1944. A demagogue, Smith's flamboyant oratory energized stump meetings. A racist, when needed, Smith turned to white supremacy to bolster his arguments and ensure his reelection.

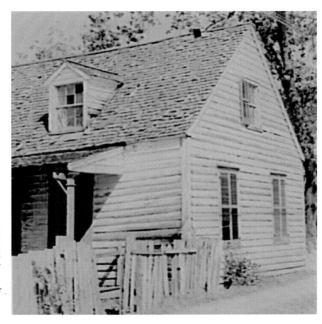

Frame house, March 1936. Many residents of Beaufort and of the county suffered during the Great Depression. *Walker Evans, photographer. LC-USF342-008048-A. Courtesy of the Library of Congress.*

181

In 1932, the Democratic National Convention was meeting in Philadelphia, Pennsylvania. Smith arrived late, and when a black minister rose to offer the invocation, Smith left the convention. He later returned to his seat but permanently left when a black congressman from Illinois named Arthur Mitchell addressed the meeting. Smith contended that political equality for South Carolina's black residents would lead to social equality, and that social equality would lead to interracial marriage and mixed-racial children. Not everyone who lived in South Carolina supported Smith's position in 1932. But one group that did was the Beaufort City Council, which sent him a telegram of congratulations.

To add to her woes, another bad storm struck Beaufort in 1935. With wind gusts of 60 mph and heavy rain, Beaufort residents had a difficult time leaving their homes. The storm left Beaufort's streets littered with downed limbs, Spanish moss and debris, and Beaufort's inhabitants without electricity or telephone. Water and wind are dangerous combinations for a coastal city.

Beaufort lost her grand lady of the stage when "Tillie" Maude Odell Doremus died in 1937. A well-known stage actress, Doremus appeared in *The Prisoner of Zenda* and *Show Boat*. At the time of her death, the actress was reprising the role of Sister Bessie Rice in *Tobacco Road*.

On 21 July 1939, Beaufort residents interested in history and preserving Beaufort's unique past organized the Beaufort Museum. The seven original trustees were J. E. McTeer, W. E. Nelson, Chlotilde R. Martin, Major George Osterhout, W. Brantley Harvey, F. H. Christensen and Howard Danner. Beaufort attorney W. Brantley Harvey served in the South Carolina Senate from 1928 through 1952. His son W. Brantley Harvey Jr. was South Carolina's lieutenant governor from 1975 to 1978. One of the museum's early acquisitions was a cannon found in the Coosaw River. The Beaufort Museum is currently housed in the old arsenal.

In 1940, United States Senator James F. Byrnes introduced legislation to compensate the Beaufort Library $10,000 for the books taken by the United States Treasury Department in 1861 and later destroyed by fire at the Smithsonian Institution. The bill was amended before passage to provide, instead of money, that the library would receive its choice of duplicate volumes held by the Library of Congress. The Beaufort Library found few books of interest on the list of duplicates. The few duplicate books sent to the library in 1940 were valued at $274.85. Yet, from the published sale list of 17 November 1862, the staff of the Library of Congress valued the 1861 Beaufort Library volumes at $4,300. In 1950, thanks to the intervention of Estellene Walker, South Carolina state librarian, and United States Senator Burnet Maybank, the Beaufort Library received the balance of $4,025.15. The Library of Congress raised the money by selling duplicate items from its collection to book dealers.

In August 1940, Beaufort had an unwelcome visitor. A Category 1 hurricane struck the area. The 1940 storm ripped roofs from houses and created an eight-foot storm surge that destroyed docks and bridges. An estimated forty people died as the hurricane winds plowed

their way through Beaufort, Edisto Island and Charleston. When the storm damaged the Parris Island causeway, incoming recruits had to be temporarily rerouted.

When the Japanese bombed Pearl Harbor on 7 December 1941, the United States Marine Corps had four training battalions with 2,869 recruits and 3,553 permanent staff on Parris Island. During World War II, more than 200,000 men trained there. The facility became the Marine Corps Recruit Depot, Parris Island, in December 1946. In 1941, the United States government also had a naval air station at Beaufort.

The expansion of area military installations triggered a population boom for Beaufort and Beaufort County. New residents and the military payroll boosted the local economy. Rents increased with a shortage of housing, and the service sector grew as more women joined the work force.

Arsenal cannon, 2004. A cannon that was found in the Coosaw River was one of the first artifacts acquired for the Beaufort County Museum. *Courtesy of Ned Brown, photographer.*

183

United States Marine Corps Glider Detachment, Training Camp Parris Island, May 1942. *LC-USW#3-002398-E. Courtesy of the Library of Congress.*

Administration building, Beaufort Air Base. During World War II, the United States government had a naval air station at Beaufort. *South Carolina Budget and Control Board, Sinking Fund Commission, Insurance File Photographs, 1935–1952, No. 2717. Courtesy of the South Carolina Department of Archives and History.*

In 1941, the state of South Carolina organized a State Council of Defense to coordinate the civilian war effort. Each county had its own organization and women's division. Members of the Beaufort County Council of Defense were Stratton Christensen (Beaufort), Marvin Dukes (Beaufort), Dr. George N. Pratt (Beaufort), Brigadier General Randolph C. Berkeley (Beaufort), Mayor A. H. Brant (Yemassee), Mayor J. E. Gill (Beaufort), W. Heyward Graves (Pritchardville), Mrs. Sterling Harris (Beaufort), H. L. Lancaster (Port Royal), H. E. McCracken (Bluffton), J. E. McTeer (Beaufort), E. I. Moorer (Hardeeville), Mrs. John Morrall (Beaufort), Mayor Matthew Peeples (Bluffton), J. B. Randall (Port Royal), Mayor Lemuel Ritter (Port Royal), W. L. Turner (Port Royal), C. E. Ulmer Jr. (Bluffton), Captain Rivers L. Varn (Beaufort) and S. B. Walker (Beaufort). Mrs. Morrall chaired the women's division, assisted by Mrs. W. A. Campbell of Sheldon and Mary E. Eaves of Beaufort.

In 1941, St. Helena Parish Church acquired a new steeple. Even in the midst of uncertainty, positive things happened. Another positive came on 1 May 1944, when Beaufort Memorial Hospital opened. Beaufort Memorial Hospital, licensed for 182 beds in 2004, is the largest hospital located between Charleston and Savannah. On 23 April 2004, the hospital broke ground for the Keyserling Cancer Center at Port Royal Center.

During the 1940s, efforts to preserve Beaufort's environment began in earnest. The first preservation organization—formed by Chlotilde Martin, Howard Danner and other concerned Beaufortonians—was successful in acquiring the John Mark Verdier House on Bay Street.

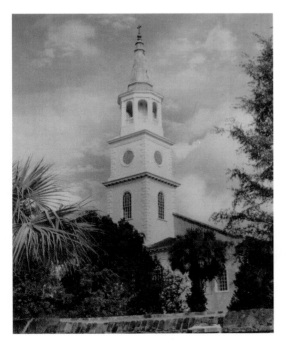

St. Helena Parish Church, 1974. Throughout its long history, St. Helena Parish Church has been enlarged and renovated many times. In 1941, the steeple was added. *South Carolina National Register of Historic Sites, Beaufort County. Courtesy of the South Carolina State Historic Preservation Office, South Carolina Department of Archives and History.*

Bay Street got a boost in 1947 when Earl and Ira Smith, twin brothers, transformed the former Beaufort Bank building into a theater. The Breeze Theatre showed motion pictures and hosted an occasional live performance. Lash LaRue performed there in the late 1950s, dazzling a packed house with his whip wizardry.

In 1947, the Charleston United States district engineer assumed control of the port at Port Royal. The South Carolina State Ports Authority sought federal funds to improve the harbor, and in 1954 the South Carolina General Assembly created the Port Royal Authority. The harbor was dredged in 1955, and Pier 21 opened in 1958. Beaufort residents attended the festivities that marked the pier's opening and entertained sailors from the German ship the *Graf Spee* when she docked at Port Royal.

In the 1950s, Beaufort was a Southern town, similar to the home of Atticus Finch in *To Kill a Mockingbird*. Beaufort's Bo Radley was a man nicknamed "Tutti Frutti" who followed the marching bands on parade through Beaufort's streets. Newcomers were amazed at the juxtaposition of old and new, paved and unpaved streets, black and white, the heavy air and the whine of the mosquito. Life was slow, but on Saturdays, Bay Street hummed as the inhabitants of Lady's and St. Helena islands came to town. Saturday was the major shopping day. The streets on court days when the circuit court sat at Beaufort were similarly thronged with jurors, witnesses, well-wishers and the curious. Beaufort had a kinetic energy on those days.

Not all was pleasant. The City of Beaufort closed the city pool rather than have it integrated. The Breeze movie theater on Bay Street had seating for white customers downstairs; black patrons had seats in the balcony reached by an outdoor staircase. At least one local store had separate water fountains for black and white customers. Tom's Shoe Shop on Port Republic was probably the only black-owned business that white customers regularly patronized. James Richardson, the proprietor, was also president at one time of the local National Association for the Advancement of Colored People (NAACP).

The shoe shop was one of many black-owned businesses that developed along West Street between Craven and Bay Streets during the period from 1924 to 1945. Research by historians Roslyn Saunders and Marquetta Goodwine indicated that a number of black businesses had developed in the area by the 1920s. Among the businesses they identified were Howard Bampfield Dry Cleaners, Henry Middleton's Club and Sam Polite's restaurant. Beaufort's black citizens also operated groceries, barber shops, beauty parlors and a funeral home in the area. Black professionals included attorneys Julius I. Washington and his son Charles, and physicians N. John Kennedy and his son Montgomery. According to Saunders and Goodwine, the shoe repair shop "stood as a monument to the African American businesses of West Street until 1998."

BEAUFORT AND THE COLD WAR

With the death of President Franklin D. Roosevelt in 1945, Harry S. Truman became president of the United States. Under Truman, the United States launched a policy of containing the USSR (Union of Soviet Socialist Republics) that came to be called the cold war. The cold war was a multifaceted diplomatic, economic and military struggle between the two superpowers. The cold war's focus on military preparedness and its emphasis on enhancing the American economy brought Beaufort into its sphere of influence. Economic incentives produced President Dwight D. Eisenhower's interstate highway initiative in 1956. That legislation eventually paved the way, no pun intended, for I-95, Beaufort's closest link to the web of interstate highways and her main evacuation route in times of disaster.

When the Russians successfully sent Sputnik into space in 1957, Americans realized they were not only losing the space race, but also lagging behind the USSR in other technological areas. This situation produced the National Defense Education Act of 1958. This act funneled federal dollars into public schools in order to improve the teaching of foreign languages, mathematics, and science. In Beaufort, this emphasis led the schools to test junior high students in order to accelerate their academic caseload. Those who scored well on the standardized tests began taking high-school-freshman-level courses in Latin, English, algebra and science in the eighth grade. The goal, as the students involved in the program understood it, was to enable them to study advanced math and additional years of science in high school. The United States was playing educational catch-up.

On the economic front, during World War II, federal programs had favored locating military industries in the South, especially in areas that been unusually hard hit by the Great Depression. With the end of the war, these industries and their well-paying jobs disappeared, and the region was embroiled in another economic depression. To counter this decline, South Carolina's United States senators and representatives joined other Southern congressional delegations in lobbying to land military bases and support centers for their constituent districts. For Beaufort, one of the most successful of these congressmen was Representative Lucius Mendell Rivers of Charleston County who represented South Carolina's First Congressional District, a district that included Beaufort County. The flamboyant Rivers wore his white hair long and was rumored to enjoy drink. Nevertheless, from 1965 until his death in 1970, he chaired the Armed Services Committee of the United States House of Representatives. So, one cannot consider the military industrial complex in South Carolina's Lowcountry without paying homage to Congressman Rivers. During his almost thirty years in the United States House of Representatives, defense spending accounted for half the jobs in his district and one-third of the district's income. In the 1960s, Beaufort residents given to black humor joked about the Soviet missiles that could be trained on the City of Beaufort

The Beaufort High School Honor Society c. 1968. Pictured from front to back, and left to right: *Row 1*: Rosalyn Browne, Stanley Crockett, Theresa Herzog, Janet Petorock, Linda Trimmel and Mike Witkoski; *Row 2*: John Wells, Barb Ewers and Uel Jones; *Row 3*: Robin Bostick, Janice Smith, Cindy Brown, Kathy Savoy, Valerie Sayers, Vera May, Pam Koth, Mary Hope Gordon, Jan Zachowski, Faith McAlhaney and Marian Rice; *Row 4*: David Aderhold, Linda MacGeary, Mary Ruth Cheesebrough, Liz Dowling, Guy Matthewes, Bruce Gandy, Harry Keyserling, Grady Lights and Ed Peterson. *Ned Brown, photographer, Uel H. Jones.*

as it innocently sat amid such military might. Surrounding Beaufort, there were the Marine Corps Air Station, the naval hospital, and the Marine Corps Recruit Depot, Parris Island. The bases and their support services—especially the naval hospital—made Beaufort a desirable retirement venue for military retirees.

While South Carolina and Beaufort County received their share of federal military dollars, they were not chosen for the highly technological defense-related research and manufacturing. Rather, Beaufort and South Carolina profited from military installations and their expansion.

On 1 January 1955, during the Korean War, the marine corps opened an air station on the grounds of the old naval air station. The naval air station had functioned during World War II, and then reverted to civilian control when the war ended. In 1955, the marine corps used the site

as an auxiliary landing field for the Corps Air Station in Cherry Point, North Carolina. But on 30 June 1956, the facility was upgraded and redesignated a Marine Corps Auxiliary Air Station. The station's metamorphosis was completed on 1 March 1960 when the Auxiliary Air Station was commissioned the Marine Corps Air Station Beaufort. During the cold war and the Vietnam War, MCAS Beaufort's mission was to support a Marine Aircraft Group. At various times, between 1960 and 1990, MAG-32 and MAG-31 were stationed at Beaufort. With the increased military presence, the United States government constructed, within three miles of the airfield, a major new housing development—Laurel Bay—for military personnel and their families. MCAS Beaufort then had two components: the six-thousand-acre air station and the housing development.

The Marine Corps Recruit Depot, Parris Island, may not have been the largest installation in South Carolina, but it was and is probably the best known. The marine corps has been training recruits on Parris Island for seventy-eight years. Although marines first took an interest in Parris Island in 1891, the island did not become a training center until 1915 and the World War I era. Marine activity lessened when that war ended. But with the Japanese attack on Pearl Harbor, the United States was at war again. In 1946, Parris Island officially became the Marine Corps Recruit Depot. During World War II, almost a quarter of a million recruits trained on Parris Island. There was also a drill instructors' school. After the war ended, the school closed and was not reopened until 1950 and the Korean Police Action, Conflict or War. Parris Island can be an inhospitable environment. The deaths by drowning of six recruits in 1956 focused attention upon training procedures and expectations. Parris Island is normally the first leg of a marine's training. The marine would specialize at another base. However, not all marines leave Parris Island as, in addition to the drill instructors' school, Parris Island is also home to

Laurel Bay Baptist Church, 1961. With the construction of the military housing development at Laurel Bay in 1958, Beaufort Baptists began mission work in the area. The Reverend John A. Miller became the mission's first pastor in 1959. *Ned Brown photographer. Courtesy of George A. and Evelyn Jones Collection.*

special schools for field music, recruiters, personnel administrators and noncommissioned officers. The Marine Corps Band on Parris Island has a long tradition of excellence.

On 31 July 1946, the United States Navy broke ground for a new naval hospital along the Beaufort River near the site of the 1730's Fort Prince Frederick. In 1949, the navy closed the old naval hospital on Parris Island, and the naval hospital opened for business on 5 May 1949. Prior to building the hospital, the navy had operated a smaller facility on Parris Island. Originally designed as a 500-bed hospital, its peak bed use was 458 in 1960. In the 1990s, the hospital had sixty-five beds, and offered outpatient services to servicemen, their dependents and military retirees.

Beaufort and her installations made a significant contribution to this country's war readiness and fighting capabilities during the cold war. The military continues to be a major factor in Beaufort's economic development.

CIVILIAN BEAUFORT

Beaufort is justly famous for her Water Festival. With its roots in colonial and antebellum boat races, the festival capitalizes on Beaufort's natural charm and historic interdependence with the Beaufort River and the military. In the 1950s, the Beaufort Water Festival featured parades,

A replica of the Iwo Jima monument on Marine Corps Recruit Depot, Parris Island. *Courtesy of George A. and Evelyn Jones.*

beauty pageants, sailboat regattas and the flying Blue Angels, the navy's precision aeronautics team. These attractions parlayed Beaufort's local celebration into one of South Carolina's most successful local festivals. Beaufort officially held her first Water Festival in July 1955. The festival, now held at the Henry C. Chambers Riverfront Park, has grown to cover ten days of activities that include a parade of decorated boats and the blessing of the fleet. Former state Representative Harriet Keyserling recalled that one Water Festival featured a tug-of-war contest between members of Beaufort County Council and members of the Beaufort School Board.

In 1956, the James F. Byrnes Bridge linking Hilton Head Island with the mainland was constructed. Slowly and at times imperceptibly, life in Beaufort changed. Charles E. Fraser built Sea Pines Plantation, and today the island boasts bumper-to-bumper traffic as thousands of residents and visitors throng its shops and restaurants. Hilton Head became a mecca for vacationers, business travelers and retirees. Between 1950 and 1960, Beaufort County experienced the highest growth rate of any county in South Carolina.

In 1957, a contributor to the *New York Times* christened Beaufort the "Sleepy Town by the Sea." Touting the town as a "refuge for those who like the quiet life," Wayne Phillips described

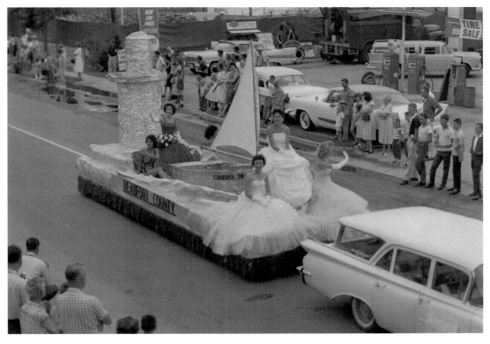

Dody (Dolores) Wallace, Miss Beaufort, is flanked by Kitty Wynn and Mary Jean Kinghorn during the 1960 Water Festival. Also adorning the Beaufort County float were Emily Lancaster, Mary Epps and Louise Kinghorn. *Ned Brown, photographer. Courtesy of Susan Wallace Whittle.*

Harbor Town, Sea Pines Plantation, Hilton Head Island, 1972. The J. Byrnes Bridge to Hilton Head opened 20 May 1956. Charles Fraser's dream for Sea Pines Plantation channeled Beaufort's development in new directions. *Courtesy of Ned Brown, photographer.*

the Beaufort of another era—"no night life, only one movie, and the streets are deserted before midnight." A dry town, Beaufort was "as yet unspoiled by any inundation of Strangers." Proud of their "9 o'clock town," Beaufort's leaders enjoyed coffee at the Ocean View Restaurant and a quiet pace of life. John P. Economy, the owner of the Ocean View, founded the Economy Club. The club was dedicated to reducing taxes, but banned all elected officials (such as long-term Beaufort County Sheriff J. E. McTeer) and lawyers from membership.

Chapter 11
Mid-century Challenges, 1958–1969

T HE SLEEPY PACE OF LIFE in Beaufort was short-lived. In 1958, there were eleven churches and one synagogue in the Beaufort-Port Royal area: Baptist, Methodist, Presbyterian, Episcopal, Roman Catholic, Lutheran, Church of God, Church of Christ, Christian, Christian Scientist, Latter-Day Saints and Beth Israel. Also in 1958, the Beaufort Presbyterian Church expanded its sanctuary and educational facilities. Life quickened as new military and civilian employees swelled the demand for housing in Beaufort, and the air station's payroll put more money in the pockets of the Bay Street merchants.

The nursery dedication at Baptist Church of Beaufort in 1958. Pictured (from left to right) are Genora Hendricks, Julia Bessinger, Mildred Freeman holding Georgeanne Jones. Seated are Shirley Frame with unknown baby. *Courtesy of George A. and Evelyn Jones.*

Hurricane Gracie damaged cars, downed trees and destroyed buildings in 1959. *Copy photograph, Ned Brown, Local History Collection. Courtesy of the Beaufort County Library, Beaufort.*

GRACIE

The forces of nature again disrupted Beaufort's recovery. On 29 September 1959, Gracie, a Category 4 hurricane with 146 mph winds, struck the town. Four died as a result of the storm. The causeways and bridges that connected Port Royal Island to the mainland and to Lady's Island were washed out. Downed trees and limbs still draped with Spanish moss formed natural barriers along the Bay obscuring sight of the river. Power lines were downed. Of those who died, one was James Chapman of St. Helena, who was struck by flying debris while trying to help a stranded motorist. The storm sank 12 shrimp boats, damaged 2,394 homes and caused $4 million in property losses.

Another fatality was Melvin T. Wildy of Frogmore. Wildy was the only black member of the Beaufort School District 1 board and also served as chairman of the board of trustees for Mather School. A graduate of Hampton Institute, he had taught at Penn School. Wildy was returning from Columbia when his car struck a tree that had fallen in the road near Smoaks. The impact of the crash sheared away the top of Wildy's car. His wife and daughter survived the accident. Judge James "Jimmy" Thomas, representing the Beaufort County School Board, and Dr. George A. Jones from the Baptist Church of Beaufort attended his funeral. The Wildy

194

funeral was held at Penn Center on St. Helena Island as the Brick Church lost her roof in the storm. Wildy mourners processed from Penn across the road to the Brick Church cemetery for the burial.

Gracie claimed two other Beaufort-related victims. One was Johnson Wiley, a North Carolina lineman. An automobile struck and killed him near the Rebel Drive-In on U.S. Highway 21. Mrs. Helen G. Morgan of 1106 Carteret was hurled from her car when she ran into a bridge near Garden City, Georgia.

The streets were littered with limbs, debris and live wires. Sheriff's Deputy C. O. Michael called the town "a total wreck." The town had no electricity, no running water and no telephone. Beaufort was isolated. For many, electricity did not return for weeks. Then, as would be the case now, restoring power to the Beaufort Hospital and to the naval hospital were the top priorities.

Residents who had survived both Gracie and the storm of 1893 noted that the big difference between the two was the lack of a storm surge. The most devastating effect of the Hurricane of 1893 was the accompanying tidal wave. Hurricane Gracie struck Beaufort at low tide. Fear of storms and high tides is ingrained in longtime Beaufort residents.

In preparation, residents had filled bathtubs and taped picture windows. Some remember the rhythmic sweep of branches across the windows during the storm. Boarding with plywood

A downed tree blocks Beaufort Street after Hurricane Gracie, 1959. *Copy photograph, Ned Brown, Local History Collection. Courtesy of the Beaufort County Library, Beaufort.*

was a coping skill of the future. The storm shattered the windows of the Bay Street stores, downed electrical lines, snapped pine trees at St. John's Lutheran Church, uprooted water oaks and split live oaks. The winds demolished a home in the Floyd Heights area and leveled the Walterboro Fruit Stand.

The wind wailed and whined, and tore the tin roof loose from the Baptist Church of Beaufort and rolled it up as if opening a can of sardines. Rainwater poured through the ornate plaster ceiling, saturating hymnals, pew cushions, and carpet. The first visitors found water standing in the sanctuary and the hymnals swollen to twice their normal size with the plaster-ladened water. The scent of wet plaster hung in the air. Within days, mold was growing. Water pooled above the church's ornate plaster ceiling. A work crew from Kinghorn Construction Company erected scaffolding and poked holes in the ceiling to drain the water. This action prevented the ceiling from collapsing. The Baptists met in their recreation hall from September until Easter Sunday 1960 when they were able to return to their renovated sanctuary.

Marine recruits from Parris Island were sent to cut downed trees and clear the streets. Citizens read by kerosene lamps or candlelight, and grilled what food they could salvage from their freezers. Some grew to dislike Spam, as once a can was opened, all of it had to be consumed at one sitting. Mrs. Otis Youngblood cooked in her Ribaut Road fireplace. The weather during recovery was unblinkingly sunny and clear—a stark contrast to the war-zone appearance of the town.

Once the bridges and causeways were reconnected, aid arrived and residents could tour the islands. There, they found scenes of capricious destruction. The top-floor walls of a house

Dr. George A. Jones, pastor, surveying the renovated sanctuary of the Baptist Church of Beaufort, 1959. *Ned Brown photographer. Courtesy of George A. and Evelyn Jones.*

The front yard of the Otis Youngblood home at 155 Ribaut Road resembled a jungle after Hurricane Gracie visited in 1959. *Courtesy of Pat Youngblood.*

were gone, but the bed, bedside table and other furniture sedately remained. The landscape looked scoured.

THE SIXTIES—TIMES OF CHANGE

The sixties for Beaufort were years of unrest and social and political change. *Brown v. Board of Education* became a reality in Beaufort. The city and county confronted poverty and exploitation. The Republican Party was reborn. Moderate political leadership focused on maintaining social stability. Developers discovered the untrammeled beauty of the Sea Islands, tourism grew and the cold war heightened the military presence in Beaufort.

During this crucial decade of the 1960s, Beaufort slowly began to integrate her public schools. In the school year 1964–1965, ten years after the ground-breaking ruling by the United States Supreme Court, the Beaufort County School Board adopted a freedom of choice option that permitted students to transfer to the school of their choice. Rowland Washington, who had attended Robert Smalls High School, chose to attend Beaufort High School for his junior year, and thus, became the first black student to attend the formerly all-white high school. At that time, William E. Dufford was the high school principal. Grace Foster Dennis was

The Baptist Church of Beaufort Chapel Choir dedication, 27 October 1963. *First row*: Gloria Graves, Linda Jackson, Linda Norsworthy, Linda Lancaster, Dorothy Kinghorn and Susan Wallace. *Second row*: Ann Hendricks, Pat Powell, Judy Brown, Nancy Hendricks, Martha Jones, Lonnie Anderson and Mike Brown. *Third row*: John Carter, Wayne Freeman, Paul Carter, Uel Jones, George Chappell, Bill Jackson and Tom Dunlop. *Ned Brown, photographer. Courtesy of Uel H. Jones.*

Washington's homeroom teacher, and Gene Norris taught his English class. Although few knew of Washington's coming, with a few exceptions, the students adapted. In 2002, students at the Beaufort Middle School housed in the former Beaufort High School facility conducted a series of oral interviews in order to document the integration of Beaufort High School. At that time, Washington commented on how Beaufort had altered since his school days, "I've seen quite a number of changes in the way people live and the way they interact with each other."

More black students joined Washington at Beaufort High School during the transitional years of freedom of choice. They wrestled together; played football, basketball and baseball; and ran track together. Life was not always kind to Beaufort's integrated teams on road trips. At least once, a student from Barnwell forfeited a wrestling match because he did not want to wrestle the integrated team from Beaufort. Some parents remember the heckling of players and a threatening mob that gathered after a basketball game in Walterboro.

Prior to July 1968, the United States Supreme Court ruled in *Green v. New Kent* that there should be only schools, not black schools or white schools. If a school district adopted the freedom of choice approach to this goal, then the burden of proving it successful rested with the school board. By 1968 the Beaufort County Community Council of Human Affairs was working with the Beaufort County Board of Education to create a unified, desegregated school system for the county.

By May 1968, the City and County of Beaufort realized that positive steps must be taken to deal with civil rights issues and growing racial tension. The Orangeburg Massacre of February 1968 was a wake-up call for Beaufort. Three South Carolina State College students

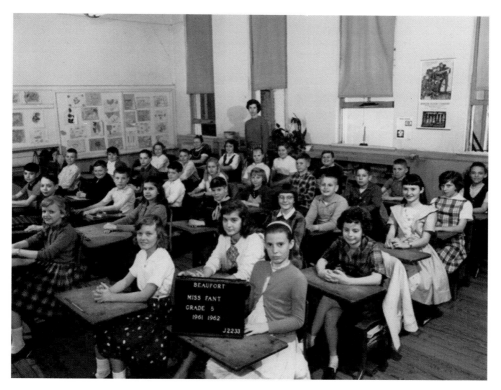

Miss Fant's fifth-grade class at Beaufort Elementary, 1961–1962. Pictured from front to back, and left to right: *Row 1*: Ralph Lewis, Janice Smith, Paula Richards and Peggy Shipman; *Row 2*: Larry Mark, Ed Peterson, Tommy Murphrey, David Tuten and Dawn Petrovich; *Row 3*: Uel Jones, William Farley, unknown, Linda Lightsey, unknown and —— Dennis; *Row 4*: unknown, Nancy Hanna, Harry Parker and rest of the students are unknown; *Row 5*: First four students are unknown, Jay Fox, unknown; *Row 6*: Ann Wood, Brenda Ripley, Doris Bonds, unknown and Donna Purvis. This classroom was in the brick Beaufort Elementary School building, constructed c. 1930 at 901 Carteret Street. Other classes met in the wings added to the former Beaufort College Building. *Courtesy of Uel H. Jones.*

Beaufort High Tidal Wave versus St. Andrews Rocks in the fall of 1966. The Wave crashed over the Rocks with Uel Jones (No. 66), Doug Maule (77), Tommy Wiggins (52), Johnny Taylor (81), Bob Millenbine (64) and Bryan Burns (85). On the ground is running back, Paul Smith (20), scoring a touchdown. *Ned Brown, photographer. Courtesy of Uel H. Jones.*

died as a result of confrontations with authorities following demonstrations to desegregate a bowling alley.

Consequently on 16 May 1968, the Beaufort County Legislative Delegation and the Beaufort City Council established the Beaufort County Community Relations Council (also known as the Community Council of Human Relations). Thanks in large measure to this council, whose membership was equally divided between Beaufort's black and white citizens, neither the city nor the county of Beaufort experienced the demonstrations and riots that occurred elsewhere in South Carolina.

In 1968, the members of Beaufort County's legislative delegation were Senator James M. Waddell, and Representatives W. Brantley Harvey Jr. and J. Wilton Graves. Dr. George A. Jones was the first chairman of the council and, at one time, he and the Reverend R. D. Dicks co-chaired it. The council facilitated discussion of hiring practices by Beaufort businesses and other community issues. The council also addressed the rising number of community

concerns about Beaufort's schools—their accreditation, the pay of black and white teachers, the physical condition of the schools, textbooks, the study of black history, and the school board's compliance with the 1954 and 1955 Supreme Court decisions. Some community activists suggested that the council needed to be a community, not a mayor's, council. Others expressed concern that the council was more concerned with Beaufort's image than with substantive matters such as poverty.

Many individuals were involved with the council at different times. A list of those who attended the council's third meeting on 18 June 1968 provides a sampling of the community leaders who participated. The attendees were Dr. George A. Jones (chairman), W. Brantley Harvey Jr., James M. Waddell Jr., A. J. Brown, J. J. Harter, Dr. B. H. Keyserling, Lloyd Graham, Mayor Monroe Key, Carl C. Hendricks Jr., Paul Hursh, Herman Gaither, Elrid Moody, Charles E. Fraser, the Reverend Cornelius Hayes, Hyland Davis, the Reverend R. D. Dicks, Mrs. Charles Washington and Mrs. J. O. Youngblood.

This council worked behind the scenes to defuse tense situations. In 1968 when Dr. Martin Luther King Jr., whose Southern Christian Leadership Conference (SCLC) had frequently met at Penn Center, was assassinated, the council asked its black members to identify appropriate community responses. Beaufort's black leaders asked for a school holiday on the day of Dr. King's funeral and for a community memorial service at Freedom Mall on Sunday afternoon. The Beaufort Ministerial Union organized the memorial service, and the council worked with the Beaufort County School Board to arrange the school holiday. Some members were also indirectly involved in efforts on the one hand to prevent the White Citizens Council from marching in Beaufort and on the other hand to reroute black demonstrators from Savannah.

The Gantt Cottage, Penn Community Center, St. Helena Island. Built in 1940, the cottage housed Dr. Martin Luther King; other Southern Christian Leadership Council staff stayed here during retreats. *Courtesy of Evelyn Jones.*

201

The sixties also brought heightened concerns for the migrant workers who picked Beaufort County's lucrative vegetable crops. The federal government ran a pilot summer school for migrant children in 1967. As their parents followed the crop-picking seasons across the United States, the students' educational opportunities were limited. In 1963, area churches, such as the Baptist Church of Beaufort, also launched migrant mission projects that included medical care, clothing centers, and religious and educational instruction. In 1963, twenty-three truck farmers in Beaufort County depended upon migrant workers to harvest their tomato and cucumber crops. At that time, approximately four thousand workers came to Beaufort County each summer.

In the early 1960s, the pharmacist Dr. Charles Aimar, who once spoke to Beaufort High School students about the John Birch Society, led the effort to revitalize and reorganize a Republican Party in Beaufort County. During the sixties, the party began offering candidates for city, county and state offices. Party strength increased during the late sixties and seventies until today, when most city and county incumbents are Republicans.

The Beaufort County Library was integrated in 1962, although the library's Washington Branch continued to operate until 1965. Between 1971 and 2003, Julie Zachowski was director of the Beaufort County Library. During her tenure, the library enjoyed a period of unparalleled growth. The Beaufort County Library constructed and renovated its

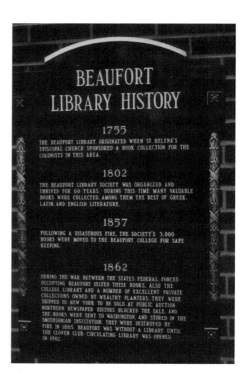

Beaufort County Library plaque. The Reverend Lewis Jones, the Clover Club, Niels Christensen and Julie Zachowski are a few of those who have contributed to Beaufort's long and historic library heritage. *Courtesy of Ned Brown, photographer.*

Right and below: Migrant laborers picking vegetable crops in Beaufort County in June 1966. Truck farming was a major factor in the economy of Beaufort County for much of the twentieth century. *The Baptist Home Mission Board Photographs. Courtesy of George A. and Evelyn Jones.*

headquarters building on Scott Street, and built branch libraries in Bluffton, Lobeco, Hilton Head Island and St. Helena Island.

A political highlight of the 1960s was the fiercely contested sheriff's race of 1962. Former Highway Patrolman L. W. Wallace challenged Beaufort County's legendary Sheriff James Edwin McTeer. The race featured ad hominem attacks on the challenger, and perhaps the largest write-in campaign in Beaufort County's history. When first elected in 1926, McTeer was reputedly the youngest person ever elected sheriff in the United States. He was also possibly the only sheriff who professed to be a root doctor. A root doctor in the Gullah culture is a conjurer who specializes in the use of roots and herbs as well as the supernatural to cure human afflictions. In later life, McTeer wrote several books including *High Sheriff of the Lowcountry*. The McTeer Bridge over the Beaufort River honors McTeer's long years of service to Beaufort County. The bridge was featured in the movie version of *The Prince of Tides*.

In the evening of general election day in 1962, early returns gave Wallace the lead. Wallace supporters had gathered at his home when a radio broadcast disrupted their celebration. Calhoun Thomas, chairman of the Beaufort County Democratic Party, announced over the radio that another ballot box had been found and the results of the election were in question. Concerned citizens present at the Wallace home—including Elbert Sweat and Dr. George A. Jones, pastor of the Baptist Church of Beaufort—hurried to the community center, located on Carteret Street next door to the post office, where the ballot boxes were being stored. Amid fears that the election was being "stolen," they learned that the Lady's Island results had been phoned in and that the box remained on the island. Sweat and others retrieved the ballot box. That night, at their insistence, all the ballot boxes were stored in the vault of the Peoples Bank. The initial tally showed 2,006 votes for Wallace and 1,979 for McTeer. There were charges and counter-charges of intimidation, falsified ballots, missing ballots, destroyed ballots and other campaign abnormalities.

The Beaufort County Board of Canvassers certified the results of all of the November elections, except for that of sheriff. The county board reported to the South Carolina State Board of Canvassers that "we feel that there were enough illegal ballots cast to have changed the results of the November 1962 election for sheriff and we therefore declare the election null and void." Then Governor Fritz Hollings called for a special general election to choose a sheriff for Beaufort County. The special general election was held 11 December 1962, and the voters of Beaufort County gave Wallace, the challenger, an overwhelming victory. Wallace received 2,660 to McTeer's 1,515. On 27 December, the South Carolina State Board of Canvassers ruled that as "no protest" had been submitted, L. W. Wallace was declared the "duly elected sheriff of Beaufort County."

The Wallace victory marked a changing of the guard in Beaufort County politics and administration. McTeer had served as sheriff of Beaufort County for thirty-seven years.

Sheriff L. W. Wallace conducting a safety lesson for students at Battery Creek Elementary, c. 1963. *Ned Brown, photographer. Courtesy of Susan Wallace Whittle.*

Previously, McTeer's father had also served two terms as sheriff. The clerk of court and other key officials were also long-term incumbents, but change was in the wind. As Dr. Jones phrased it, "The old was dying, but they didn't want to turn loose."

In a humorous follow up to the election, on 19 December 1962, shortly after the election, Wallace's daughter Susan was chosen "Miss Sophomore" at Beaufort High School. When announcing the judges' decision, the emcee quipped, "We won't need a recount for this!" The politics of Beaufort and of Beaufort County were rarely dull.

The assassination of President John F. Kennedy shocked Beaufort and the rest of the United States in November 1963. Responding to President Lyndon B. Johnson's call for a national day of prayer, the Beaufort Ministerial Union conducted a memorial service on 25 November at the Baptist Church of Beaufort. Among the ministers participating were Dr. George A. Jones, the Baptist Church of Beaufort; Rabbi Joseph C. Salzman, Beth Israel Synagogue; Father Ronald Anderson, St. Peter's Catholic Church; the Reverend Milton A. Wilmersherr, First Presbyterian Church; the Reverend Earl F. Lunceford, Carteret Street Methodist Church; the Reverend

Dermon A. Sox Sr., St. John's Lutheran Church; and the Reverend Zeph N. Deshields, First Christian Church. State Senator James M. Waddell Jr. commented favorably on the "impressive ceremony" put together "on such short notice."

In addition to being times of political change, the sixties were also times of religious change—times of ecumenical fervor. During the sunshine of Pope John XXIII and his successor Pope Paul IV, denominational leaders in Beaufort—particularly Father Ronald P. Anderson of St. Peter's Catholic Church and Dr. George A. Jones of the Baptist Church of Beaufort—worshipped together. During St. Peter's Week of Prayer for Christian Unity, the congregations held the most historic of these services—the Friendship Service—a joint evening worship service held on 23 January 1966 at the Baptist Church of Beaufort. The congregation that evening included 150 from St. Peter's and 400 from the Baptist Church. The Reverend Dermon A. Sox of St. John's Lutheran Church also attended. Also assisting with the service were two Baptist laymen: G. G. Dowling and Ralph Rentz, chairman of deacons. As the congregation filed out following the service, all three ministers were at the door to greet them. Beaufort was home to a rare event—one of the first of its kind in America. This event inaugurated a rare period of religious "glasnost" in Beaufort. Dr. Jones participated in an ecumenical meeting in October sponsored by Catholic clergy in Charleston and attended services at St. Peter's.

The historic Ecumenical Friendship Service at the Baptist Church of Beaufort in 1968. Pictured are (from left to right) G. G. Dowling, Baptist layman; Ralph Rentz, chairman of the deacons, Baptist Church of Beaufort; Dr. George A. Jones, pastor of the Baptist Church; Father Ronald P. Anderson of St. Peter's Catholic Church; the Reverend Dermon A. Sox, St. John's Lutheran Church; and Father Creston Tawes, St. Peter's Catholic Church. *Ned Brown, photographer. Courtesy of George A. and Evelyn Jones.*

In 1964, Beaufort County's 17 manufacturing plants employed the greatest number of county residents—278. Tourism-related employers (a wide category that included a variety of lodging alternatives ranging from campgrounds to hotels) employed more people with 239 than the third place contender, agriculture with 236. In fourth place was the service sector with its 223 employees. Although the difference between the number who worked in the tourism sector and those who worked in agriculture was small, it signaled a shift in the economic focus of the county. In 1966, the county had a population of 51,900. In 1960, Beaufort County trailed the United States in per capita disposable income. Local governments in the county had revenues and general fund expenditures of $74 per person. Nationally, the average per-person general-fund expenditure by local governments was $206. Owner-occupied homes in Beaufort County had a median value of $6,200. Nationally, the median value of owner-occupied homes was $11,900. The median value of owner-occupied homes in Beaufort County, though, had risen 104.6 percent since 1950, when the median value was only $3,030. In reviewing certain indicators of relative wealth in 1960, Beaufort County trailed the United States in all areas except in the percentage of owner-occupied homes with air conditioners and the percentage of owner-occupied homes with one car. The county trailed the nation in percent of washing machines, food freezers, televisions, telephones, and two or more cars.

By the mid-1960s, Beaufort had seen the historic Sea Island Hotel demolished and replaced with the brick Sea Island Motel. Concerned citizens who had rallied to save the John Mark Verdier House organized to preserve Beaufort's architectural and historic buildings. The Historic Beaufort Foundation, with the impetus of Howard Danner, was incorporated 18 June 1965. The foundation met at the parish hall in 1967 for an organizational meeting. Danner warned that Beaufort "had lost and was in the process of losing some of its old and valued buildings." The group that had saved the Verdier House then transferred ownership to the foundation. The foundation restored the house and opened it as a house museum in 1975. The foundation actively supported efforts in 1968 to hire Russell Wright and Carl Feiss to survey and identify Beaufort's historic structures.

In 1960, residents, aged twenty-five or older, on average, had completed nine years of school. Beaufort County was improving, as the average in 1950 had been only six years. Even worse, in that same age group, 20.5 percent had completed less than four years of school. On the plus side, the number of students enrolled in schools rose from 9,327 in 1960 to 10,202 in 1965. Home values and the number of students being educated increased in Beaufort County between 1950 and 1960. Educationally, the trend continued into the 1960s. Yet, per capita income and amenities in owner-occupied homes trailed the national average.

Consequently, some were not surprised in 1969 when Beaufort and Beaufort County grabbed unfavorable headlines in the state and nation. Sparked by Dr. Charles Gatch's report on hunger in Beaufort County, United States Senator Ernest "Fritz" Hollings

Made between 1935 and 1945, this image details the many commercial enterprises housed in the John Mark Verdier House. Fish, bananas and other fruit were for sale on street level; while an art school and public stenographer had offices above. *Walker Evans, photographer. LC-USF342-008098-A. Courtesy of Library of Congress.*

personally conducted a highly visible tour of poverty-stricken areas in South Carolina. Based upon his findings, Hollings, writing in *The Case Against Hunger*, advocated school breakfast programs and food stamps. Many government aid programs followed.

Resort development has heightened economic disparity between income groups in Beaufort County. For example, when land values and assessments rise, and much of the job growth involves housekeeping, retail and restaurant positions in the tourism-related service sector, poorer landowners cannot maintain their economic position. As a result, increased land assessments and higher taxes forced, and are continuing to force, many of Beaufort County's black citizens to sell or lose their land at a tax sale. The land that is being lost is land that had been in their families for generations—land that their ancestors acquired in the post-Civil War era when the freedmen struggled to gain an economic toehold.

Another situation in Beaufort County caught the eye of the press in 1969—one of the first successful protests of economic development in South Carolina. "An unlikely coalition,"

The Beaufort High School gym during the campaign speeches for the 1962 student body elections. From left to right are Bruce Harper, Martha Jones, Chuck Richards, Candy Dobyns, Linwood Pollin standing, unidentified, Molly Quinn, Linda Mixon, Jo Shearer, Jimmie Sammons, Mary Alice Taylor, unidentified, Vicki Qualls, Pat Conroy, Gary Fordham, Bruce Byrum and Barry Johnson. *Ned Brown, photographer. Courtesy of George A. and Evelyn Jones.*

as historian Walter Edgar described the members united to prevent BASF, a German chemical firm, from constructing a petrochemical plant on Victoria Bluff in Beaufort County. Fishermen, environmentalists, county planners and developers from Hilton Head contended with the state development board. Politicians and even the secretary of the interior agreed that the plant was a potential threat to the area's ecosystem. Eventually, the company dropped its plans for the development. Pollution, the environment and development were front-page news and major concerns for residents of the city and county of Beaufort.

The year 1967 was a memorable one for the city of Beaufort. That year, Beaufort elected a slate of candidates running as a block for mayor and city council. In addition to electing Monroe Key as mayor, the voters of Beaufort also swept into office the first black city council member, Joseph M. Wright. Wright operated the Wright, Donaldson Funeral Home and served on the city council from 1967 to 1974. Other city councilmen elected that year were John M. Griffin, Carson R. Rentz and Ralph Ray Kearns. In a sense, the Baptists captured city government that year. The mayor and all the newly elected city councilmen were members of

the Baptist Church of Beaufort, except for Joseph Wright, but his home was across the street from the church.

On 24 January 1967, Beaufort's City Council established the Planning Commission. Dr. George A. Jones was the first chairman of the city's Planning Commission. Under the leadership of the Planning Commission, on 8 October 1968, the City of Beaufort began the process of protecting her historic buildings. On that date, Colonel J. R. McCoach of the Planning Commission presented an ordinance to rezone the entire city of Beaufort. The city councilmen—Carson R. Rentz, John Griffin, Joseph M. Wright and Ralph Ray Kearns—approved the recommendation. Monroe Key was the mayor, and Don H. Fisher, the city manager. By 18 November 1969, the Planning Commission had dissolved and the Beaufort County Joint Planning Commission formed. The officers of the Joint Planning Commission were Dr. George A. Jones, chairman; Sumner Pingree Jr., vice chairman; and A. R. McAfee, secretary. C. R. Gatch was the commission's engineer. In November 1969, the city manager recommended the establishment of an architectural review board and its incorporation in the zoning ordinance.

In 1967, Joseph M. Wright was the first black elected to Beaufort City Council possibly since the election of George A. Reed as warden in 1897. Wright owned Wright, Donaldson Funeral Home. *Copy photograph, Ned Brown. Courtesy of the Wright-Donaldson Funeral Home, Beaufort.*

The groundbreaking for the Bayview Geriatric Center, c. 1969. Pictured (from left to right) are Elrid Moody, James G. Thomas, Carson (Jim) Rentz, Lawrence Davis and Tom Ramsey. In the front is George A. Jones. *Courtesy of George A. and Evelyn Jones.*

On 18 November 1969, the Beaufort city manager reported that the Bureau of the Census had conducted a special census of the city on 29 September 1969. According to that census, the 1969 population of the city of Beaufort was 9,299. That total reflected steady population growth in the city since 1930.

Chapter 12
Toward the Light, 1970–Present

T HE CITY OF BEAUFORT WAS growing. She left the turbulent sixties behind and rediscovered herself. In the late twentieth century, Beaufort became sleek and well-groomed with her beautiful new riverfront park and meticulously restored historic homes. But dark clouds loomed as the county's growth began to outpace the growth of the city and as the downside to development gained attention.

Molly Quinn, left, and Martha Jones at the 1962 Christmas parade. *Ned Brown, photographer. Courtesy of Martha Jones Denka.*

Total integration finally arrived in Beaufort with the 1970–1971 school year. That year, the students from the formerly white Beaufort High School and once black Robert Smalls and St. Helena High Schools attended school together. To ease the consolidation of the three high schools, school leaders effected a compromise. The school took its name from Beaufort High School; its colors (green and white) from Robert Smalls High School, and its mascot (the eagle) from St. Helena High School. Before consolidation, the colors of Beaufort High School were scarlet and white, and the school's mascot was the tidal wave. The Robert Smalls Generals wore green and white, and the colors of the St. Helena Eagles were green and gold.

Due to the large number of students and the limited number of classrooms, Beaufort High School held double sessions. One group of students attended school in the mornings, and the other group, in the afternoons. According to former teacher Gene Norris, the situation "was hard on the school, hard on the teachers and hard on the kids." When the school board built Battery Creek High School four years later, the overcrowding eased and the split sessions ended.

There was resentment among the white students at Beaufort High School toward their new black classmates. Similarly, there was resentment at Robert Smalls Junior High School by the black students toward the new white ones. Incidents occurred, but according to Norris, who taught at the high school and then moved to the junior high two years after full integration, the incidents "weren't anything so drastic or terrible."

With school integration, integration of other public facilities followed. By the early 1970s, the separate water fountains at Edward's Department Store disappeared and seating at the Breeze Theatre was open to all moviegoers.

The development of resorts and retirement complexes in Beaufort County brought increased numbers of visitors and permanent residents. During the 1970s, as had been true during the 1960s, Beaufort County was one of the fastest growing counties in South Carolina. By 1990, more than half the population of Beaufort County was not native to the county. Besides water use and conservation concerns, development also brought concerns of traffic congestion, infrastructure, services and evacuation in the case of natural disasters.

Residential development brought another concern to Beaufort and her citizens. As more people discovered the beauty of the Lowcountry, more moved there. As more moved there, the demands for housing, support services, infrastructure and entertainment increased. With these increased activities came increased demands for water. Consequently, the underground aquifers that furnish much of Hilton Head's water are being depleted. Saltwater is invading these prehistoric pockets of freshwater. While alternative water supplies are being developed, conservation remains a long-term commitment.

Beach maintenance is another concern. Erosion at Hunting Island and Hilton Head affects the quality of life for Beaufort residents who enjoy surfing, swimming, sunning or beach walking. Beach renourishment projects are expensive and often of short-lived effectiveness. As a barrier island, the sea is not only washing away the beach from the north end of Hunting Island but also cutting a channel through the island. The historic and picturesque Hunting Island Lighthouse, originally constructed in 1875, was moved due to erosion and rebuilt in 1889. Confederates destroyed an earlier lighthouse built in 1857 so that federal forces could not use it. Now, the waves again threaten the lighthouse, an important visual landmark for sailors between Charleston and Savannah.

Beaufort resident Harriet Keyserling was the first woman elected to the Beaufort County Council in 1974. In 1976, she began the first of her eight terms in the South Carolina House of Representatives. Keyserling was the wife of Beaufort physician Dr. Herbert Keyserling. During her tenure in the House, she focused on the arts, education and environmental issues. Keyserling served during a new openness in South Carolina government—a time of reform. She was an active leader of a small group of legislators, nicknamed the Smurfs, who wanted to make substantive change in how South Carolina educated her children. Thanks to their

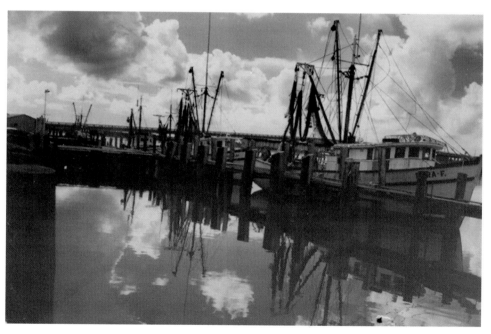

Shrimp boats on the Beaufort River. The seafood industry epitomizes Beaufort's historic dependence upon her waterways. By the late 1920s, Beaufort County led the state in number of licensed shrimp boats. *Ned Brown, photographer. Courtesy of the author.*

efforts, under the leadership of Governor Richard W. Riley, the Education Improvement Act became a reality in 1984. Keyserling retired from the South Carolina House in 1992. Their son Billy Keyserling also served in the South Carolina House of Representatives.

In addition to the Water Festival in July, Beaufort holds two other festivals. The Gullah Festival in May celebrates the unique cultural heritage of the Sea Islands—the language, literature, arts and history of Beaufort's black residents. In the fall, Beaufort hosts the Shrimp Festival. Inspired by the success of the movie *Forrest Gump*, Beaufort held her first shrimp festival in 1994.

MAYOR CHAMBERS

On 5 May 1970, Henry C. Chambers was sworn in as mayor of the City of Beaufort. After he took the oath of office, Chambers presented to the city council his Beaufort Plan. The plan outlined Chamber's commitment to clean up the city and improve living conditions (sanitation, health and beautification) of low-income areas. On 8 December 1970, Chambers discussed with the city council the value of Beaufort's historic buildings and the "urgent need to prepare a plan which would insure the preservation of the historic aspects of this community." Chambers also expressed concern that the city needed to establish architectural guidelines that would govern any new construction in the historic areas of Beaufort. In October 1970, the Community-Planning Division of the South Carolina State Planning and Grants Division in the Office of the Governor completed the City of Beaufort's first development plan for the Beaufort County Joint Planning Commission. On 23 March 1971, the Beaufort City Council voted to hire Russell Wright, a "professional consultant" to prepare an "historical development plan for the City of Beaufort." Thus, the City of Beaufort began her efforts to systematically preserve her priceless architectural and historical heritage.

The efforts of the preservationists bore fruit in 1974. On 28 May of that year, Chambers announced that the United States Department of the Interior had designated Beaufort's historic district as a National Historic Landmark. The Historic Beaufort Foundation urged approval of the designation. After considering the business implications of the designation, council approved the designation on 25 June 1974.

THE RIVERFRONT PARK

In 1974 Mayor Chambers and the Beaufort City Council began planning a waterfront recreation park. A federal grant funded much of the project. Park development had three phases: bulkhead construction; fill and parking; as well as planting, lights and recreational facilities. On 8 October 1974, the Beaufort City Council voted to proceed with the project. The city held a groundbreaking for the new park on 7 January 1975.

The Marshlands at 801 Pinckney Street, 1974. In the heart of Beaufort's historic district, Dr. James Robert Verdier, son of John Mark Verdier, built this house c. 1814. Dr. Verdier was renowned for his successful treatment of yellow fever. The house is named for one featured in Francis Griswold's novel *A Sea Island Lady*, published in 1931. *South Carolina National Register of Historic Sites, Beaufort County. Courtesy of the South Carolina State Historic Preservation Office, South Carolina Department of Archives and History.*

The Henry C. Chambers Riverfront Park adjoined Freedom Mall. Freedom Mall was the paved parking area behind John Griffin's Sinclair Gasoline Station. Before the riverfront park was built, rallies, concerts, and other public meetings were held at Freedom Mall. On one memorable day (it may have been the Fourth of July), Congressman L. Mendel Rivers, Senator Fritz Hollings and Republican United States senatorial candidate William D. Workman all attended. In 1969, the city council approved a request to hold a folk music concert on the mall, but refused a request from representatives of Penn Center to hold a discussion of the Vietnam War there.

The Henry C. Chambers Riverfront Park hugs the Beaufort River and features walkways, swings, a playground and public concerts. The park is named for Chambers who, as mayor of Beaufort, conceived the idea of transforming Beaufort's waterfront from commercial piers to a public park. Federal grants helped fund the ambitious project. The town devoted a number of

years to the project and had to negotiate with a number of landowners. Some businesses that adjoined the proposed park were not enthusiastic about the project. In addition to proving ownership of the low-water lots, the town had to condemn and purchase other tracts. Most merchants on Bay Street, however, supported the mayor's dream.

The park is built over the original low-water lots for the town of Beaufort. In the colonial era, merchants such as Francis Stuart and John Gordon (in 1763) held title to these lots. Wharves, warehouses, cotton gins and stores once stood where children now play. So, in a sense, building the park destroyed an aspect of Beaufort's historic relationship with the river.

In 1979, the Beaufort County Joint Planning Commission prepared a revised City of Beaufort Development Plan. The plan detailed specifics about the status of education, the effect of the military presence, population, employment and commercial development. In 1979, the naval hospital, Marine Corps Air Station and Marine Recruit Depot, Parris Island, accounted for 4,755 military and civilian individuals and 5,739 total dependents. These figures gave a total military connected presence in Beaufort County of 10,494, out of a total county population in 1970 of 51,136.

In 1970, the city of Beaufort's total population was 9,434, with 76.7 percent of her population white and 40.2 percent younger than nineteen years of age. Only 10.2 percent of the city's population lay in the 60 and above age brackets. The year 1960 marked the first time the white population of Beaufort County exceeded the county's black population. Between the years 1960 and 1970, 15.1 percent of Beaufort County's black population left. Beaufort County's black residents sought better job and educational opportunities elsewhere.

Also in 1970, only 1 percent of the city's population age twenty-five and older had never attended school. The median number of school years completed was 12.3 in the city. That year, the city of Beaufort led the county and the state of South Carolina in the number of post-high school years completed. The City of Beaufort housed a mobile, but it was well-educated, population. Concomitantly, Beaufort also led South Carolina and Beaufort County in median and per capita income. Those figures were skewed as they included Beaufort's military residents whose incomes often exceeded that of the other residents. Excluding the military, 17 percent of Beaufort's families were below poverty level, compared to 24 percent in the county.

In the late 1970s, agriculture was a strong component of the county's employment. However, the number of farms in the county and the number of agricultural employees had been declining since 1960. At the same time, manufacturing jobs increased in Beaufort County. In the City of Beaufort, employment was nonmanufacturing and nonagricultural. With slightly more than 6 percent of the city's population unemployed, the majority of city workers were first, salaried workers, second, government workers and third, self-employed. In Beaufort, most of her residents were classified as professional, administrative, or technical.

A streetscape (with Verdier House), 800 Block, Bay Street, 2000. The three blocks of Bay Street between Charles and Carteret have been Beaufort's central commercial district from the city's beginning. *South Carolina National Register of Historic Sites, Beaufort County. Courtesy of the South Carolina State Historic Preservation Office, South Carolina Department of Archives and History.*

As of the 1979 report, the mercantile interests in the city included hardware, garden supplies, mobile homes, building supplies, clothing and general merchandise, furniture, restaurants, pharmacies, twenty-three groceries, gasoline stations and sixteen automobile dealerships. Given all this activity, the 1979 report summed up the situation by stating that the city of Beaufort "was the commercial and service center of the county."

Challenges loomed as the report noted that merchants in the city and county had difficulties competing with the more diverse retail markets of Savannah and Charleston. One recommended way to address that situation was the completion of the waterfront park project first proposed in 1975. The report also cautioned that the city could not always count on military dollars and military personnel to shore up its economy. Despite these concerns, the city's economy grew steadily between 1960 and 1972.

In 1972, Beaufort's recreational opportunities were limited. While the city had a number of small parks, only one had lighted tennis courts. The largest was Pigeon Point Park, a six-acre sports complex. Under construction at the time of the report was the Henry C. Chambers park. Plans for the seven-acre park included a marina and common area linking the river with Bay Street businesses.

In January 1988, Beaufort's dark past reared its ugly head. The Ku Klux Klan marched again in Beaufort from Bay Street to Carteret and Craven and back to Charles Street. The parade

The May Court of Beaufort High School, 2 May 1963. Bruce Harper crowned Pat Conroy the May king with his queen, Gloria Burns. Members of the court (from left to right) include unknown and Frank Pape. In the front, second from the left is Georgeanne Jones and third from right, Tim Conroy. *(Courtesy of Georgeanne Hammond.)*

ended in the marina's parking lot. Horace King, the Grand Dragon, postponed the October 1989 march as Beaufort's firefighters and police were assisting with cleanup from Hurricane Hugo. In February 1990, the Klan march ended at Freedom Mall.

In 1989, Hurricane Hugo triggered a massive evacuation of Beaufort and Beaufort County, but had minimal impact on the area. Fortunately, Beaufort escaped the devastation and death wrought by the hurricanes of 1893, 1940 and 1959. On 14 September 1999, the approach of Hurricane Floyd triggered a massive evacuation of an area that stretched from Florida to Virginia with Beaufort in the middle. The storm veered and Beaufort was saved, but forty-one people died in North Carolina. Real estate agents traditionally promote "location, location, location." That mantra is the reason the residents of Beaufort remain alert and cautious. In some ways, history does repeat itself.

In the late twentieth century, the Beaufort area has become well-known for the movies filmed there. Major motion pictures set in the town of Beaufort include *The Great Santini*, *The Big Chill* and *The Prince of Tides*. Two of these movies were adapted from novels written by Beaufort County resident Pat Conroy. Conroy, a graduate of Beaufort High School and the Citadel, taught in Beaufort and on Daufuskie Island. His novels capture the lyrical beauty of Beaufort and the Sea Islands. Beaufort has a long literary heritage. The continuum includes, in addition to Conroy, Francis Griswold's *Sea Island Lady*, Stephen

Elliott's *Carolina Sports by Land and Water*, Ann Head's *Mr. and Mrs. Bo Jo Jones* and Valerie Sayers's *Due East*.

Born in Beaufort in 1944, "Smokin'" Joe Frazier captured the gold medal in the boxing heavyweight division at the 1964 Tokyo Olympics and won the New York State Athletic Commission's World Heavyweight Championship in 1968. Frazier retired from boxing in 1976.

Beaufort is home to the University of South Carolina at Beaufort. This successor to the dream of those who founded Beaufort College in 1796 is a four-year branch of the University of South Carolina. Created as a branch in 1959, the main campus actually includes the Beaufort College building constructed in 1852. During the 1950s, hundreds of Beaufort's elementary students attended classes in that building and its annexes. USC-Beaufort renovated the structure to house the campus library. The South Carolina Commission on Higher Education made USC-Beaufort a four-year college in 2002. In 2004, USC-B began construction of the South Campus located near Sun City Hilton Head between Bluffton and Hardeeville. The Technical College of the Lowcountry on the site of the former Mather School campus, on Ribaut Road, provides technical and vocational training for the area's students.

The Beaufort High School junior class carnival, 1968. The desperados pictured here included (from left to right) Uel Jones, Mike Kollar, Larry Mark and Robert Long. *Ned Brown, photographer. Courtesy of Uel H. Jones.*

In 1980, Beaufort had a population of 8,643, a 15 percent decrease from its reported population in 1970. While the city's population growth declined, the population of Beaufort County grew during the decade. According to the South Carolina Development Board, in 1985 Beaufort residents had one local newspaper—the *Beaufort Gazette*, published daily—to read and three local radio stations. The major employers in the county were Coastal Seafoods, Graves Construction Company Inc., National Water Lift Company, Parker White Metal and Pirelli-Jerome Inc. While Beaufort was part of the Beaufort County School System, the city had four elementary schools, two junior high schools and one high school.

With these opportunities, by 1990, the city's population had grown to 9,576, and by 1994 the city had 11,302 residents. While the city had grown almost 11 percent between 1980 and 1990, it grew 18 percent between 1990 and 1994. Of interest is the statistic that the city's unemployment rate in 1994 was 6.1 percent, the same rate reported in the city's development plan of 1979.

The Baptist Church of Beaufort, thanks to the generosity of John and Flora Trask, acquired a new steeple in 1962. Augustus Constantine designed the steeple. Watching while the crane put the new steeple in place on 10 July were Martha, left, and Alexia Jones. The tip of the steeple is the highest point in the city of Beaufort. *Ned Brown, photographer. Courtesy of Martha Jones Denka.*

In 1994, the City of Beaufort still had a council/manager form of government. City residents elected four council members to four-year terms. Beaufort had one hospital, four banks, two savings and loans, ten parks, one television and six radio stations, twenty-one Protestant churches, one Catholic Church and one synagogue. Also, in 1994, the United States Marine air base with 781 employees was the largest employer in Beaufort County. The United States Marine Corps on Parris Island was the second largest county employer with 105. The county's other major employers were Resort Services (Bluffton), ABEX/NWL Aerospace, PHB die Casting - South and Lowcountry Manufacturing Inc.

In 2001, the National Trust for Historic Preservation honored Beaufort's devotion to preserving her past and gave the city one of the trust's "Dozen Distinctive Designations" for the year. The Beaufort Historic District is a National Historic Landmark District. Despite the city's commitment to preserving her heritage and specifically her historic built environment, a review of Beaufort's historic district revealed great and unwelcome change between the 1968 survey and 2000. Historic properties had been altered so extensively that their historical character was lost or destroyed. The survey also found that new development in the historic district had not always been compatible. In yet another irony, rising property values and an economic upswing threaten the very treasures that made living and working in Beaufort so desirable.

Epilogue:
Queen City
of the Sea Islands

Throughout her history, Beaufort has often been the bridesmaid and not the bride. She became the second, not the first, permanent English settlement in South Carolina; the temporary, not the permanent, colonial capital; a second-class, not a first, port; second choice for the naval yard. No mention of her natural gifts can fail to enumerate the depth and breadth of Port Royal Harbor. Yet, the port has never fueled the Beaufort economy as planners and observers have wished through the centuries. Rather, Indian trade, naval stores, indigo, sea-island cotton, phosphate mining and the military in succession have brought periods of stability and, at other times, great prosperity to the charming city beneath the moss-draped oaks. The picturesque, poignant beauty of the lush vegetation, the flowers, the trees and the sweep of marsh intrigue visitor and resident alike.

Beaufort scenes, 1925. A view from the river of the inlet that flows by the Castle. *Christensen Family Papers, Folder 46. Courtesy of the South Caroliniana Library, University of South Carolina.*

True lovers of Beaufort roll down their car windows when crossing Whale Branch and ecstatically inhale the miasma of marsh baking in the hot sun. Beaufort is an ever-changing river. As currents and cross-currents merge, salt and freshwater roil together, the sun never glints on the same wave. Beaufort is the amalgam of her past and present. She is the wily chief of the Huspa and the Gambian slave mending the rice dyke. She is a contradiction, or many contradictions. She is the seat of the father of secession—Robert Barnwell; and of the slave who became a United States Congressman—Robert Smalls. She has always traded on her charm, while wishing desperately to be taken seriously and recognized as a great port. She has encapsulated her past as a museum to historic preservation. Once again, many of her stately homes belong to absentee owners—who, like the cotton magnates who built Tidalholm and other cotton-financed mansions, only visit seasonally. In perhaps the greatest irony, like the former slaves who lost their stakes in freedom to tax sales and political machinations, many of Beaufort's long-term residents are squeezed between rising tax assessments and limited job opportunities. The old conflict between the "been-yahs" (natives) and the "come-yahs" (newcomers) lives on. The stage remains, only the players change.

Selected Reading List

Edgar, Walter. *South Carolina, A History*. Columbia, SC: University of South Carolina Press, 1998.

Hilton, Mary Kendall. *Old Homes & Churches of Beaufort County, SC*. Skolfield, Ellis, Photographer. Columbia, SC: State Printing Company, 1970.

History Committee, St. Helena's Episcopal Church, Beaufort, South Carolina. *The History of the Parish Church of St. Helena, Beaufort, South Carolina, Church of England, 1712–1789, Protestant Episcopal, 1789–1990*. Columbia, SC: The R.L. Bryan Company, 1990.

Jones, Katharine M. *Port Royal Under Six Flags*. New York, NY: Bobbs-Merrill Co. Inc., 1960.

Keyserling, Harriet. *Against the Tide: One Woman's Political Struggle*. Columbia, SC: University of South Carolina Press, 1998.

Maddox, Annette Millliken. *A Lamp Unto the Lowcountry: The Baptist Church of Beaufort, 1804–2004, Beaufort, South Carolina*. Brentwood, TN: Baptist History & Heritage Society; Nashville, TN: Fields Publishing Inc., 2004

Marscher, William & Fran. *The Great Sea Island Storm of 1893*. Macon, GA: Mercer University Press, 2004.

McLaren, Lynn (Photographer). *Ebb Tide-Flood Tide*. McLaren, Lynn & Spieler, Gerhard. Columbia, SC: University of South Carolina Press, 1998.

Rose, Willlie Lee. *Rehearsal for Reconstruction: The Port Royal Experiment*. New York, NY: Oxford University Press, 1964.

Rowland, Lawrence C., Alexander Moore, and George C. Rogers Jr. *History of Beaufort County, South Carolina, Volume 1, 1514–1861*. Columbia, SC: University of South Carolina Press, 1996.

Saunders, Roslyn, and Marquetta Goodwine. "African-Americans in Beaufort, South Carolina." Beaufort, SC: Historic Beaufort Foundation, 2000.

Trask, George Graham, ed. *Beautiful Beaufort by the Sea Guidebook*. 4th Ed. Beaufort, SC: Coastal Villages Press, 1998.

Wallace, David Duncan. *South Carolina, A Short History*. Columbia, SC: University of South Carolina Press, 1961.

Index

About the Author

Alexia Jones Helsley joined the South Carolina Department of Archives and History in 1968. She spent twenty years in the reference department, including twelve as supervisor. In addition, she served as director of public programs for eight years, director of education for two years, and as editor of the *Biographical Directory of the South Carolina House of Representatives*. Retired in July 2001, Helsley is currently developing a genealogical guide for the archives, teaching world and U.S. history at USC-Aiken, and managing a genealogical and historical consulting business. Her eight-part genealogical series *Branches* will air on SC-ETV's new South Carolina Channel in 2005. The series will be repeated later on SC-ETV and available for sale on DVD.

Helsley was graduated magna cum laude from Furman University; received her MA in history from the University of South Carolina, and completed doctoral coursework in public administration. She also was graduated from the Modern Archives Institute, National Archives and the South Carolina Executive Institute.

Among other publications, Helsley is the author of the following: *Researching Family History: A Workbook*; *The 1840 Revolutionary Pensioners of Henderson County; NC*; *Silent Cities: Cemeteries and Classrooms*; *Unsung Heroines of the Carolina Frontier*; *SC Secedes: a Drama in Three Acts*; *SC's*

African American Confederate Pensioners, 1923–1926; and *South Carolinians in the War for American Independence*. In addition, she co-authored: *African American Genealogical Research*; *SC Court Records: an Introduction for Genealogists*; *The Changing Face of SC Politics;* and *The Many Faces of Slavery*. Helsley also compiled the historical data for the George F. Cram Company's *South Carolina Map*.

Helsley has lectured for the National Genealogical Society, the Federation of Genealogical Societies, and the Institute for Genealogy and Historical Research at Stamford University. She has also given presentations for the Society of American Archivists, the American Association for State and Local History, the National Association of Government Archives and Records Administrators, and the Council on Public History. She is a charter member of the Henderson County Genealogical and Historical Society and currently serves as program vice president. Helsley is also president of the South Carolina Archival Association and a member of the National Genealogical Society, the Joseph McDowell Chapter, NSDAR, South Carolina Council for the Social Studies, and the South Carolina Historical Association.

She is a former president of Richland Sertoma and was named Richland Sertoman of the Year in 2000. In 2002 the South Carolina Archival Association honored her with a lifetime achievement award.

Married, Helsley is the mother of two children and active in her church, First Baptist Church of Irmo, South Carolina. An ordained deacon, she currently serves as church treasurer and on the church history committee. She and her husband Terry live in Columbia, South Carolina.